Archaeological Sites
in their Setting

Claudio Vita-Finzi

Archaeological Sites in their Setting

WITH 103 ILLUSTRATIONS

THAMES AND HUDSON

THIS IS VOLUME NINETY IN THE SERIES

Ancient Peoples and Places

GENERAL EDITOR: GLYN DANIEL

For my father

Contents

Acknowledgments

The author is grateful to D. D. Anderson, R. W. van Bemmelen, L. K. Campbell and Oxford University Press, J. G. Evans, B. C. Heezen, R. W. Hey, M. R. Jarman, S. Judson, A. J. Legge, L. B. Leopold, B. Messerli, J. P. Miller, D. Ninkovich, D. Nir, E. W. Russell, E. C. Saxon, I. J. Smalley, D. A. Sturdy and D. Webley for permission to use published material in the preparation of the illustrations.

Preface

Most archaeologists and historians have had occasion to ask whether the physical conditions that now prevail in the area they are surveying or excavating differ from those of the period that interests them. It may be that a site which now lies inland would make much better sense on the coast; that an infamous stretch of malarial swamps is nowhere to be seen; that a major city appears to be singularly lacking in arable land; or perhaps that an eyewitness account cannot easily be squared with the modern scene.

Some of their colleagues will not need the prompting of a puzzle of this sort to investigate the landscape in which their work is set. A few will have come to view the human record as just one of the many sources of inorganic and organic material bearing on ecological history.

This book discusses the kind of information that might be found useful by a member of one of the above groups who is too poor (or proud) to hire an earth scientist to do the work. Its

1

1 Like many other ancient sites, Roman Cuicul (Djemila), in Algeria, occupies a setting whose barrenness contrasts with the magnificence of the ruins

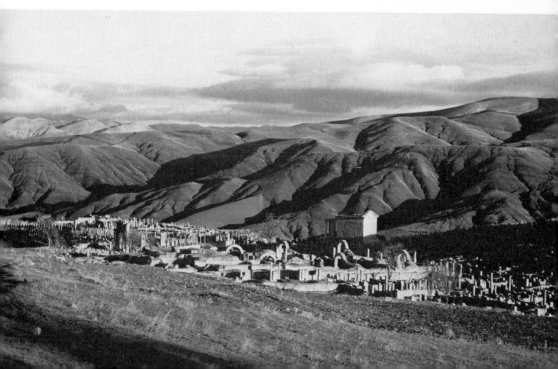

aim is not so much to provide a crash course in physical geology and geomorphology (there are, in any case, plenty of excellent textbooks which will do this) as to show that their subject matter is a natural ingredient of field archaeology and history (People *and* Places). Rather than an interdisciplinary approach – one which stresses the separateness of disciplines – the book is designed to promote an eclectic standpoint.

If this aim governs what is to be included, so does it lead to certain omissions. There is in what follows an intentional (some will say regrettable) failure to say much about climatic change and allied issues generally regarded as being of paramount importance in environmental archaeology. In my view they are at present too intractable to warrant routine investigation and not always easy to evaluate in archaeological terms, whereas the more homely themes of physiography are relatively easy to study in the field and of immediate relevance to the analysis of ancient settlement and ways of life – a Panglossian standpoint I shall try to justify.

The sequence in which the chapters below are arranged is meant broadly to represent the successive stages in a field investigation; their content is designed to show that useful information will emerge at each one of the stages. As the examples are dominated by material I know at first hand, there is a bias in favour of locations lying above sea level and freezing point, and I can only hope that the deficiencies in the data are outweighed by the benefits of familiarity.

Most of the areas I discuss were visited in the course of geological field work which was supported chiefly by the Nuffield Foundation and the Central Research Fund of London University. The better ideas I advance arose in the course of collaboration with the late Eric Higgs. Professor Glyn Daniel is responsible for my writing the book but not, of course, for what I have written. David Harris, A. J. Legge and Stephen Lintner read through the first draft and made many valuable suggestions for improving it. Alick Newman drew the figures, Chris Cromarty processed my photographs, and Annabel Swindells prepared the final manuscript.

Finally, I must apologise for the large number of end notes. But if I could not resist putting them in (on the grounds that there is nothing more annoying than an unattributed finding or quotation) the reader can always refuse to look them up.

C. V.-F.

1
Physiographic history and archaeology

Given the Duke of Wellington's high regard for 'guessing what was on the other side of the hill' it is hardly surprising that military men are well represented in the annals of archaeology. An eye for country is as essential to the field archaeologist as to the field commander. That their interests will sometimes coincide, and fruitfully at that, is illustrated by Sir Mortimer (then Brigadier) Wheeler's assessment of where the Romans were most likely to have sited their fort at Dover, an assessment which some twenty years later was proved correct to within a few metres.[1] But one should not stake all on 'the virile spark of the mind militant':[2] Woolley proved just as successful in his search for the royal palace on the mound of Atchana, in Syria, by arguing that it would lie 'where you got the benefit of a cool breeze and the wind carried away from you all the smells of the huddled town'.[3] (Woolley's Arab foreman did not need to be told where to dig, but we shall never know whether he followed a similar line of reasoning.)

Now, neither Woolley in his *Digging up the Past* (1930) nor Wheeler in his *Archaeology from the Earth* (1954) had much to say about the landscapes in which his excavations were set. In part this doubtless stemmed from a reluctance to state the obvious; in part, perhaps, from a belief that once a site had been located the other side of the hill became largely irrelevant. Whatever the reasons, this tradition lives on in those archaeological and historical accounts that mention the physical environment only when it turns sour by flooding or succumbing to volcanic eruptions, or when the artefacts and documents under scrutiny – an aqueduct, say, or a reference to animals now locally extinct – provoke a sally into the surrounding countryside.

The silence becomes more acute the younger the material at issue. Thus Burkitt felt no compunction in saying that the Bronze and Iron Ages had to be excluded from the realm of true Prehistory, being cultures 'the interest in which is never geologi-

cal'.[4] Students of the Palaeolithic (and of human evolution) have always maintained close links with the earth scientist, not uncommonly by being one and the same person. A popular introductory text on archaeology tells us that much of the fieldwork of palaeolithic archaeologists is devoted to collecting stone implements from gravels and other Pleistocene deposits and to identifying 'the geological significance of these deposits'. (So much for the field. At all other times, it would seem, their principal concern must be the typology of the stone implements.)[5]

The frequent inclusion of geologists in the motley teams that are nowadays almost *de rigueur* on large excavations or surveys might suggest that there is a growing acceptance of geological research as an integral part of field archaeology in general. But what acceptance there is recalls Margaret Fuller's of the Universe, given – as one prehistorian has wryly commented – the bias towards the natural sciences displayed by many grant-giving bodies;[6] and, while it is doubtless true that archaeological projects are becoming more 'problem oriented' and hence dependent on the services of geologists, hydrologists and other specialists,[7] the substitution of teams for polymaths (and of appendices for continuous prose) could misleadingly convey a change of heart by labouring what had previously earned no more than passing mention.

There is in fact much to suggest that the excesses perpetrated in the past in the name of geographical determinism[8] still make many archaeologists chary of letting an earth scientist loose on their sites, or at any rate of taking much notice of his findings. But who is to lay down what is the right environmental dosage? Need we know whether the Nile was especially muddy in the day of Tutankhamun? This book does not provide the answer – assuming there is one – and merely draws attention to features which appear to warrant the excavator's attention in the knowledge that he may decide to disregard them.

The items on offer are physiographic, that is to say they have to do with the form, composition and to some extent the origin of components of the physical landscape. No attempt is made to deal in any detail with the related floras and faunas, let alone the human record. Again, rather than, say, seek to explain why food production, domestication or urban life arose, we shall be content to tackle issues whose links with physiographic change are self-evident. 'The water of Chhin', we read in the Kuan Tzu, 'is laden with sediment, muddy and clogged with dust; thus its people are greedy, deceptive, and given to machinations.'[9] There

is much in this book about muddiness, and a little about its effects on ditches and fields; the moral consequences have been left to others better qualified.

If a phrase is required to encapsulate the author's standpoint it is 'geological opportunism'.[10] The term is intentionally reminiscent of 'determinism' and its half-hearted derivatives 'possibilism' and 'probabilism', being designed to convey the notion that it is helpful to know what was feasible even when we cannot always hope to discover how far advantage was taken of the possibilities. The restraint is not voluntary, being a product of defective data; but it may make what follows more palatable to those who have had to get over their dislike of the 'determinist bias', for surely they will not strain at the gnat of opportunism.

The above prescription does not preclude, but only postpones, the search for grander designs and broader explanations. The mapping of bog after bog, or dune after dune, can ultimately lead to a pattern that cries out for some large-scale explanatory mechanism; at the very least, as Butzer has suggested, it may prove possible to convert 'surficial geology maps into archaeologically significant units'.[11] But it seems unwise to discard the humbler issues prematurely.

Climatic change

One item which will receive little mention is climatic change. As was stated in the Preface, the reasons for this neglect are theoretically defensible and also rooted in expediency.

Historians and prehistorians seeking to account for the demise of former settlements or for a mode of life that seems out of tune with present-day conditions have often been led to appeal to a change in the local climate. Now, it cannot be denied that (as we have recently witnessed south of the Sahara) a run of exceptionally dry years at the margins of cultivation can have dramatic effects on the map of human distribution; and one can see how a cumulative climatic trend could work more insidiously to similar effect by reducing the frost-free season, shifting rainfall totals above or below some crucial threshold, and in countless other ways. Yet to define these limiting climatic values is very difficult at the present day, not least by virtue of the variability inherent in the most stable of climates; to define them for societies whose technology is little understood and whose social structure and demography even less, seems optimistic; and the problems increase when we turn from the simple issue of whether

2 Ploughing after the rains in North Africa. Note fading furrows from the previous year

self-sufficient occupation was feasible to the possible links between its character and that of the prevailing climate, as a glance at the vast literature on this subject will show.[12]

Moreover, all but the most extreme of climatic controls are too far removed from the data in the archaeological record to provide fruitful explanations of past human achievements and failures. The steps between a run of dry years and the decision to abandon a settlement (or to dig more wells) are rarely recover-

able; consider then, the causal chain between an alleged period of desiccation and the process of domestication. Add the difficulties that hamper the unambiguous reconstruction of ancient climates, and also the likelihood that the minor climatic changes which were ecologically significant have left no physical trace,[13] and we would seem justified in turning our attention to lowlier nettles which are at any rate substantial enough to be grasped.

By good fortune, many of the items on which climatic reconstruction depends are in themselves worthy of the archaeologist's attention, and can be evaluated with greater assurance in their own right than as palaeoclimatic indicators. A dried-up bog could perhaps connote greater rainfall in the past; its former bogginess is incontrovertible. (The assumption is being made here that the field evidence has been interpreted correctly; but few would dispute that it is easier to recognize a bog soil than to translate this into an annual rainfall figure.) Again, a field of fossil dunes may tell us something about former wind directions; it tells us much more about ground conditions where they accumulated.

Such physiographic components provide easily defined opportunities and limits to human exploitation. And even if the limits can be circumvented by technology – bogs can be drained, dunes stabilized by planting vegetation – the archaeological record will often reveal the methods by which this was achieved. In brief, both the permissive and restrictive factors, and the responses they have elicited, lend themselves to recovery by excavation. Of course, the issues that now become amenable to discussion are on the whole mundane: where others have related temperature and rainfall to civilization, we are dealing with, let us say, the limitations on irrigation posed by a broken topography. But much benefit is to be gained from the reproducibility of the results and the corresponding scope for comparisons between widely-separated periods and regions.

Physiographic history

The first item to be considered is land morphology. The archaeologist is no stranger to the interpretation of geographical setting. Away from Pompeii, Thera and other geological casualties, the present lie of the land – as the example of Roman Dover showed – will often enable him to pick out the locations that have long enjoyed topographical advantages from the viewpoint of military strategy, road layout, seafaring and the like. But the possibility always remains that the reasoning is based on an anachronistic

landscape (harbours may silt up, landslips can obliterate mountain passes, sand bodies are notoriously mobile) and one needs to ascertain whether this is in fact the case before rather than after assessing the archaeological evidence in order to avoid being led into invoking *ad hoc* environmental change.

The investment is a wise one. Now and then we may come across a topographic change which is in itself an adequate explanation of a hiatus or drastic change in the pattern of settlement. Or it may turn out that man's infinite capacity to survive natural catastrophes[14] is not necessarily a match for any prolonged if imperceptible change for the worse in his surroundings. But, more important, morphological evidence plays a very important part in the study of landscape evolution as a means of subdividing the record and as an aid to understanding the processes responsible for physiographic change. In other words, morphological studies often form the basis of analyses that go beyond mere topography.

Our second major theme can be given the short umbrella title of 'composition', because it is a matter of ascertaining the nature – physical and chemical – of the materials forming the successive landscapes, and if possible of reconstructing this aspect of the evidence for those tracts of the landscape that have disappeared in the interim. Here again we are dealing with matters which have long concerned archaeologists routinely: the rock type on which a citadel stands or the texture of the soil by which it is surrounded is as likely to be mentioned in a field report as the character of its walls. The difference is merely one of emphasis. To the physiographer, composition is of interest both in its own right and as a further piece of evidence from which to infer the mechanisms responsible for change.

This, the third of our areas of enquiry, includes such considerations as whether a particular sediment was laid down by running water and if so whether flow was perennial or seasonal. Besides contributing to the reconstruction of the ancient landscape, the results tell us something about the day-to-day changes experienced by its inhabitants and hence about the physical resources available to them. How far one should go along the causal path clearly depends on the needs of the archaeological study. Thus, in the example just cited, one would not be unduly concerned with the provenance of the sediment unless the conditions in the upper reaches of the river basin were felt to bear on the pattern of land exploitation throughout the valley during the period of deposition.

The aim should be to isolate and exploit to the full the range of information that can be derived from the physical record while holding in reserve evidence from other sources until the time is ripe for corroboration. Blinkered though this viewpoint may appear, it gives coherence to the study and ensures that the evidence is evaluated solely on its own merits. If the answers appear incomplete or ambiguous (and the temptation to turn elsewhere for supplementary data is correspondingly strong) it is as well to bear in mind that findings which have been dismissed by a geologist or a palaeoclimatologist as beneath his notice could prove of great value to the student of early human settlement. A poorly-sorted alluvial fan deposit may be the product of either a semi-arid or a periglacial environment, yet it is almost certainly the result of ephemeral stream flow, and this weighs more than considerations of atmospheric temperature in any discussion of irrigation practice or of the navigability of the local rivers; the fact that a solitary spring once flowed profusely does not make a pluvial period, but it may be enough to account for an anomalous concentration of animal bones and hunters' debris.

Yet certain complementary indicators have to be considered concurrently with those strictly pertaining to physiography. Fossil beaches can rarely be identified with conviction in the absence of shells *in situ*; the distinction between freshwater and estuarine deposits likewise depends on organic evidence. How then is one to adhere to the recommendation that one should eschew such clues at least until some preliminary conclusions have been drawn?

In most cases common sense will provide adequate guidance. To return to our fossil beach, the detailed identification and ecological interpretation of its fauna can await preliminary analysis of the beach and its deposits. Where a line warrants drawing uncompromisingly is between ancillary sources which bear solely on the local situation and those that pertain to regional conditions. Into this latter category fall all palaeoclimatic indicators or, more correctly, all indicators which have been interpreted in palaeoclimatic terms. The pollen record, for example, is often presented as a succession of episodes distinguished by particular temperature and rainfall values, whereas we are more interested in the actual pollen counts as possible guides to local vegetation and ground conditions. Again, the study of glacial episodes is generally geared to their climatic interpretation, whereas what concerns us is whether or not ice and permanent snow were present in a particular area during a specified period.

The dating of ancient landscapes

The successive mosaics of physiography and ancillary information can be constructed only if the fragments are individually dated. This is one area in which the long and fruitful association between geology and archaeology has proved less than productive. If the most striking achievement of the alliance has been to demonstrate the antiquity of man and to erect a chronological

3 structure within which his development could be traced,[15] the concomitant concern with strata has meant the ingestion by archaeology (notably, but not solely, when concerned with prehistory) of certain questionable assumptions and procedures from geology.[16]

Prior to the introduction of radiocarbon and other radiometric methods of age determination, it was generally possible to assign a specific age to sediments only when their accumulation was recorded in dated historical accounts or where they contained datable artefacts. The correlation (that is to say the matching) of geological sequences from place to place thus had to depend on the assumption that a certain line of development – a faunal succession, or a series of distinctive strata – had unfolded simultaneously at two or more locations. With the recognition of former glacial periods and the attendant fluctuations in climate beyond the ice sheets the geologist came to apply this procedure

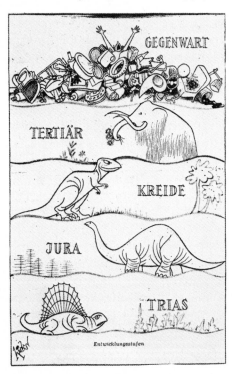

3 Archaeology and the geological column.
Trias = Triassic;
Jura = Jurassic;
Kreide = Cretaceous;
Tertiär = Tertiary;
Gegenwart = Recent

to the study of the Quaternary, climatic episodes serving to integrate the disparate data at his disposal: the last glacial advance in Europe might be identified at one spot by the presence of distinctive glacial deposits, at another by a fossil flora indicative of cold steppe conditions, and at a third by traces of a phase of active frost weathering within a cave. Dating by varve-counting, by tree-ring analysis and more recently by radiometric methods meant that some of these episodes could locally be allocated an age expressed in years; the temptation was strong to assume that this age applied to the episode wherever it was recognized.

The geologist has long acknowledged that the contemporaneity he speaks of when engaged in palaeontological correlation is not more than relative: a fauna whose fossilized remains serve as the basis of correlation cannot have spread instantaneously throughout the area in question. Climatic correlation suffers from the same difficulty, as it cannot be assumed that the changes on which it depends occurred simultaneously at the two locations under study; indeed, simultaneity can be discounted when the change stems from a progressive shift in the circulation pattern. Moreover, the matching of sequences of cooler and warmer, or wetter and drier episodes, unlike the correlation of fossil sequences representing an evolutionary progression, may well be 'out of phase' by one or more cycles (as when a glacial episode at one location is equated with a later glacial elsewhere) or by part of a cycle (as when a wetter episode in a low-latitude area is erroneously linked to a high-latitude glaciation).

In brief, extrapolating a measured date by climatic correlation probably entails a loss of definition, as climatic time-boundaries are not necessarily isochronous (i.e. of the same age throughout their extent); and it can give rise to gross error if the correspondence between the various sequences is misjudged. The use of certain well-established sequences or horizons as standards against which the local record can be matched appears an economical device for spreading the benefits of radiometric dating: many prehistoric caves are dated by correlating the cold episodes apparently represented in their infills with an accepted glacial chronology. The economy is a false one which leads at best to circular argument and at worst to misleading conclusions, and any procedure which divorces climatic interpretation from excavation is to be welcomed.

In this respect, at least, the separation of roles promoted by team research may prove beneficial by enabling the archaeologist

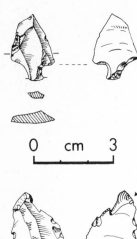

0 cm 3

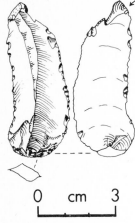

0 cm 3

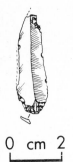

0 cm 2

4 Archaeological dating. (a) Aterian point from alluvium at Mazouna, Algeria (see Ill. 5); (b) Baradostian blade from alluvium near Khorramabad, Iran (see Ill. 6); (c) Late Palaeolithic blade from Lisan Formation, Jordan (see Ill. 7)

to discard some of the modes of thought associated with his geological tasks. (The shedding of preconceptions is of course not incompatible with solitary research: one can learn from teams without joining them.) This boils down to dating as much of the evidence as possible independently of the archaeological record it is designed to illuminate. Besides the benefits this will bring to any local reconstructions – in that various pieces of a mosaic for any one particular period can be assembled purely by virtue of their age – the door is now open to the archaeologist for eventual comparisons with the wider world.

From the above it would appear that the chronological burden should fall on non-archaeological sources of dates, and in particular on those based on radiocarbon and other radiometric methods. That suitable material will rarely be available in the right place, and that the methods are themselves open to a wide range of errors, are familiar counters to such proposals. The arguments are valid enough; but the superiority of a few independent dates to a large number which prejudge the crucial issues will be accepted by most readers. It is worth remarking that datable samples are more likely to be found if funds are already available for dating, a component of the archaeological budget often low on the list of priorities.

But the exclusion of archaeological dates need not be total. Artefacts whose age has been determined without recourse to geological correlation, such as sherds readily placed within a clear pottery sequence or distinctive flint implements from a local stratified cave which is well endowed with radiometric dates, can be used to date deposits into which they have been incorporated. True, they will merely indicate the maximum age of the beds in which they lie or by which they are overlain, and the minimum age of those beneath, but this will often prove as instructive as a radiometric determination.

A good example is furnished by the sherds found embedded in a lava flow on Santiago Island (one of the Galápagos group), as they could be identified with the jars in which a buccaneer party had stored eight tons of quince marmalade in 1684 and which had then been destroyed by the Viceroy of Peru.[17] No less useful were the three artefacts here illustrated. The classic (though unusually small) Aterian point (a) was found within an Algerian deposit which had previously yielded 'primitive' Mousterian artefacts, and hence it supported the proposed identity of the deposits with coastal sediments also containing Aterian artefacts.[18] The large blade (b) came from a valley fill in Iran for

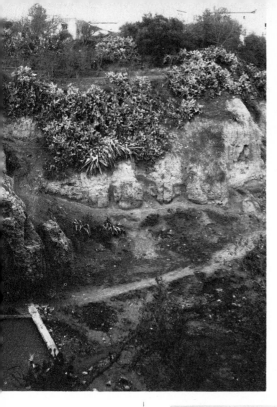

5 Mazouna Alluvium (M)
overlying tufa (T)
at Mazouna, Algeria

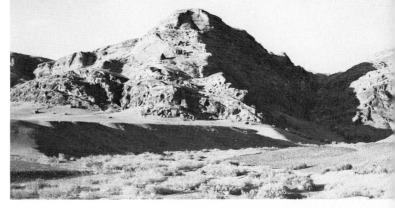

6 Khorramabad
Alluvium near
Khorramabad, Iran

7 Lisan Formation in
Wadi Jurfa, Jordan,
overlain by alluvium. The
blade shown in Ill. 4c and
discussed in the text was
found in the gravel near
the head of the hammer

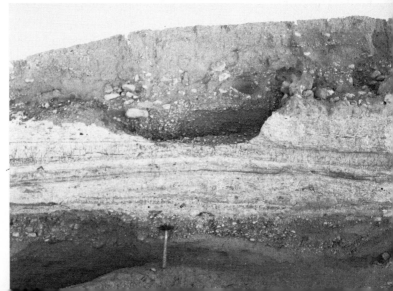

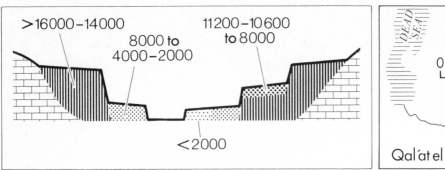

8 Alluvial fills in Wadi Hasa, Jordan, and ages indicated by artefacts in or on them

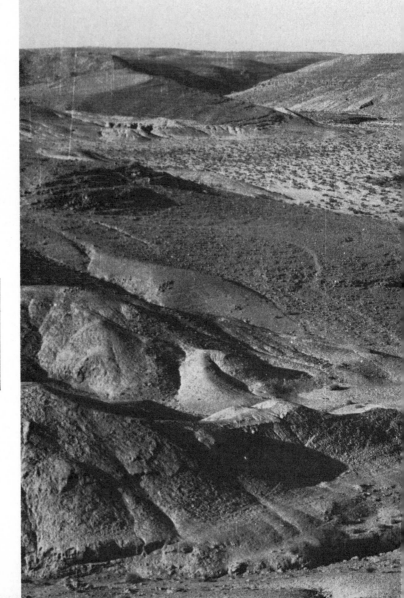

9 Wadi Hasa, Jordan.
The Kebaran site
discussed in the text was
found on the eroded
remnant of the oldest fill
(I) visible in the left
foreground

which a terminal age of 2740±100 yr BP (I-3781) was obtained by radiocarbon dating of an overlying hearth; the attribution of the blade to the Baradostian, an industry dated by C14 in a nearby cave to approximately 38,000–29,000 years ago, supplied a maximum age for the onset of aggradation.[19] The small blade (*c*) came from a unit – the Lisan Formation – which was laid down in the precursor of the Dead Sea; its late 'Upper Palaeolithic' character implied a value in the region of 20,000–14,000 years, and radiocarbon dating was later to show that deposition had in fact not ceased until 18,000 (and conceivably as late as 15,000) years ago.[20]

7

Needless to say, assemblages rather than individual pieces are required for archaeological dating to inspire any confidence.

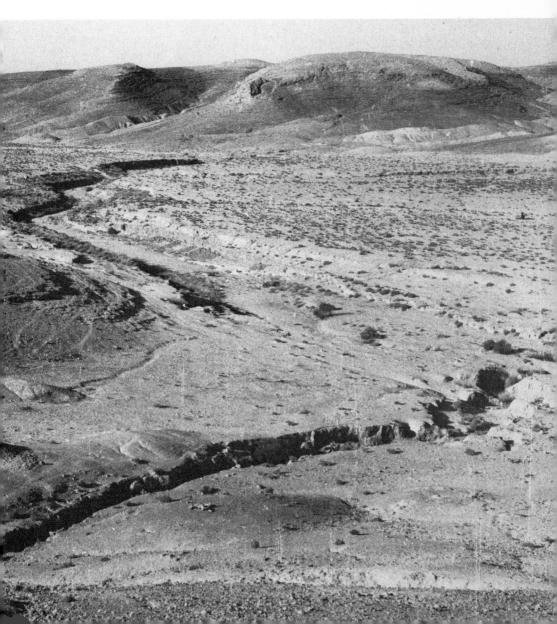

8, 9 Three of the four successive alluvial fills in the middle Wadi Hasa, Jordan, yielded artefacts which could individually invite attribution to the Neolithic; but once the rest of the material had been compared to well dated assemblages from various Levantine sites, an internally consistent alluvial chronology emerged.[21] One can see how further sampling, directed at differentiating between artefacts at the base and at the top of each of the fills, could further refine the results. The fact that all three of the distinctive tools described in the previous paragraph turned up within the first five minutes, and that many hours of additional searching yielded nothing, is perhaps better forgotten.

2
Spheres of interest

How far afield should the physiographic study be extended? There are ample practical reasons for asking the question. Time, money and personnel impose a limit on what can be accomplished during a field season, and the opportunity for a second visit cannot always be taken for granted. In addition, the map of information owes more to the possessiveness of landowners, the activities of gravel extractors and road builders, and the whims of officialdom than to the needs of the investigator; a rough plan of campaign is therefore needed to stiffen one's resolve in some directions while softening it in others. Trinil, Swanscombe, Solo, Olduvai and many other major sites have amply demonstrated that what modest (or envious) authors term luck usually has its roots in the judicious selection of an area or outcrop worthy of sustained attention.

The case for circumscribing one's view is easily made with the help of an extreme example. How many readers would fault a study of conditions in prehistoric Florida which failed to mention the presence of glaciers on the Rocky Mountains? Yet to assume that glacial history did not prey on the minds of the Palaeo-Indian inhabitants of the peninsula is not to deny that glacial history influenced the Gulf indirectly, among other things by contributing to fluctuations in sea level, by modulating the behaviour of some of the Mississippi headwaters and hence the sediment load carried to the coast, by distorting the climatic pattern, and doubtless by affecting the distribution of plants and animals. But if (to borrow Medawar's terminology[1]) we are to tackle 'causal parentage' before 'causal ancestry', such matters can wait until the local, physiographic tale has been reconstructed.

Site territories

Where we are dealing with a known site – a term used in this book to denote any location which attracts the archaeologist

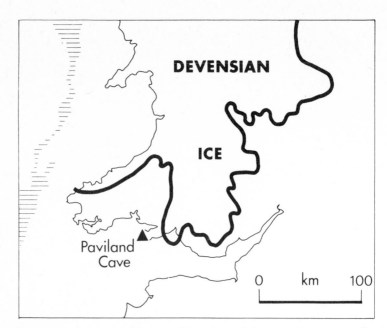

10 Position of Paviland Cave in relation to Late Devensian (Würm) ice sheet of Britain. Contemporaneous coastline indicated by horizontal shading

because it betrays evidence of human activity – the issue is easily grasped.

Butzer has drawn a clear distinction between 'the local habitat or setting of a site' and 'the regional environment' or, again, between the 'physical environment of the immediate site and of the wider habitat'.[2] Coe and Flannery contrast macroenvironments with microenvironments, the latter defined as 'smaller subdivisions of large ecological zones' and illustrated by 'the immediate surroundings of an archaeological site' as well as by 'the bank of a nearby stream, or a distant patch of forest'.[3]

Although there are a few workers who can rely upon their experience in defining what is local or immediate, most of us need some rule of thumb by which to draw the line, at least initially; and repugnant though such mechanical devices may appear, they have the virtue of rendering the findings from different sites (and different investigators) amenable to valid comparison. To take a specific example this time, a radiocarbon date of $18,460 \pm 340$ yr BP (BM 374) for Paviland Cave, in South Wales, shows that it was occupied at a time when glacier ice lay 6 km. north of it. At no stage during the Last Glaciation was the cave overrun by ice.[4] Were the glaciers alarmingly close or comfortably distant? Or, to put it another way, granted that the ice reflects generally chilly conditions, how are we to judge whether or not it impinged directly on the daily life of the 'Red Lady' and of the other Upper Palaeolithic inhabitants of the site?

10

Considerations of this sort led to the formulation of 'site catchment analysis', a technique which has proved helpful in collaborative studies by workers with differing skills and preconceptions.[5] The notion of 'catchment' arose from analogy with the area drained by a river, or perhaps better (in view of the contributions subsurface water can make to a river) with the zones from which schools are intended to draw their pupils. Even if neither analogy is open to severe scrutiny, the term should still convey the general idea of an area which supplies one particular component of the site record.

Many sources, organic and inorganic, contribute to this record. If we consider a series of sediments in a cave, for example, we find material brought in through the cave mouth and through holes in the roof by wind and water, airborne pollen, tools, and the remains of animals which either walked in or were brought by predators. Each of these will reflect a 'catchment' of its own: hunting territories in the case of predators, drainage basins in the case of water-laid sediments. Not all of these will lend themselves to demarcation, the provenance of windblown material (including pollen) presenting the greatest difficulty. But some of them will, to produce a pattern of overlapping or nested related *11* territories.

Given the archaeologist's primary concern with human remains, it is essential to identify the site exploitation territory, namely the area exploited for food by the inhabitants of the site, the intended contrast being with localities visited to obtain flint,

RELATED TERRITORIES

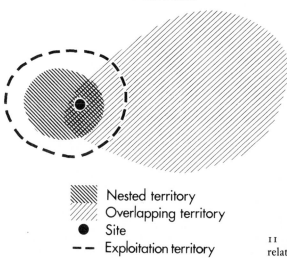

Nested territory
Overlapping territory
Site
Exploitation territory

11 The concept of related territories

say, or ochre. In the first attempts to define such areas the emphasis was placed on distance, but the criterion of time was substituted once it became obvious that broken country would produce boundaries departing markedly from the ideal circular shape. The problem still to be faced was that of determining the distance that could be covered in a given period of time in any one direction: even where good topographic maps were to be had, there was no simple conversion factor which would enable contour interval to be transformed into rate of movement. The solution finally adopted was to draw the boundary with the help of radii representing the distance that could be walked on a particular bearing within a specified period.

12

The time-interval to be adopted would clearly depend on the economy thought to have been in force during the period of occupation. Where the aim of the analysis is to elucidate the probable function of a site, one can hardly set out by assuming that hunting, say, was the key activity; but where physiographic change is the primary concern it is not unreasonable to make such an assumption on the basis of whatever artefactual, organic or other evidence is to hand, on the understanding that the analysis may yield results which are incompatible with it. To take an example, an 'agricultural site' could be found to lie beyond easy reach of adequate arable land.

The method was first tested using two-hour radii for sites occupied by 'hunter-gatherers' and one-hour radii for agricultural sites, on the grounds that the daylight hours left over after travelling to the outer boundary and back would suffice for the related activities. The resulting territories were then compared with case-studies in the ethnographic and agricultural literature and were found to accord reasonably well with the size of the territories exploited from home bases respectively by collecting and agricultural communities. Thus certain Bushman groups in the Kalahari normally confine their collecting activities during the dry season to within a radius of 10 km. (6 miles) from the home base;[6] and in many parts of the world, despite great technological and environmental differences,[7] the decline in net return becomes significant at a distance of 1 km. from the farm and oppressive at 3–4 km.

Numerous objections can be made to the 'catchment' idea. Ethnography is hardly a secure basis for the analysis of ancient economies, as the primitive societies it documents could turn out to be ephemeral and may well owe their survival into recent times at least partly to attributes lacked by their extinct counterparts.

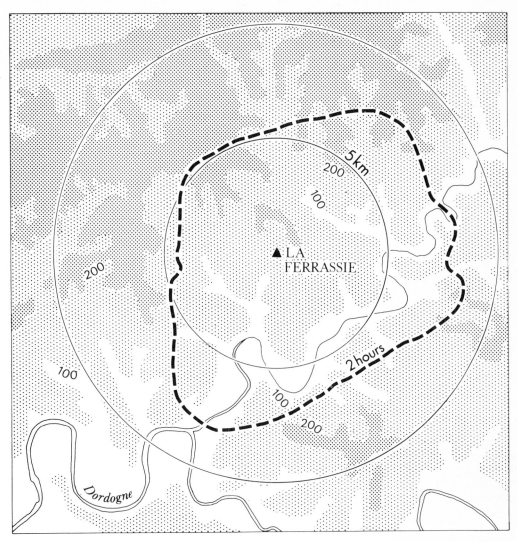

What is more, the subsistence behaviour of many of the hunter-gatherer groups that have been observed deviates markedly from the tidy scheme postulated here, especially in the extreme irregularity with which they occupy their sites. Similarly, farming communities may disregard the diseconomies of distance, notoriously where the laws of inheritance, the needs of security, or the obstacles posed by malarial or otherwise inhospitable terrain create wide gaps between a settlement and its land. In addition, many colleagues have questioned the arbitrary nature of the one- and two-hour limits, the emphasis placed on food supplies, and (in all seriousness) the validity of equating our walking speeds with those of our Stone Age ancestors.

12 The site exploitation territory of La Ferrassie, Périgord, France. Note distorting effect of topography (heights in metres)

The first set of objections overlooks the exploratory nature of the approach and the scope it offers for correcting the underlying assumptions. For example, should a site emerge as being poorly located for year-round occupation, its demotion to the rank of 'seasonal' or even of 'transit' site can always be contemplated. As regards the time-radii (and the question of walking speeds), one can only appeal to the virtues of simplicity and to the reasonableness of the adopted values; while the charge that the technique stresses food at the expense of military, trading, artistic and other locational factors amounts to accusing a plumber of overlooking the aesthetic properties of flowing water: site exploitation territories are explicitly intended to evaluate the food resources near a site. And, in any case, locations selected for other purposes are not wholly immune from the selective pressures that afflict self-supporting settlements.

The territories of seasonal or transit sites may be found to have offered resources which were in some way complementary. Without necessarily invoking the concepts of 'home range' and 'lifetime range' employed in the study of other mammalian populations,[8] one can here progress beyond a formula for determining 'immediate vicinity' to a stratagem for delimiting the likely 'annual territory' of a group. The net can be cast more widely where it is possible to identify 'extended territories', defined by D. A. Sturdy as areas which lie outside the exploitation territory and are seldom if ever visited by man but which support mobile resources (such as animal herds) used by the inhabitants of the site.[9]

13 The concept of extended territory. A=exploitation territory; B and smaller outlying areas=extended territory. Home bases marked by triangles

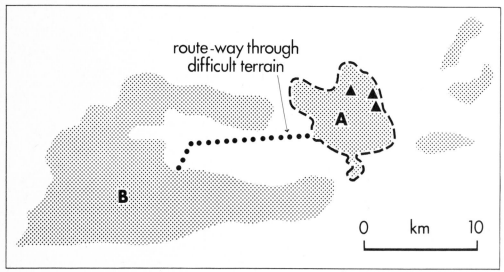

route-way through
difficult terrain

A

B

0 km 10

The archaeologist may wish to go even further, and take into account the 'extra dimension' of social territory, which at an economic level can be defined as 'the territory drawn upon for resources by any community by virtue of belonging to larger social groupings'.[10] But students of physiographic change are well advised to resist the temptation: catchment analysis was formulated as a surveying device, and will start to creak if too much is asked of it. Conversely, the 'walking' of territories – or even the drawing of circles – around sites is only a first step. If it is not corrected for the physiographic changes that have taken place since occupation, the map is misleading, just as classifications which group sites into alluvial, lacustrine, coastal and similar categories not only overemphasize this aspect of its location but also risk getting it wrong.

Physiographic units

Where no sites have been recorded, or where the survey has already progressed to the mapping of several site territories, a convenient framework within which to proceed is provided by the 'physiographic units' of the earth scientist. The most familiar such units are the river basin[11] – the prototype for our 'catchments' – and the lake basin. Where there is no drainage system to unify a portion of the landscape, recourse may be had to other criteria. In a desert area, for example, predominantly sandy terrain will be found to border rocky surfaces; on coasts, zones characterized by cliffs alternate with low-lying stretches. Provided the functional nature of the resulting boundaries is borne in mind, their lack of precision presents little difficulty: one can with advantage take a leaf out of the oceanographer's book, for he identifies mid-oceanic ridges and abyssal plains by their gross topography with more concern for their possible significance than for the relative merits of any particular isobath.

14

The scraps of narrative are obtained from natural exposures, quarries, boreholes and so forth, and should in due course add up to the sequence of changes by which the physical landscape has acquired its present character. Any site territory which is subsequently mapped within the physiographic unit will thus be readily 'corrected' for the corresponding interval. If, for example, occupation is found to coincide with a period during which an adjoining lake was higher than it is now, the area of land accessible from the site must be evaluated accordingly whatever the gain in aquatic resources.

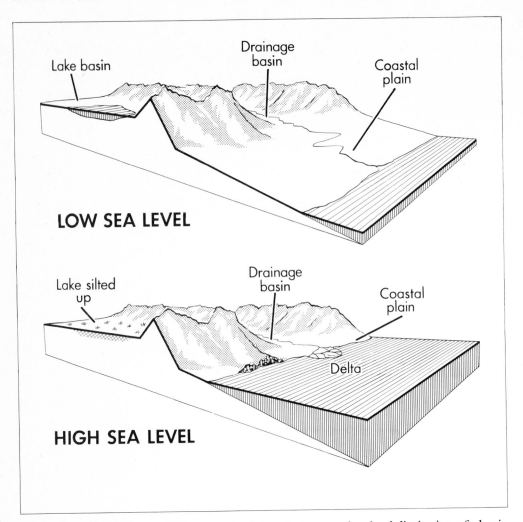

Lake basin

Drainage basin

Coastal plain

LOW SEA LEVEL

Lake silted up

Drainage basin

Coastal plain

Delta

HIGH SEA LEVEL

14 Major physiographic units (uplands, lake basin, river basin, coastal plain) and effects of submergence

Where territorial analysis precedes the delimitation of physiographic units, however, evidence from the site itself as well as from its environs may supply the bulk of the evidence for change. The fact that many site territories straddle physiographic boundaries – perhaps because it was advantageous to have equal access to two contrasting sets of resources – simply means that the evidence has to be apportioned accordingly. A series of territories strung out along a single valley will throw light on, for instance, downstream changes in the composition of the alluvial floor and on the progress of channel incision; territories located at its margins may enable the evolution of the valley to be linked to that of adjacent lakes and uplands.

The scale at which one operates, the fineness of the detail resolved, and the order in which territories and physiographic

units are attacked, are matters of personal preference or local circumstance. Many of the examples that follow are based on work carried out before the suggestions advanced in this chapter had been formulated and often during geological surveys which were not geared to archaeological aims. As a result, the physiographic viewpoint is more prominent than the territorial. The use of 5 km. and 10 km. circles on some of the site maps should be seen as a temporary expedient.

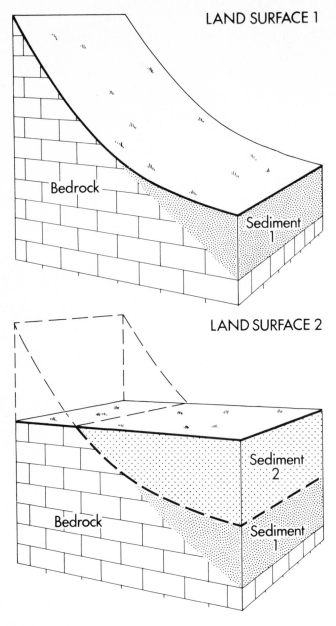

LAND SURFACE 1

Bedrock

Sediment 1

LAND SURFACE 2

Sediment 2

Bedrock

Sediment 1

15　Two successive land surfaces, the younger produced by both erosion (*left*) and deposition (*right*)

Ancient land surfaces

In his essay on *Landscape in History*, Sir Archibald Geikie suggested that the Battle of Bannockburn would have seen 'a far other ending' had the local topography been then what it is now; for the ground on Robert the Bruce's left was covered at the time by impassable bogs and sheets of water which prevented Edward's army from outflanking the Scots. Thus the Bruce's 'device of the "pots" was only an extension of the kind of defence that nature had already provided for him.'[1]

For his account of the original setting, Geikie drew on Barbour's poem *The Bruce*, and he justified his trust (which lay this side of accepting the 'complete historical veracity of the Archdeacon of Aberdeen') on the grounds that Barbour was born a mere two years after the battle, that he travelled a good deal, and that he had nothing to gain from inventing topographic details. Occasions will arise when it is simpler to challenge the poet or historian than to invoke geological change. In either case, one must get the site right: for example, equating Minoan Crete with Plato's Atlantis, which is difficult enough chronologically, calls for fairly substantial adjustment of the island's size and position.[2]

For our purpose, the evidence for topographic change must be confined to the physical record, any historical or literary corroboration of the conclusions ranking merely as a bonus. As we have seen, archaeology may need to contribute to these conclusions by supplying dated material; but its role is otherwise limited to framing questions which give point to the investigation. The slope of a parcel of land is a fairly uninteresting item until (for example) the former extent of irrigation comes to be considered; similarly, the fact that a plain was undergoing erosion by gullies gains appeal once we turn our attention to the route (or plough) in whose path the gullies lay.

The simplest way of approaching the study of topographic history is to view it as a succession of land surfaces leading up to

15

that of the present day. Although it is not unusual for such surfaces to survive relatively unscathed for several million years, geological agencies can transform recent topographies beyond recognition, and on occasion may then restore the original situation by stripping away superficial sediments or filling in depressions. The ideal is to piece together land surfaces whose ages correspond to crucial stages in the archaeological sequence, such as the onset and close of occupation at a group of caves, or a period of active agricultural settlement. Nevertheless surfaces which do not meet this requirement can still prove informative – always provided their age is known – not only as rough guides to the conditions that followed their creation but also as clues to the nature and rate of physiographic development.

Given the importance of age, the task of reconstruction is greatly facilitated if isolated fragments of the surface can be shown by independent dating to warrant inclusion; but more often than not, there will be large tracts whose place in the jigsaw depends on indirect dating or on the apparent unreasonableness of alternative views. Provided the basis for inclusion is made clear, no harm need come of this as further work can always lead to revision. The danger lies in assuming that continuous surfaces are of the same age throughout just because they are continuous: both deposition and erosion tend to produce diachronous surfaces, that is to say surfaces which 'cut across' a theoretical time-plane. Take, for example, the gradual advance of blowing sand or the progressive removal of soil from an eroding field.

16 One of the ventilation shafts of Lepcis aqueduct (Libya) exposed by erosion. The top of the shaft marks the original ground level

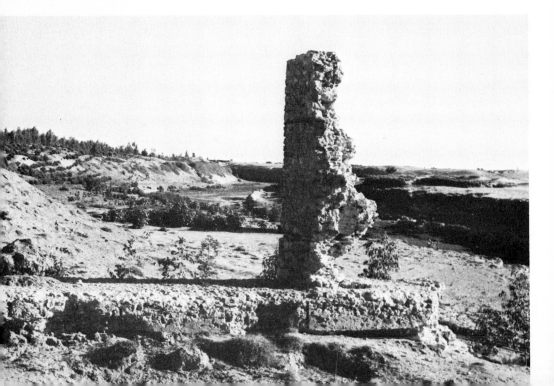

Exposed land surfaces

Sir Aurel Stein was always at pains to supplement 'the archaeo-
logical task' with the observation of geographical features.[3] In
the Bushire peninsula of Iran he encountered a deeply eroded
area where small terraces served as 'witnesses' to the original
ground level. The terraces had been preserved by ruined
structures associated with potsherds dating from early Muslim
or possibly Sassanian times, and Stein found a satisfactory degree
of agreement between the 14 ft (4·3 m.) of vertical erosion that
had taken place since occupation there and the corresponding
value of 20 ft (6 m.) near a similar terrace capped by a Chalco-
lithic mound.[4] It may of course be that erosion began at both
sites after Sassanian times; even so, Stein's observations nicely
illustrate the use of superficial material as a *terminus ante quem*
for the underlying deposits and (on the assumption that a surface
now eroded was once unbroken) as a *terminus post quem* for their
erosion.

Stein also described various masonry-lined wells which had
been left standing above ground by erosion of the sediments into
which they had been dug. A similar effect may be observed near
the mouth of Wadi Caam, in Tripolitanian Libya, where the
tops of masonry shafts (*spiramina*) which ventilated an under-
ground aqueduct to Lepcis Magna now stand exposed to varying
degrees. In both places the coexistence of surface and subter-
ranean conduits gives us some idea of the extent to which the

16, 17

17 Part of subterranean
Lepcis aqueduct exposed
in floor of Wadi Hasnun

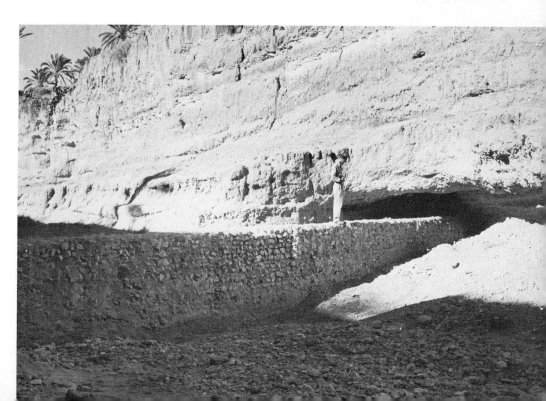

surface had already been eroded by the time of their construction, on the reasonable assumption that excavation would be avoided where possible, although it always has to be borne in mind that other considerations – ease of maintenance, gradient and so forth – could tilt the balance in favour of tunnelling.

One possible implication of stream incision into this kind of surface is illustrated at the Neolithic site of Beidha, in Jordan. According to Raikes, 9000 years ago the valley downstream of the site was filled with deep alluvium which provided its inhabitants with soil and, thanks to the runoff it received from the surrounding bedrock surfaces, was better watered than an exiguous annual mean rainfall of some 200 mm. would otherwise warrant. In due course, gullying of the fill progressively removed the cultivable sediment and also reduced surface and sub-surface water-flow in the remainder, and Raikes has suggested that this erosion was one of the reasons why the site was abandoned.[5]

The creation of a cultivable surface could presumably prove no less momentous. Near Ajalpan, south of Tehuacán (Mexico), the alluvium that underlies the bulk of the valley floor ceased to accumulate about 9000 years ago. This terminal date was derived from two C14 determinations on charcoal 3·50 m. below the surface of the deposit (which has a thickness of at least 19 m.) the first of 9750 ± 140 and the second of $10,050 \pm 150$ yr BP (I-4587, 4800). A date of $17,500 \pm 320$ yr BP (I-4602) on tufa higher in the section was discounted as this material, already prone to give exaggerated ages through the incorporation of 'old' carbon from groundwater, here took the form of derived fragments and could therefore only provide a maximum value for the time it was embodied in the sediment. The decision seems reasonable in the light of a date on charcoal of 9150 ± 500 yr BP which has been reported from a depth of 1 m. in a similar valley fill south of Puebla. Renewed aggradation took place in the first millennium A D within channels cut into this surface, the implication being that the plain was trenched in the interim.[6]

Previous workers had identified four 'microenvironments' in the Tehuacán area, one of which – the alluvial valley floor – was seen as offering fairly good possibilities for primitive agriculture dependent on rainfall.[7] Geological and geographical studies indicated that the local topography and physiography had not undergone drastic changes since men first entered the valley, although there was some evidence for a continuous fall in the level of the water table throughout that period and hence for a progressive increase in the aridity of the microclimate.[8] If the

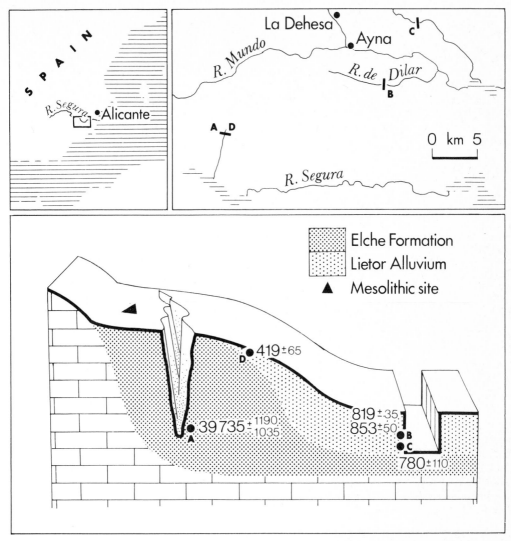

chronology presented here is compared with the land-use sequence elaborated from the analysis of artefacts and of plant and animal remains, there emerges an interesting correspondence between the completion of the plain and the rise of the El Riego cultural phase (7000–5000 BC), whose closing stages witnessed a noticeable increase in the area's population. One is also prompted to ask whether progressive stream incision perhaps began by favouring agriculture (Coxcatlan phase, 5000–3400 BC) and ended by stimulating irrigation (S. María phase, 900–150 BC). Such conjectures are wholly consistent with the accepted view that no marked climatic changes here took place during the period in question.

18 Location of Mesolithic sites on surface of Elche Formation in Ayna area, Spain

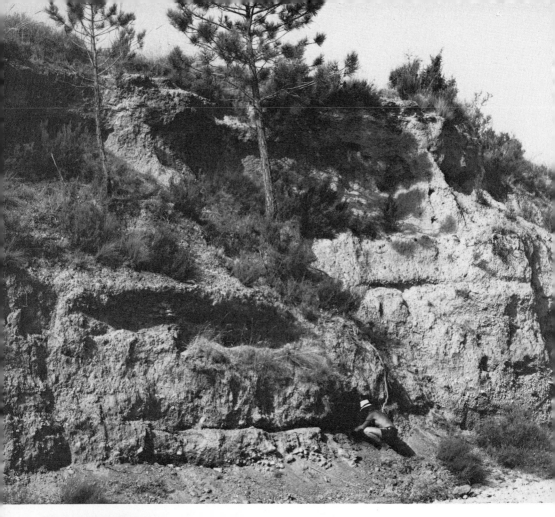

19 (*above*) Excavating hearth at base of Lietor Alluvium in Rambla de Dilar (B in Ill. 18)

20 Excavating deposits below Mesolithic site near La Dehesa (see Ill. 18)

The recognition of constructional land surfaces can prove *18–20* helpful in the early stages of a site survey even if nothing can be assumed about their possible economic significance. The first open Mesolithic sites to be found during a reconnaissance of the Ayna area in southeastern Spain lay on the surface of a red valley fill which had elsewhere undergone severe gullying. This morphological clue led to the discovery of several other Mesolithic sites in comparable locations well before the chronology of deposition had been worked out.[9] In the Transvaal, C. van Riet Lowe observed from the air 'a dirty creamy coloured area undergoing surface erosion'; knowing that similar areas in other parts of Africa had yielded Mesolithic implements he later visited the spot and was suitably rewarded.[10]

Buried land surfaces

The buried portions of ancient land surfaces are recognizable as breaks in the rock record. The geological terminology for features of this kind includes 'non-sequence' for a break that betrays only a halt in deposition, and 'unconformity' for one that indicates erosion as well as non-deposition, an 'angular unconformity' being one where tilting or faulting has displaced the underlying beds prior to their erosion and a 'parallel unconformity' (or 'disconformity') one where the beds on either side of the break have similar dips. These categories do not meet our present needs: although earth movements have rarely been active enough to produce clear angular unconformities in the space of a few centuries or even millennia, many of the depositional breaks that are used in tracing buried land surfaces do not qualify as 'parallel', either because they depend for their recognition on criteria other than dip or because they are on too small a scale for the twofold classification to be applicable. More important, there is a divergence of aim: the geologist tends to see the breaks as irritating gaps, whereas the site physiographer is glad to discover them.

The simplest solution is to use the stratigraphic terminology purely for description, while basing the identification of breaks on evidence for periods of land stability, such as soil and weathering horizons or widespread traces of human activity coincident with a lithological boundary of some kind.

The age of the beds underlying such a boundary provides nothing more than a maximum age for the surface, just as that

of the overlying beds provides a minimum, hence the desirability of finding datable material directly associated with the surface. This may take the form of artefacts within a soil, or of charcoal from a hearth which has been buried without undue disturbance; or indeed of an entire city. Lyell cited more than 5 m. of alluvium over 'a very ancient subterranean town, apparently of Hindoo origin' to illustrate the rapidity with which rivers may build up their plains;[11] volcanologists find the pre-Classic Mexican site

21

of Copilco, like Pompeii and Herculaneum, a useful time-marker for the topography that was buried by a particular set of volcanic deposits.

In northwestern Libya, ancient dams and other structures enable the land surface of the Roman period to be traced in some detail.[12] The limestone hills of the Tripolitanian Gebel have been partially buried by fine-grained sediments, a process described as *imbottitura* (or stuffing, in the sense that a tomato rather than an armchair is stuffed) by Italian geologists. The upper part of the infill (or Jefara Formation) contains Middle Palaeolithic artefacts; its surface is strewn with late Palaeolithic and younger

21 The site of Copilco, Mexico, overlain by lava (*left*)

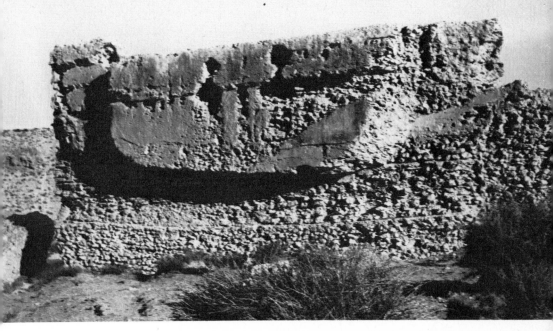

material. In Wadi Gan, where the deposit attains a thickness of 50 m., a late Aterian site has been found 10 m. below the surface; a cultural layer resting on the infill and sealed by hillwash contains artefacts showing some relationship to the Upper Capsian of the Maghreb. On the basis of the dates available for these industries in the Maghreb, one may infer that deposition off the Jefara deposits gave way to stream downcutting about 13,000 years ago. The depth to which downcutting had progressed by Roman times can be determined by reference to masonry barrages and cisterns originally erected on the wadi floors and now lying from a few centimetres to several metres above the modern stream beds. The form of some of the dams also reflects the shape of the channels they blocked.

The dams and cisterns rest on resistant calcareous crusts within the Jefara Formation which had arrested stream incision. These calcretes can therefore be used as a rough guide to the original position of the wadi beds. In some of the larger wadis the calcretes grade laterally into alluvium which is only partially cemented by calcium carbonate, but as the overlying deposits are unconsolidated the ancient land surface can be identified with blows from a geological hammer. In Wadi Megenin, measurements of the shear strength of the pre- and post-Roman deposits obtained with a pocket shear-vane gave readings of 3·5–5 lbs/

22 Roman dam in Libya indicating shape of channel it formerly blocked

22

23

sq. in. for the former and 2 lbs/sq. in. or less for the latter; the instrument was then used to link those sections in which the deposits had been dated by artefacts *in situ*.

The topography that emerged from these studies was evidently undergoing active dissection by gullies and ravines; indeed, some of the deep channels that are now eating into fields and orchards are ancient gullies which were temporarily passive in post-Roman times and which have since been reactivated. It is therefore not surprising that, as Oates has shown, practically all the dams were built to trap sediment rather than water. This sediment, irrigated by the spates that brought it down, could support crops which, unlike the olive, were not amenable to dry farming.[13] Rather than attempt to stem erosion, the Roman engineer turned it to advantage.

23 Calcareous crust at base of Roman structures in Wadi Caam, Libya, now being eroded

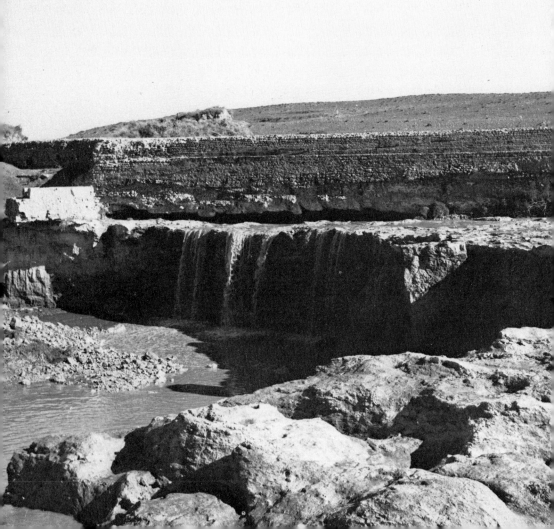

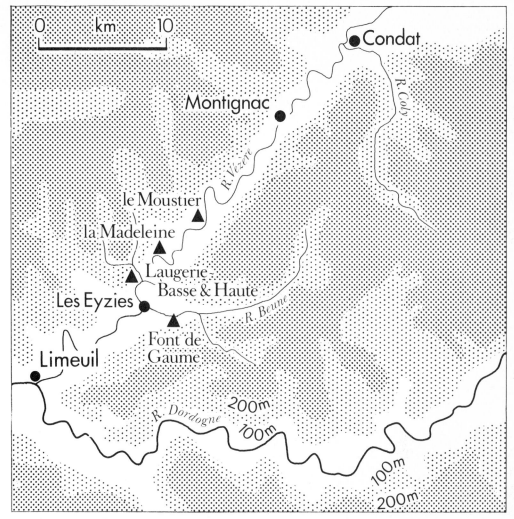

24 Locations in Périgord, France, discussed in text

Périgord

One of the earliest attempts to relate the archaeological site record to topographical evolution appears in the literature dealing with the prehistory of Périgord. In 1887, Massenat, Lalande and Cartailhac observed that the strata from the 'âge du renne' in the shelter of Laugerie-Basse could be followed down to the level of the highest floods in the Vézère, and they concluded that occupation had taken place in a valley very much like that of today.[14]

Valley evolution figures prominently in later studies of the area, but although artefacts are widely used to date successive

43

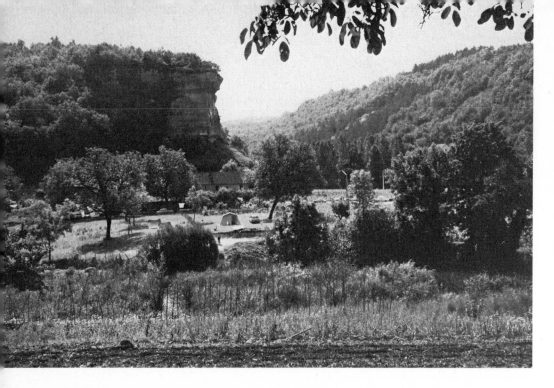

25 Alluvial valley floor bordered by steep limestone cliffs, near Les Eyzies, Périgord

alluvial terraces, the main thrust of the work is towards unravelling geomorphological history for its own sake or as an indicator of changing climate.[15] Indeed, the growing concern with climatic chronology came to divert attention into caves and shelters and away from their environs, the primary aim being to establish 'a sequence, as complete as possible, of the climatic and ecological variations during the Pleistocene, so as to get a relative chronology permitting the correlation, layer by layer where possible, of different shelters or open-air sites in the southwest of France'.[16]

In an attempt to complement existing knowledge of topographic change during prehistoric occupation, a study was made of valley evolution in a small part of Périgord.[17] As no site territories had been mapped, the drainage basins of the Vézère and its tributaries were used to define the survey area, with the middle Dordogne supplying a check on the resulting chronology. The most prominent depositional unit to be identified was named after Montignac, in whose outskirts it is well displayed. The various sediments of which the unit is composed are linked by a surface which decreases in gradient from about 30° near the higher limestone escarpments to near-horizontality close to the larger streams. The available C14 dates suggest that deposition began about 22,000 years ago and ended 13,000 years later. The sediments yielded Upper (as well as Middle) Palaeolithic artefacts; as it happens Fénelon could find evidence for only one

24, 25

26–27

44

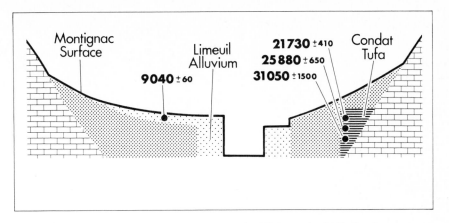

26 C14 dates for depositional units present in the Vézère and middle Dordogne

generation of slope deposits, and they yielded Aurignacian, Solu-
trean and Magdalenian artefacts. The question that has to be
asked is whether the associated topographic changes (whatever
their climatic origin) bear on the pattern of human occupation.
Discussion will be limited to the Magdalenian simply because
its span coincides with the latter part of the Montignac phase.

How justified was it to speak of the 'age of reindeer'? The fre-
quency of reindeer, if measured as a percentage of the total bones
in an occupation level,[18] commonly gives values in excess of 90
per cent in the Magdalenian sites; and 99 per cent has been
recorded in the Solutrean of Laugerie-Haute. No Mousterian site
exceeds 87 per cent; yet we also encounter over 90 per cent in
some Upper Perigordian levels, in the Aurignacian (99 per cent
at one level in the Abri Pataud at Les Eyzies) and in Acheulian
horizons at Combe Grenal. Although there is a pronounced

27 Part of the
Montignac surface (level
of field beyond track) in
the Vézère valley near
Montignac

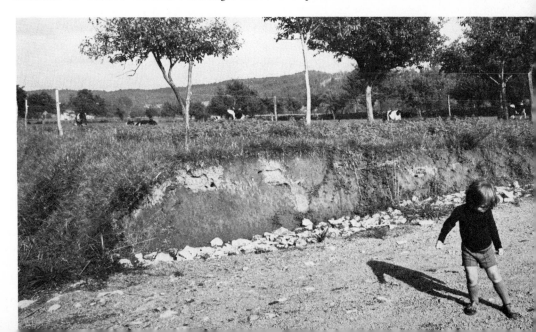

increase between Mousterian and Solutrean times in the per-
centage of occupation layers in which reindeer is clearly domi-
nant,[19] layers of this kind are present throughout. In contrast, the
human map shows pronounced changes.

Mellars has pointed out that the number of known sites in Péri-
gord is far greater for the Magdalenian than for any earlier
period; that they include some exceptionally large ones, among
them Laugerie-Haute and La Madeleine; and that Magdalenian
settlements tend to be low-lying and often occur close to river
banks. The issue of total numbers is perhaps misleading in giving
undue prominence to scattered finds which happen to be readily
allocated to a cultural tradition; and, however important such
evidence of widespread activity might be to a study of, say, hunt-
ing or collecting patterns, it will not tell us why certain locations
were persistently favoured. As regards the other two trends it
is noteworthy that, whereas major Upper Perigordian sites such
as the Abri Pataud fell out of favour, Laugerie-Haute did not;
while La Madeleine, previously neglected, now became desir-
able. The answer cannot be that shelters became too full of sedi-
ment to be habitable: numerous cases exist of sites cleared of
earlier deposits by prehistoric occupants.

One suggestion is that propinquity to river banks was favoured
by an increased emphasis on fishing in the Magdalenian. If we
consider the valley-floor topography as it was immediately before
and during Magdalenian occupation, any advantage currently
enjoyed by fishermen operating from La Madeleine or Laugerie-
Haute is eradicated by the substitution of an aggrading valley
floor for the modern, crisply-defined boundary between river and
alluvial banks. More important, fishing – though influential in
the art of the period – apparently did not compete with reindeer
as the major source of food; and it seems reasonable to look to
the staple food rather than ancillary sources in seeking to explain
the selection, perpetuation and rejection of sites.

The long-standing contention (based largely on the analysis
of reindeer teeth and bones) that Mousterian sites in Périgord
were in use throughout the year has recently been challenged in
favour of the view that short-term occupation was the rule.[20]
Whatever the exact subspecific identity of the reindeer of the
period (another subject of debate) they are likely to have under-
taken periodic migrations between their winter and summer
ranges. Some workers argue that a location at the boundary
between the two ranges is advantageous in giving the hunting
population easy access to the reindeer at all seasons. Others

28

28 Magdalenian reindeer hunters

LAUGERIE HAUTE

NW

0 m 250

Vertical exaggeration
×2

ABRI DE LA MADELEINE

NW

0 m 250

Vertical exaggeration ×2

29 Topography at La Madeleine and Laugerie-Haute at the close of the Montignac phase

favour the view that exploitation would be restricted to the period of migration; and Burch has pointed out that large archaeological deposits containing over 80 per cent of reindeer remains could represent nothing more than sites of major kills.[21] Yet to occupy Périgord simply as a base for sallies into adjoining summer and winter ranges would not seem to provide my justification for favouring river-side sites; and the 'ambush' strategy would require a more precise adherence by the reindeer to a migration route than modern experience justifies.

Yet there is a third possibility, namely that the Magdalenian 'hunters' were not wholly passive observers of seasonal movement but, like the Lapp reindeer herders observed by Sturdy

in Greenland, engaged in some measure of control over it. Itvinera, the central site of a reindeer station, lies between the summer and autumn grazing grounds, and its environs provide a natural corral which can support all the station's reindeer for the short period required for the annual killing.[22] E. S. Higgs had suggested that Laugerie-Haute and La Madeleine were occupied for similar reasons; the suggestion made all the better sense once the topographic setting of the two sites had been *29* 'restored' to its original condition.

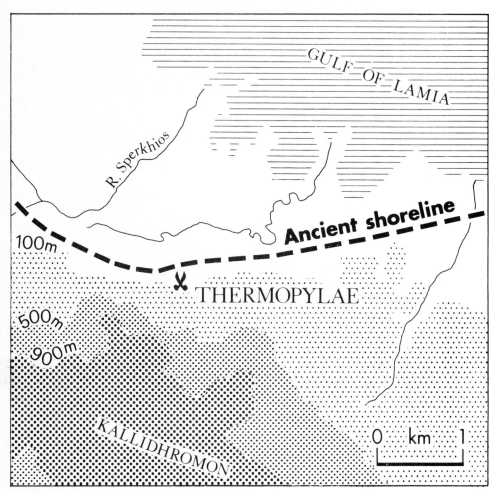

30 Coastal advance at Thermopylae

Littoral history

Like the Battle of Bannockburn, Leonidas' stand at Thermopylae *30*
makes little sense in its present setting, this time thanks to the
coastal plain built up by the River Sperkhios. Deposition is of
course only one of the many processes than can modify the posi-
tion and nature of the shoreline on lakes and seas: erosion may
make it retreat; changes in the elevation of the land, or in the
level of the water, may submerge or expose tracts of land and
as a result alter the character of the shore from one dominated
by cliffs to a monotonous plain.

The investigation of shore development is an extension of the
task outlined in the previous chapter, the ultimate aim still being
to recreate the ancient topography. The one important difference
is that, when we are dealing with marine shores, 'external
sources', in the form of sea-level chronologies constructed out-
side the area of study, can supplement or even replace local evi-
dence of shoreline displacements without first being translated
into the terminology of climate. But the controversy that sur-
rounds such chronologies, and the complications introduced by
vertical movements of the land, make this procedure too risky

31 Severan harbour
works at Lepcis Magna,
Libya, indicating little
change in sea level

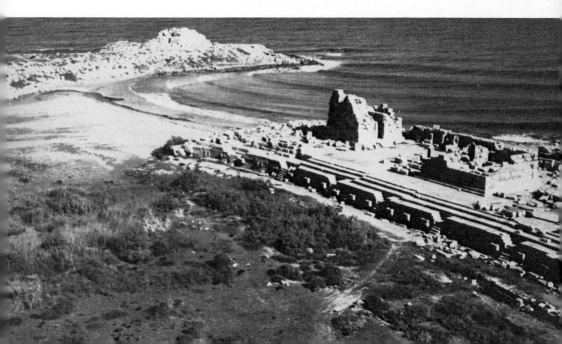

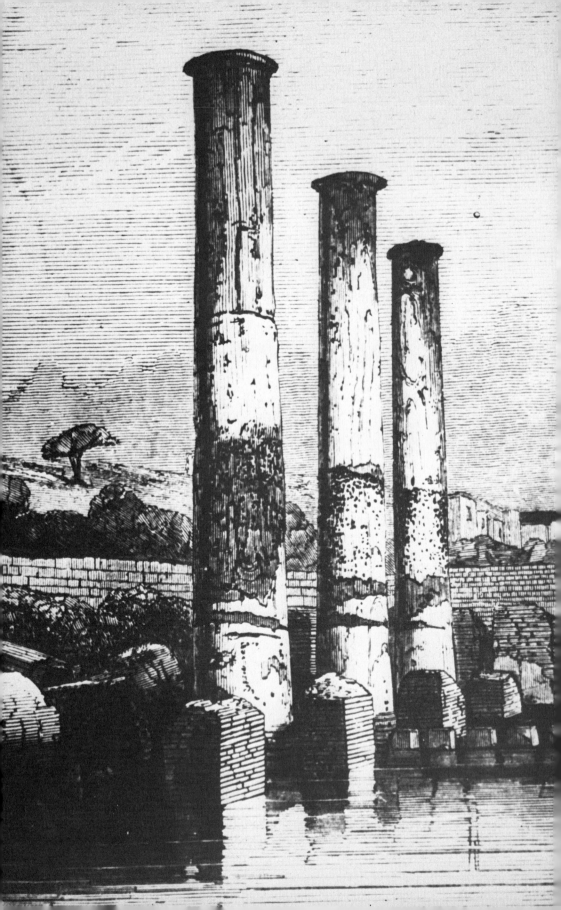

to be adopted in anything more ambitious than a reconnaissance (see below, chapter 8).

Littoral sites whose history is well documented can often supply the requisite chronological evidence. At Lepcis Magna (Libya), the elevation of mooring rings, steps and related structures appears to show that sea-level has not changed by more than the margin of error implicit in this kind of evidence – say 0·5 m. – since the Severan port was built, although there are indications of a rise of about 1·5 m. during the earlier part of the Roman period in the form of blocks of masonry incorporated in an intertidal organic deposit.[1] The borings produced by marine molluscs in the columns of the Temple of Serapis at Pozzuoli, near Naples, have long been cited as evidence for localized submergence followed by emergence.[2]

31

32

Where the local sites are either unsuited to this function or still to be discovered, we revert to quantitative dating as the link between the littoral and human sequences. Radiometric dating of shells and other marine organic materials poses special problems to the geochronologist, and coastal sections appear to be unusually prone to conflicting interpretations, although some of the disputes in the literature stem more from partisanship than geology and can be avoided by studious parochialism. Archaeological dating is less generally helpful than in fluviatile sections but has occasionally proved very rewarding. In Cyrenaica, for example, the presence of Middle Palaeolithic artefacts in three exposures of the '6 m. shoreline' gave some indication of its age and, by extension, of the extensive continental deposits known to postdate it.[3]

Concentrations of datable material are often associated with beaches indicative of a relatively static water level, and the narrative will be correspondingly dominated by periods of stability; but, as was the case inland, nothing justifies the assumption that these periods were coterminous with phases of human occupation. Moreover the beaches merely mark halts in a sequence of phases of submergence and emergence, both of which will produce diachronous surfaces. The one advantage offered by littoral sequences over inland ones is that, as the traces left by the advancing or retreating waterline are spread over a wide front, the diachronism may be more easy to document.

Territorial analysis can help in determining the effects of changes in the position of the shoreline on the economic potential of a site, especially when the site lacks harbour works, shell middens or other tokens of dependence on aquatic resources, or

Opposite: 32 Columns of the Temple of Serapis at Pozzuoli showing *Lithodomus* borings

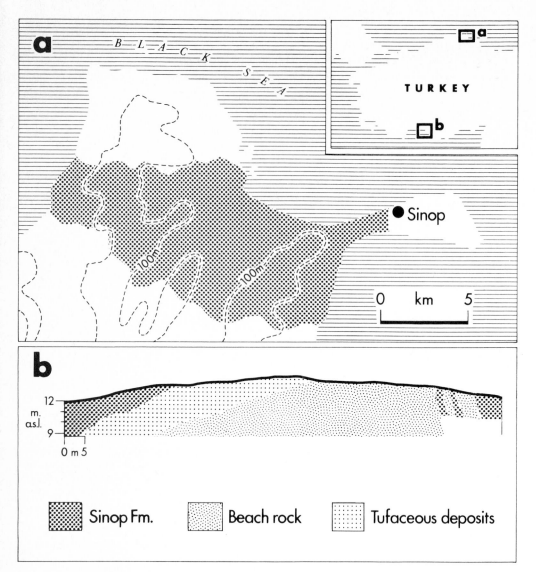

33 Turkey. (a) The depositional unit marked by the stipple overlies a fossil beach near Sinop (see Ill. 34) and interfingers with fossil dunes (see Ill. 60); (b) between Alanya and Manavgat the same unit overlies tufas and beachrock

indeed appears to have been wholly dependent on cultivation. It can also link the littoral evidence with that obtained inland where there is some indication that two sites were occupied by the same group at different times of the year in order to utilize complementary sets of resources.

Where the survey is set within a physiographic framework rather than one dictated by the known pattern of sites, little difficulty is found in defining convenient units in the case of lakes, as gross topography will generally permit the identification of the major watersheds. Fossil lake basins in low-lying terrain, especially when obscured by drifting sand, are less readily demarcated,

but the lacustrine beds themselves supply an adequate starting point. In the Rub' al Khali, for example, McClure found a series of ancient lake deposits exposed wherever deflation had removed the overlying sands, and went on to plot the probable extent of the areas that had supplied run-off to the lakes.[4] Marine shores are often difficult to subdivide into coherent units but in time a manageable scheme is likely to emerge. In parts of coastal Turkey where the topography is unhelpfully subdued, the mapping of a series of alluvial deposits overlying fossil beaches and interbedded with fossil dunes supplied a convenient framework for the study of late Quaternary landscape evolution.[5]

34 View of portion of Section a, Ill. 33, showing fossil beach and overlying deposits

33, 34

Emergence

Where emergence has been relatively abrupt, the strip of land thereby added to the existing land surface is likely to contrast markedly with it in form and composition. The Peloponnese coast near Corinth provides good examples of this effect. That the process can operate with extreme suddenness is shown[6] by the deformation of an area of between 170,000 and 200,000 square kilometres during the Alaska earthquake of 27 March 1964, with uplifts on land locally attaining 10 m.

35

35 Fossil beach near Corinth now lying 20 m. above sea level

Gradual or irregular emergence, especially when combined with (or produced by) littoral deposition of land-derived sediment, may lead to a poorly-defined contact whose clarification requires sections cut transverse to the zone of transition. In the Dead Sea basin, one such natural section revealed a reversal in the progressive shrinking of the Lisan Lake by showing that a wave-cut terrace lay beneath the lake beds, beach deposits and alluvial-fan material into which the beach terraces now exposed at the surface had been eroded.[7] It is of course the picture at the surface that bears on the soil map: cultivation in the area is almost wholly restricted to tongues of alluvium which have encroached on the sterile lake deposits. The attractiveness of the site of Jericho owes as much to one of these tongues as it does to its perennial spring.

36 Any 'gain' in land area, needless to say, will not invariably prove profitable. At Semarang, in Java, there is historical evidence for a seaward shift in the coastline of about 8 m. a year between 1695 and 1847 and of 12 m. a year thereafter; extrapolation of the resulting curve into the past suggests that the harbour at Bergota, which was in use in AD 916, had begun to silt up soon after that date. Van Bemmelen[8] is of the opinion that this

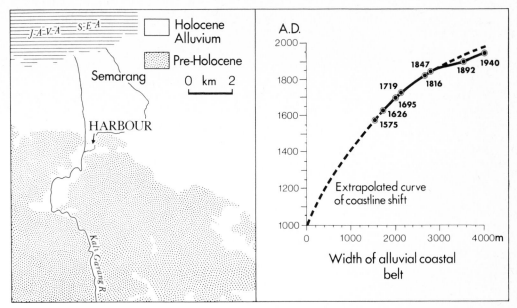

36 The chronology of coastal advance at Semarang, Java

process promoted the decline of the Hindo-Javanese state of
Mataram even though the death-blow was probably dealt by a
catastrophic volcanic eruption in about AD 1000. The problem-
atic siting of the Harappan outposts of Sutkagen-dor and
Sotka-koh, in west Pakistan, has been ascribed by Dales to a
combination of uplift, littoral sedimentation and silt deposition,
there being ample evidence for emergence earlier in the area's
geological history.[9]

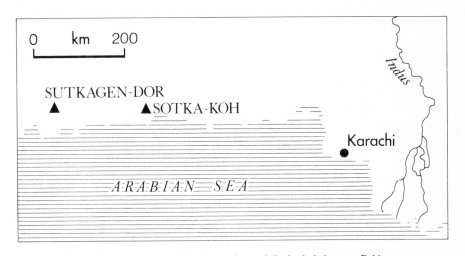

37 Location of Harappan sites of Sutkagen-dor and Sotka-koh in west Pakistan

The ecological and economic effects of such shifts will vary a good deal even along a short stretch of coast. Fairbridge has shown how the physiographic setting of shell-midden sites in coastal Brazil influenced the extent to which their productivity was affected by the shoreline oscillations of the last 7000 years. For instance, sites located near shallow tidal rivers fell into disuse when emergence led to a freshening of the estuarine waters and hence to the disappearance of oysters formerly present in profusion, whereas sites located by deep estuaries remained unaffected.[10]

In time, a littoral change which is initially detrimental to the local economy can emerge as advantageous thanks to the cumulative action of natural processes, technological progress, or a combination of the two. The infilling of coastal embayments and estuaries in south and west Anatolia led to the abandonment of many harbours by the sixth and seventh centuries AD, two prominent examples being Ephesus and Miletus. An allied consequence is generally held to have been the 'conversion of fertile lowlands into malarial swamp'. Modern drainage practices have rectified the loss and capitalized on the territorial gain, and it is not inconceivable that early moves in this direction help to account for the shift in emphasis from central Anatolia to the coastlands and river valleys that characterized Byzantine agriculture in the region in the twelfth century and perhaps as early as in the ninth and tenth centuries AD.[11]

Many site surveys have benefited from the knowledge that emergence had taken place during a specified period even though its implications for the local population were not fully understood. The Alexandersfontein Pan, near Kimberley in South Africa, only holds water sporadically; C14 dating indicates the presence of substantial lakes about 16,000 years ago, and at least one Middle Stone Age site has been found 'partly in primary context' in the 18–19 m. shoreline. Lake Mungo, in New South Wales, has been dry for the last 15,000 years; some 26,000 years ago it contained water to a depth of over 8 m. – ample justification for the claim that the environment exploited by its shoreline inhabitants 'was very different from that of today'. The El Jafr depression of Jordan, which now receives less than 50 mm. of annual rainfall, was covered about 27,000 years ago by a lake between 1000 and 1800 km². in area whose desiccation apparently occurred during Middle Palaeolithic occupation of the basin. *38, 39* Physiographic evidence for former high stands in lake level in various parts of the Atacama Desert of Chile and the adjoining

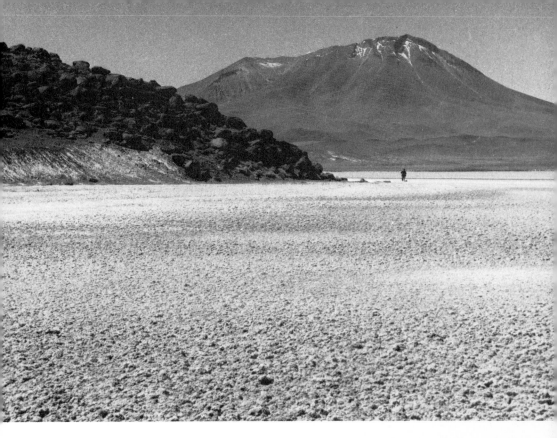

38, 39 Site survey based on lake-level studies in the Atacama Desert of Chile

Bolivian Altiplano, though bereft of age determinations, encouraged the search for lithic material along the ancient shore-lines and led to the discovery of numerous palaeo-Indian sites.[12]

Submergence

Only in areas of pronounced relief is a drowned landscape self-evident, and even here there is always the possibility that a complex sequence of positive and negative shifts in the waterline awaits recognition. In many parts of the Mediterranean basin, tilted marine deposits and beaches – including those near Corinth – demonstrate that differential movements of the crust have interacted with sea-level fluctuations to produce a deeply indented coastline which is in some places the product of recent emergence and in others of submergence.

The archaeological evidence can be just as ambiguous. The submerged prehistoric lake dwellings of Switzerland provide perhaps the most celebrated example of sites apparently affected by submergence, yet it was long believed that the dwellings had been built out over the lakes in the first place.[13] On a grander scale, it was suggested in 1964 that the Italian coast from Sicily to Tuscany had been submerged and then uplifted as a unit by 20 m. between the fall of the Roman Empire and the seventeenth century AD. The implications of this claim, and the many violent ways in which it conflicts with the geophysics, archaeology and history of the area, have been treated by Flemming. But does the field evidence indicate submergence? The key exhibit cited was the site of Paestum, where traces of wave action and mollusc *40* borings were reported from its temples; as a visit to the site was to show, the former could be attributed to weathering processes that are at work at many other classical sites, the latter by the fact that the columns were made of travertine, a material whose irregular, porous structure creates holes and notches which could be mistaken for the products of marine action.[14]

Submergence is doubtless generally unwelcome. The case is self-evident when the rate at which it progresses is sufficiently rapid for harbour installations and dwellings to be adversely affected or exposed to a higher incidence of storm damage than previously; let alone when, as at Helike in 373–372 BC, an entire town plunges into the sea during an earthquake. The cumulative effects of imperceptible submergence can be no less damaging: there is evidence on the north coast of Crete for slow subsidence 'which since Minoan times has robbed the island of valuable

Opposite: 40 Temples at Paestum showing columns in which the effects of weathering have been mistaken for those of submergence

cultivated land' and perhaps also accounts for many of the ninety to one hundred Cretan cities of which Homer speaks.[15]

Viewed retrospectively, however, submergence may appear beneficial. The littoral chronology that has been constructed for Unmak Island, in the Aleutians, with the help of radiocarbon-dated volcanic ash stratigraphy indicates a shoreline lying 2–3 m. above its present level between about 8250 and 3000 years ago, when emergence supervened. According to Black, no major land-based food resource appears to have been available to the ancient Aleuts, who were consequently dependent on the sea at a time when free-swimming marine life was probably plentiful and sessile (attached) forms were in limited supply. It was during the period of submergence that wave-cutting produced the strandflats now providing easily gathered, year-round, renewable food resources. There was a corresponding 'proliferation of Aleuts', the absence of kitchen middens more than 4000 years in age serving to date the switch in emphasis to the intertidal zone.[16] The extent to which a population will adjust to a change in the nature of the available resources emerges as one of the issues that can to some extent be pursued by comparing the physiographic 'stimulus' with the debris of 'response'.

Qatar & Oman

The wealth of Qatar in prehistoric remains was first revealed by a series of Danish expeditions in the 1960s. In his entertaining account of his association with these expeditions – *Looking for Dilmun* – Bibby tells us that P. V. Glob located several Palaeolithic sites by assuming (for reasons not specified) that sea level had originally lain some 10 ft (say 3 m.) higher than at present and hence produced inlets and headlands in areas now dry. One such location, 'an ideal site for a Stone Age fishing encampment', was to produce the first Palaeolithic find of their survey.[17]

The hunch gains support not only from its archaeological success but also from the results of C14 dating applied to fossil beach deposits on Qatar. In 1974 ages of 5370 ± 80, 4690 ± 80 and 5830 ± 70 yr BP (HAR-528, 523 and 525) were determined on samples from deposits at 1·5, 1·7 and 2 m. above high water respectively. Taylor and Illing had previously obtained values of 3930 ± 130, 4200 ± 200 and 4340 ± 180 yr BP for beaches in western Qatar at about 1·5–2·5 m. above sea level; in nearby Abu Dhabi, Evans and his associates determined an age of 4002 ± 202 yr BP on shells from a beach ridge 1·9 m. above high water.

41

Opposite: 41 Fossil beach overlain by medieval ruins in Qatar

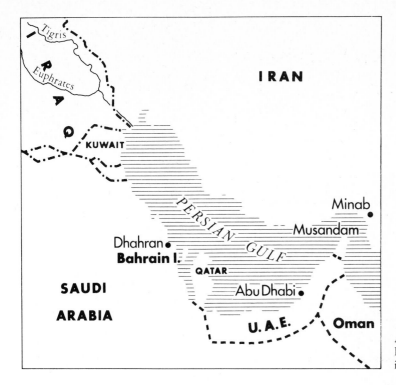

43 Locations in the Persian Gulf discussed in text

There is thus good local evidence for some 2 m. of emergence in the course of the last 5000 years or thereabouts. In view of the low relief of the coastal and offshore zones the resulting shifts in the shoreline and in littoral productivity cannot be neglected in any study of the protohistory and history of Qatar. One can only hope that the veil that still surrounds the earlier part of the narrative will shortly be lifted.[18]

In the Musandam Peninsula of Oman, at the mouth of the Gulf, the physiographic evidence points to rapid submergence over the corresponding period. The morphological evidence for submergence is sufficiently compelling for one observer to compare the peninsula's inlets and embayments with fjord coasts and thereby to infer that the topography had been sculptured by glaciers. The cliffs, which locally exceed heights of 200 m., are undoubtedly steep, as indeed are the inlets, and the earliest values for the extent of submergence were obtained by estimating the depth at which opposing side slopes would meet if extrapolated below the water and the sediments that partially fill the inlets. A second method, also physiographic, was to work out the depth of the valley floors now submerged on the assumption that the original streams had gradients of at least 100 ft per mile (c. 19 m. per

42, 43

Opposite: 42 The steep cliffs of Musandam, Oman. Note restricted site of fishing village

65

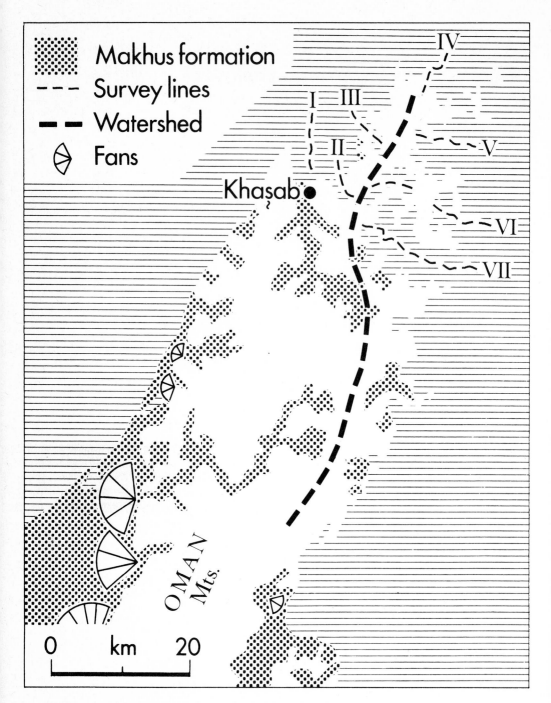

44 Evidence for differential submergence of Musandam peninsula.
(*above and opposite*). Ra's al Khaymah lies on the coast west of the large semicircular alluvial fan marked on the map

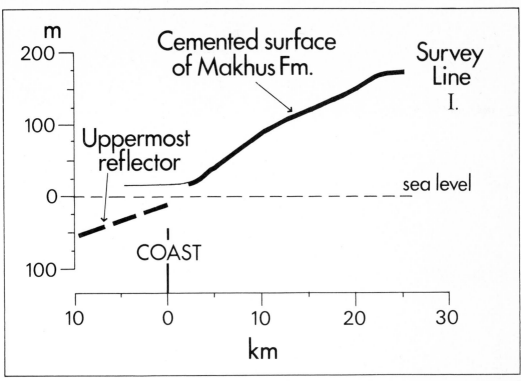

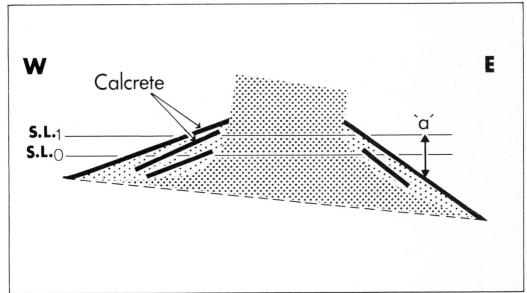

km.). The results were put at about 1500–3000 ft (*c.* 450–900 m.) of land subsidence since the Pliocene.

A geophysical survey carried out around the coasts of Musandam in 1971–2 failed to show how far the above estimates were justified, as the instruments were not sufficiently powerful to locate bedrock over the larger part of the 195 km. traversed. But the 'sparker' profiles were found useful in complementing the morphological evidence in another way. Most of the profiles displayed reflecting horizons at various depths within the sediment flooring the inlets and inshore areas. In unsubmerged parts of the Musandam valleys, the channels have trenched a gravelly fill which, both at the surface and at various depths, displays horizons strongly indurated by calcium carbonate to form calcrete. The simplest interpretation, namely that the submerged deposits are identical to those still exposed, is supported by the apparent continuity of the uppermost reflector with the cemented surface of the valley gravels. Granted the validity of this assumption – and only offshore drilling can test it – the fact that the deposits were laid down on land means that their present depth is a direct measure of submergence.

The original gradient of the valley floors is not known, and one cannot correct for the distance offshore of the various depth measurements; the values derived from this simple analysis are therefore very approximate. What they show is that the greatest submergence was towards the north and east, where it amounted to at least 100 m. This tallies with two other lines of evidence, namely the position of the main watershed – which now lies far to the east of a meridional line dividing the peninsula down the centre – and the pronounced truncation of the drainage systems trending north and east. Moreover, the uppermost reflector along one of the survey lines in Khawr ash Shamm (Survey line II) slopes northeastwards where the drowned valley represented by this inlet might be expected to have a gradient in the opposite direction.

Raised beaches and recent marine shells have been reported farther south on both flanks of the Oman Mountains. One such terrace, on the west coast, plunges northwards near Ra's al Khaymah to disappear below the sea. The presence of some kind of 'hinge line' crossing the peninsula at about this latitude is also suggested by the extensive alluvial fans whose calcrete capping passes inland into valley fills identical with those of the northern wadis, the implication being that similar features were originally displayed around the entire coastline.

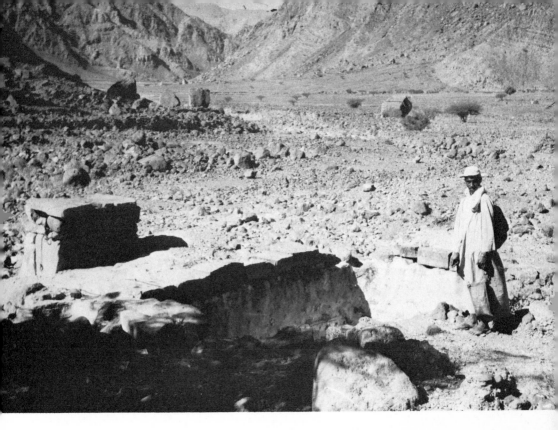

The differences between the northern and southern shores demonstrate that any general rise in sea level played a subordinate role in the drowning of the Musandam inlets. The timing of the northeastward tilting can only be conjectured; if the close resemblance between the calcreted gravels with the cemented fills of northern Iran is taken to imply identity of age, the Musandam fills formed roughly between 50,000 and 10,000 years ago, and – whatever the extent of movement that accompanied deposition – we must ascribe more than 100 m. of submergence to the last 10,000 years.

Hitherto no Palaeolithic sites have been reported from Musandam, and it is not unreasonable to suppose that submergence, coupled with the rapid cliff recession that is being promoted by the activity of rock-boring molluscs, offers a simple explanation. But, as the fishermen who frequent the peninsula will testify, one beneficial effect of drowning was to facilitate inshore navigation by sizeable craft, and it cannot be excluded that the area's attractions may thereby have been enhanced without any archaeological remains to show for it. Compare the opposite shore, where Stein felt compelled to attribute the decline of the medieval port of Old Hormuz (near modern Minab) at least in part to local subsidence.[19]

45 Cistern excavated into cemented wadi gravels at Shamm, in Musandam

Linear features revealed by detailed sounding of the Gulf floor southwest of Bushire have been plausibly interpreted as longitudinal dunes. In coastal Musandam the cemented valley fill used above as a sea-level indicator interfingers with fossil dunes whose mere presence argues for an exposed Gulf floor at the time of their accumulation. The base of the fill lies at depths in excess of 170 m. off Musandam; at Ra's al Khaymah, two boreholes drilled at the margins of a cemented alluvial fan show that it rests on bedrock at depths of about 103 and 143 m. below sea level. The implication is that relative sea level lay at least 103 m. below its present position when the fill began to accumulate. Besides the evidence of wind action, the paucity of river-borne sediment on the Gulf floor argues for the prevalence of arid conditions at the time. The dates tentatively proposed for the Musandam fill would place this period between 50,000 and 10,000 years ago. The closing date is in broad agreement with the C14 ages of between 12,500 and 7000 years obtained by Sarnthein for sediments on the floor of the Gulf which had been laid down in very shallow water.[20]

It has been suggested that, during its emergence, 'the bottom of the Persian Gulf must ... have been a fertile plain, floored with alluvium from the united waters of the Tigris and Euphrates'.[21] The picture needs to be amended: for several millennia the Gulf was a sandy depression apparently bereft of watercourses. Qatar as it were recoiled from the ensuing submergence; Musandam plunged in with a will – and took with it any sites its coasts may have boasted.

5
Land potential

Just as a contour map is a useful but limited basis on which to
decide whether to purchase a farm or where to site a new house,
so will the resurrected topography answer only a narrow range
of archaeological questions. The obvious next step is to deter-
mine the nature of the materials that made up the ancient land
surface.

We shall be here chiefly concerned with the potential of these
materials to sustain plants which are directly or indirectly of value
to man. The restriction is made partly because crops and live-
stock are in themselves important and partly because, if it is to
go beyond the trivial, the evaluation of ores and of raw materials
for tool-making and building calls for geochemical analyses and
economic appraisals that lie well beyond the scope of this book.
This is not to suggest that agricultural matters even if inade-
quately treated will acquire profundity, nor that what follows will
render a townlubber proficient in assessing land potential. The
argument is, rather, that the student of sites cannot evade think-
ing about soil and yet need not be daunted by the prospect.

The benefits of a clearly formulated enquiry are obvious, not
least because it will govern the thoroughness with which the
study is conducted: compare, for example, the detail required
to settle whether or not a site was advantageously located for
cereal cultivation with that required for an attempt to assess the
likely annual yield of a particular area of land. But it probably
pays to set a minimum level that will at the very least show
whether further work is justified and at the same time shed light
on the origin of the various landscape units (see below, Chapter
6). Needless to say, existing information on this score is helpful
when it comes to sampling and analysis; if a couple of specimens
generally suffice to define the range of materials present in a bed
of windlaid sand, several dozen may be required for a reasonably
full description of a unit deposited by glacial meltwaters.

Nevertheless, a survey aimed at agricultural analysis or conducted with some other purpose in mind may produce results which bear on issues which had not initially loomed large. In the Nile valley, Butzer found that the bulk of the Predynastic settlements were located on soft, fine, unconsolidated or semi-consolidated sediments, and concluded that this was because the dwellings, which consisted of shallow pits surrounded by daub and wattle walls, demanded an easily excavated subsoil. The location of the settlements beside the modern floodplain was largely accidental, other sites of the same date having been engulfed by sediment or destroyed by the spread of cultivation.[1] (Equally 'opportunistic' in tone is the suggestion that West European prehistorians have developed the habit of cutting vertical sections because most of their sites are caves cluttered up with stalagmites and boulders; their East European colleagues can boast about uncovering large areas only because many of their open sites occur in incoherent deposits or soils.[2])

Which attributes of the former land surface best lend themselves to a survey that yields the kind of answers likely to be sought by archaeologists? The standpoint adopted by this book leads to additional restrictions: the attributes should be amenable to observation by workers lacking a training in pedology, they should not call for complex laboratory analysis, and they should be couched in terminology which can be applied to a variety of themes. What is more, the ideal case, in which a soil is preserved and rendered datable by being 'sealed' beneath a barrow or similar structure,[3] will remain the exception: one is generally confronted with eroded or degraded soils whose original chemical and biological constitution is unlikely to have survived the vicissitudes through which the ancient land surface has passed.

Many of the existing systems of soil classification do not meet our needs, either because they are dominated by a concern with genesis or, if primarily descriptive, because they require a reasonably undisturbed soil profile – and a reasonably well-trained observer. One of the schemes that comes close to our requirements is to be found in G. R. Clarke's unassuming handbook,[4] and hinges on the tenet that the attributes that affect plant growth the most and that can most readily be measured in the field are soil texture, soil depth and the quality of soil drainage. As we shall see, this way of thinking underlies some land-use classifications, as they accept the premise that physical limitations are in general 'more permanent and difficult to rectify' than any but the most severe of chemical limitations.

Apart from their simplicity and their agronomic significance, these attributes remain measurable even when allowance has to be made for erosion, aggradation and other post-occupational changes. The closeness with which they are linked to physiography may be judged from the successful use by the Australian CSIRO (Commonwealth Scientific and Industrial Research Organization) and analogous bodies elsewhere of 'land systems' as a guide to the planning of land use, drainage, erosion control and the like.[5] For the land-systems approach relies on the principle that landforms will often serve to identify areas displaying some measure of homogeneity as regards soil, hydrology and vegetation, one implication being that certain land systems are likely to recur (let us say wherever springs debouch at the foot of an escarpment), and another that they are likely to have many points of resemblance in their evolution.

Finally, a scheme of land classification based on physical attributes yields results which can be reproduced by different workers and hence facilitate ready comparison between different areas in the light of any climatic information to be had.

46 Representation of the concept of land systems. 1 = ridge crests; 2 = ridge slopes; 3 = alluvial fans; 4 = low interfluves; 5 = stream channels and floodplains; 6 = alluvial terraces

47　Textural classifications and sieve sizes

Texture

In the geological and pedological literature, texture refers to the *47*
form, size and arrangement of the particles constituting a deposit
or soil.

Texture influences the capacity of a soil to retain moisture,
its tilth, and to some extent the ease with which it will yield
nutrients. One could rightly argue that soil texture is not the
whole story (and in some areas today, no part of the story), as
a host of other factors come into play; to name but a few, moisture
retention is strongly affected by organic content, as is the crumb
structure and hence the feel and fertility of a soil. But it is equally
true that relevant information on such matters can always be
added to data on texture without impairing the value of the preli-
minary conclusions these yield. We can also take into account
the technical competence and manpower of the exploiting popu-
lation when considering such matters as the ease with which a
particular area of soil could be worked. Wunderlich has the 'rela-
tively primitive agricultural implements of the Stone and Bronze
ages' clearly in mind when he draws attention to the location of
Knossos, Mallia and Phaistos near expanses of rich, friable soil.[6]

The agronomic literature of the pre-industrial periods suggests
that texture was seen as of importance in its own right by cultiva-
tors who were not so naive as to overlook related controls on soil
quality. For example, the *Shu Ching* of the fifth century BC tells
us that the soil of Chi Province is 'white and loose', whereas that
of Yen is 'black and fat'. The Greek and Roman authors used
an inexact and confused terminology, but their concern with
practical matters is reflected in an emphasis on the ease with
which different soils could be worked.[7] In south-east England,
early prehistoric settlement was seemingly favoured by loams.
There is no general agreement about the relative importance of
soil, as opposed to the original vegetation cover, in guiding this
preference; Evans suggests that the potential of a soil to with-
stand agricultural processes was the key factor, and sees in this
'a sophistication in man's knowledge of the environment which
it is hard for us to appreciate'.[8]

The critic will rightly point out that structure – the arrange-
ment of the soil particles – is likely to have been far more influ-
ential than texture, and that its dependence on the nature and
quantity of colloidal material present in the soil makes the task
of reconstruction an impossible one: cultivation, for example,
may destroy an aggregate structure by depleting organic colloids,

whereas suitable tillage can go a long way towards improving a defective structure. But few would view a gravel bed or a pure clay as more amenable to management (or mismanagement) than a loam.

There is no short cut to a map of soil texture. Geological maps are rarely of help as they tend to be dominated by information on stratigraphical age. To the excavator it matters little whether a clay is Tertiary or Mesozoic provided it is clay, and when the map key employs this or similar descriptive terms as part of the nomenclature, the use of a capital letter warns us that we are dealing with a piece of shorthand. For example, the Ashdown Sand of the English Weald includes siltstones and shales, and the Weald Clay itself contains shales, mudstones and limestones. Our hopes may be raised by detailed subdivisions of the Quaternary units on the map into, say, 'Terrace Alluvium' and 'Lacustrine Beds', but the names often tell us more about the postulated origin of the deposits than about their composition. Finally, we turn to the Memoirs that accompany some sheets, only to find that descriptions of the physical character of the various units are either couched in broad generalizations or given in great detail for type sections. Soil maps are likely to prove equally unhelpful for reasons already considered.

The determination of grain size is very time-consuming and tedious. It is the one kind of analysis undertaken by most field workers, but the results so laboriously obtained are often ignored in the accompanying text. A glance at a specialist journal such as the *Journal of Sedimentary Petrology* will show why the silence is wise. Few textural analyses point unambiguously to the nature of the depositional environment, either because the grain-size distribution has been influenced to an indeterminable degree by the effects of a previous depositional environment on the texture of the sediment, or because there is little agreement on the textures that characterize particular environments today; and it is precisely in order to reconstruct the depositional environment that archaeologists usually perform or commission textural analyses.

For our purpose all that is required is a description which expresses both the dominant texture and the degree of variability likely to be encountered within the selected unit. With a little practice much can be accomplished by simple manipulation of moistened specimens.[9] Once some impression has been gained of the dominant textural type and of important zones which deviate from it, samples can be collected for sieving; more often

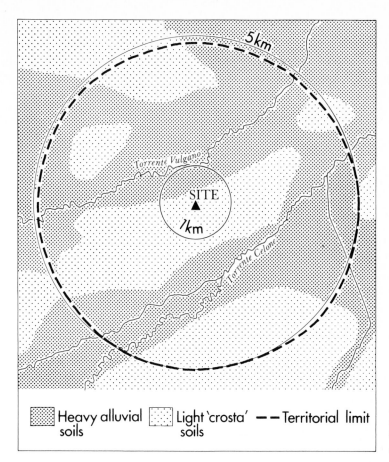

48 Soil types within the exploitation territory of the Neolithic site of S. Marcello, Apulia, Italy

than not the results of laboratory analysis will do little more than tilt the adjectival balance between, say 'silty clay' to 'clayey silt'; but the reproducibility of the results adds greatly to the rewards. A unit which shows no consistency will earn an apposite label along the lines of 'clays, sands and silts showing no obvious pattern'; a silty sand with a few pebble bands here and there needs to be described as just that. The accounts will evidently benefit from the maximum possible information on changes with depth, so that the superficial soil pattern can be related to three-dimensional bodies of sediment and rock.

The fact that 'mere' – but informative – description is being aimed at removes the sting from any charge that no orderly sampling programme has been adopted. Were the aim that of drawing statistical inferences, a randomized procedure would indeed be desirable. (The elusiveness and expense of such an ideal fortunately does not concern us). But our needs are adequately met by what some call 'purposeful' sampling and others dismiss as

'subjective', guided by the availability of exposures and the doctrine that it is better to collect material where there is an obvious change in the character of the unit than to stick to some rigid procedure which may lead one to overlook gross differences.

48 In their study of Neolithic sites in northern Apulia (South Italy), Jarman and Webley found it informative to group the local soils primarily on textural criteria linked to topographic position. Two major soil categories were found of special importance, the first comprising various heavy clays and alluvial deposits and the second represented by light silty soils underlain by a calcium carbonate crust (or *crosta*) generally 30–80 cm. below the surface of the ground. The second group accounted for about 20 per cent of the area of the Tavoliere, yet all but two of the twenty-one Neolithic sites surveyed in the study were situated on them. The mapping of soil textural types also showed that the *crosta* soils and the equally light and well-drained hillwash deposits bordering the slopes of the Gargano and the plain on average made up two-thirds of the areas within 1 km. of each of the sites. According to Jarman and Webley this was because, unlike the heavier soils, they were both easily worked and well drained. Textural analysis proved equally crucial to the interpretation of prehistoric settlement in parts of southern Bulgaria, especially where soils had been robbed of fine particles by erosion, rendered unusually clayey by impeded drainage, and in various other ways locally differentiated.[10]

Depth and drainage

We have already been made aware of the close links between texture and moisture retention. The links are in no way simple: Varro makes the point in his claim that stony, moderately stony, and almost stone-free soils can each be subdivided into wet, dry and intermediate types.[11]

49 As with structure, so with drainage: texture provides a rough guide which meets the needs of those who prefer part of the answer to no answer at all. The extremes are well established: gravels and sands drain freely, clays are moisture-retentive. The middle-ground is more contentious but rarely departs drastically from Varro's third category. It is also fair to say that, in the absence of an interstitial cement, poorly sorted materials are likely to prove more permeable than well sorted ones.

Soil depth, and the nature of the contact between beds of contrasting texture, must also be considered: impeded drainage may

49 Relationship between suction and relative moisture depletion for soils of different textures. Note greater availability of water in coarser soils

be produced in any material by an impermeable (or relatively impermeable) horizon, such as a clay band. A high water table may be supported in permeable sediments by outflow from a through-flowing stream or a lake, and its depression will therefore follow stream entrenchment or a fall in lake level. In the Atoyac valley of Mexico, the presence of a high water table beneath the floodplain and parts of the 'high alluvium' bordering it made possible the use of shallow 'pot-wells' for small-scale irrigation early in the Formative period (1500–900 BC). This gave the Oaxaca area 'a head start over other valleys' (such as Tehuacán) where the technique was not feasible.[12]

A potential drawback of impeded drainage under conditions favouring rapid evaporation is the accumulation of salts within the soil. Jacobsen and Adams have traced the spread of salinization in parts of Iraq and found historical evidence for three major phases, the first and most serious in southern Iraq from 2400 until at least 1700 BC, the second in central Iraq between 1300 and 900 BC and the third east of Baghdad after AD 1200. Whatever the precise contribution of ill-managed irrigation, the prevalence of soils generally low in permeability has favoured a rise in their content of salt and exchangeable sodium which, among other things, is thought to have 'played an important part in the breakup of Sumerian civilization'. Using sun-dried mud bricks

of known age as a guide to the composition of the contemporaneous soil, Hardan found evidence for excessive soil salinity even earlier in the history of Mesopotamia and concluded that irrigation had only exacerbated an existing trend, but it has yet to be shown that water and clay used for the bricks were not made unusually salty by local or seasonal circumstances.[13]

Impeded drainage or high moisture retention may of course be an advantage in areas deficient in water during part or all of the year. Webley has drawn attention to the potential value of hydromorphic soils during the dry season in Palestine both for pasture and as a source of moisture for adjoining slope deposits.[14] Where we lack information on the contemporaneous climate, this kind of argument would seem unjustified; yet little harm is done in tentatively advancing it to see where it leads, and, as we shall see in the next chapter, the information on depositional processes yielded by the sediments themselves is often as good a guide to seasonal periodicities as conventional palaeoclimatic sources – and sometimes a better one.

Land use potential

'Land use' is sometimes taken to 'cover data on the land resource which is relevant to the way in which land is presently used, has been used in the past, or may be used in the future'.[15] But as our primary aim is to assess the range of uses to which tracts of land might formerly have lent themselves, it seems safer to remove any ambiguity by appending 'potential' (as the UK Soil Survey does) to the phrase.

The need for flexibility in classifying land-use potential should by now be apparent. What we require is a scheme which enables the physical evidence to be converted into categories applicable to a variety of sites or to different modes of occupation at an individual site. It has been suggested that prior to the discovery of agriculture the suitability of much of the earth's surface for food production – in the broad sense – was relatively uniform, and that differences in soil fertility, climate and other environmental factors acquired prominence only after the adoption of agriculture.[16] Quite apart from the question of whether it is any longer tenable to speak of the 'discovery' of agriculture, there seems little justification for believing that the range of variation in areas exploited primarily by hunters and gatherers was negligible even in relative terms. At all events we cannot build this assumption into our classification.

The scheme developed by the US Department of Agriculture grades land into eight capability classes each of which can be broken down into subclasses according to the physical factor or group of factors that limit production. The UK Soil Survey[17] has adapted the classification, deleting one class and adding a subclass in the process. The spectrum now ranges from Class 1 ('Land with very minor or no physical limitations to use') to Class 7 ('Land with extremely severe limitations that cannot be rectified'). The subclasses refer to the limitations imposed by wetness (w), erodibility (e), shallowness (s), climate (c) and gradient and soil pattern (g). For example, subclass 4s refers to land in which the choice of crops is restricted or which requires careful management (or both) because moderately steep gradients predominate.

The fact that both classifications were intended for agricultural purposes need not debar their application to surveys which beg no particular technological level. Take, for example, the statement in the handbook for the UK classification that 'a poor type of rough grazing may be available for a few months' of the year on Class 7 land. A little ingenuity will also allow the most extreme of physical environments to be accommodated in what are avowedly devices geared to the needs of the USA and the UK.[18] It is instructive to note that, although the classification proposed by the World Land Use Commission appeared inadequate when it came to plotting areas under shifting cultivation, in Liberia the problem was neatly countered by using the existing category of 'Forest with subsidiary cultivation'.[19]

As regards the subjective and somewhat arbitrary nature of the subdivisions, experience shows that workers differing greatly in background and training often produce maps which show a good measure of agreement even in very complex areas.

A more serious difficulty may be posed by the failure of the resulting units to be coterminous with the land systems or physiographic units identified earlier in the survey. As Cooke and Doornkamp point out, 'land systems may contain land units of differing slope steepness and liability to erosion'.[20] The rather crude classification used in the Mount Carmel area and discussed below was devised to cope with this problem.

Whichever scheme is adopted, it will provide a framework within which to proceed to higher planes of analysis. The use of Stamp's Standard Nutrition Units, for example, each of which is equivalent to 1 million calories produced annually, would enable the carrying capacity of parcels of land to be compared

50 Locations in the
Levant discussed in text

despite differences in the use to which they are or could be put.[21]
But the concept of soil fertility remains of little value to us.
According to the Soviet pedologist Vilenskii, V. I. Lenin has
proved the complete falsity of the 'law of diminishing soil fer-
tility'. 'This infamous law is nothing else than a manifestation
of Malthusianism in problems of agriculture and racist–cannibal-
istic ranting', as it is applicable only where technology has
remained unchanged. Vilenskii goes on to quote Marx's dis-
tinction between primary (or natural) fertility and artificial
fertility.[22] Our objection is less violent: fertility is difficult to
evaluate and in any case unlikely to remain constant for long.

The Carmel Coast

There is an extensive literature on the coastal evolution of the Levant,[23] much of it aimed at elucidating the number and ampli- 50 tude of successive marine incursions and retreats and at exploiting the results in order to date associated Palaeolithic sites. The Abri Zumoffen in Lebanon, for example, contains clear traces of a beach at 12–13 m. above sea-level on which rests an Amudian (pre-Aurignacian) industry characterized by choppers and chopping tools fashioned out of beach pebbles. The beach has been attributed to the marine transgression of the Last Interglacial; some will find more interest in the suggestion that the overlying industry represents a 'hitherto unknown coastal facies of the Amudian, likely to occur only where stretches of pebble or shingle beach had been exposed in the neighbourhood of a cave or shelter'.[24]

Some of the data on the evolution of the Coastal Plain of Israel have been used in a study of land potential within the framework 51, 52 of site catchment analysis. The results, though hardly startling, will do to demonstrate the advantages of a flexible if unsophisticated classification. It goes without saying that the findings could only be related to sites known at the time of the study; colleagues have reported with ill-concealed delight the subsequent discovery of fresh sites although they have yet to show that the original findings are thereby wholly invalidated.

Echo-sounding off the coast of Israel enables the topography of the modern coastal plain to be traced offshore to a depth of at least 130 m. below sea level. Particularly prominent is a series of north–south features which appear to correspond to the ridges composed of sandy limestone (*kurkar*) that lie east of the present coastline and parallel to it. Five such ridges are present in the southern part of the coastal plain; in the vicinity of Mt Carmel a maximum of three can be identified.

The ridges (or at any rate those that are still exposed) are thought to represent dune sands blown inland at successive positions of the shoreline. They are interbedded with layers of red alluvium (known as *hamra* and commonly termed 'soils' for no good reason) which can be traced eastwards into alluvial fans at the mouths of valleys draining the Carmel hills. Near Dor, two major *hamra* horizons have been exposed by road cuts in the easternmost ridge, which now lies 1–1·5 km. inland.[25] The lower has yielded fresh Middle Palaeolithic artefacts and the upper a blade-and-bladelet assemblage which has been equated with the

51　Mount Carmel viewed from the west. El Wad is located above bushes to right of hut

52　Fertile alluvial and lake deposits on the coastal plain, seen from the cave of El Wad

Epi-Palaeolithic. This fits in with the discovery elsewhere in Israel (and the rest of the Levant) of Middle and Late Palaeolithic artefacts within alluvial fans and fills with a red matrix which have the same stratigraphical and morphological characteristics as the *hamra* fans. The *kurkar* overlying the upper *hamra* has given $C14$ ages of $10,060\pm180$ yr BP at Tel Aviv and 7620 ± 125 yr BP at Natanya (I-2462 and 2463).

Granted that the two above dates are not very dependable, as they were determined on material prone to contamination by secondary carbonate, they are consistent with the archaeological evidence for dune accumulation side by side with alluvial deposition from a late stage in the Middle Palaeolithic until the close

of Kebaran occupation at the earliest: in Israel the Levalloiso-Mousterian has given C14 ages of 42,000±1000 yr BP at El Kebarah (Gro 2552), and 39,500±800 and 40,000±1000 yr BP (45,000±2000 at the second attempt) at Tabun (Gro 2534, GrN 2695), while the Epi-Palaeolithic industries known as Kebaran give dates of between 18,900 and 15,500 yr BP.[26] It follows that any attempt to assess land potential for this period must postulate an expanded coastal plain while excluding from consideration any sediments that postdate the *hamra* alluvium.

53 Ancient drainage ditch cut through *kurkar* ridge

54 Section in marsh soil behind *kurkar* ridge after drainage. Notebook gives scale

53, 54 An additional source of change is provided by the impeded drainage occasioned by the dune ridges. Some of the inter-dune depressions thus rendered marshy were drained in antiquity by the cutting of artificial outlets through the *kurkar*.[27] The marshes later returned, and were once again drained by settlers during the present century. Documentary evidence coupled with the distinctive character of the marsh soils allows us to trace the extent of the affected zones.

Four basic categories of land use potential were used: arable, potentially arable/good grazing, rough grazing, and (biologically) unproductive. Two headings which were not required in other areas included in the survey were introduced for the coastal belt, namely 'marsh' and 'dune'. An area of marsh which might rank as a source of grazing could well emerge as arable land after drainage; similarly, under a grazing economy the 'arable' and 'potentially arable' acreage would invite inclusion in the total values for grazing land. If we disregard the headings for dune and marsh, the classification does not seem to be geared to physiographic interpretation, but its suitability for this purpose resides in the looseness of the categories, as (at least here) texture and depth are intimately linked to erosional and depositional history; for example, the arable land is largely confined to well-drained alluvial and colluvial deposits, whereas the rough grazing zones include poorly-drained alluvial deposits as well as slopes which have not been wholly denuded of soil, and both of these groupings turn out to correspond to episodes in the evolution of the landscape.

55 Let us consider two sites in the area. El Wad contains industries which range from the first stage of the Advanced Palaeolithic of Palestine to the Natufian.[28] The industrial succession of El Kebarah extends from the Aurignacian to the Natufian. Garrod found a close resemblance in the Aurignacian material of the two caves (layers D and E in both cases) and in view of the chronological position of this cultural phase immediately before the Kebaran at El Kebarah (and hence safely within our phase of coastal emergence) we can use it as our plane of reference.

After making the necessary physiographic adjustments, the terrain within the two-hour territories of the two sites was translated into land use potential according to the scheme discussed earlier in the chapter. The table on page 88 shows the resulting percentages, as do the pie graphs opposite. It may be noted in passing that the walked territory of El Wad barely exceeds in area the 7854 ha enclosed by a circle 5 km. in radius; this,

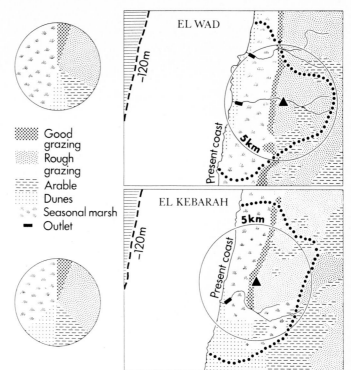

55 Land-use potential of
site exploitation territories
of El Wad and El Kebarah

56 (*below*) Land-use
potential of site
exploitation territories of
Megiddo, Sheikh Ali and
Nahal Evtah. Position of
sea level for Nahal Evtah
uncertain though
probably below present

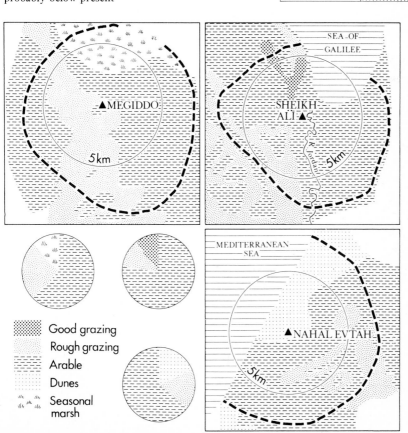

as it happens, is the value preferred by Saxon in his re-survey of El Kebarah,[29] presumably in the light of his finding elsewhere in the area that 'Two hour territories would have involved inefficient competition between several sites for most resources.'

	territory (ha)	marsh (%)	dune (%)	rough grazing (%)	rough grazing/ potentially arable (%)	arable (%)
El Wad	8000	48	7	28	5	12
El Kebarah	10,750	36	13	31	6	14

Both territories are seen to be rich in 'rough grazing' land. The contribution made by the marshes and dunes is debatable. The presence of water and fresh vegetation in the former could have proved an attraction to some species of herbivore in the summer months; once covered by soil, the dunes may well have supported a 'parkland' vegetation, but this is unlikely during their accumulation. At all events any contribution from these two zones would further enhance the 'rough grazing' area. In contrast, the 'arable' component remains low even when we add to it land deemed to be marginal in quality. Compare the results obtained at three *56* 'agricultural' sites east of Mount Carmel, which gave arable percentages of 62 per cent (Megiddo), 65 per cent (Nahal Evtah), and 78 per cent (Sheikh Ali). In brief, as we saw with regard to topographic factors in Périgord, site selection – or at any rate site fitness in Darwinian terminology – can in these two cases be shown to make economic sense.

6
Agencies of change

Discussion of the mechanisms responsible for producing the sur-
faces and materials of our successive landscapes has so far been
kept to a minimum on the grounds that useful information might
otherwise be lost. The time has come to tackle the question. But
we need not pursue it further than our archaeological tasks war-
rant: once again, interpretations that might appear half-baked to
a geological audience often prove more nutritious to us than the
finished article. The 'inferential leaps' by which the experienced
earth scientist links the field data with his chosen explanation
tend to disregard many of the key items: moreover, in seeking
to identify and explain regional trends and patterns he will be
forced to overlook or play down local anomalies, when it is pre-
cisely because they were anomalous in their character and evolu-
tion that many sites or territories have proved attractive to their
prospective occupants.

What we require is some understanding of how different parts
of the landscape were changing both during and between phases
of occupation. Besides lending animation to an otherwise static
picture of the physical environment, this greatly enhances our
grasp of contemporaneous human activities. Was the river valley
subject to silting or to incision? Was the coastal plain built up
by wind or by longshore drift? How was a particular land surface
cut? The geophysical, climatic or other models to which the
answers will doubtless contribute can wait.

The fundamental unit of the physiographic narratives con-
sidered here will be termed the episode. What this amounts to
is a self-contained trend in landscape development which leads
either to the accumulation or the destruction and removal of rock
materials. Most physiographic processes either combine erosion
and deposition in adjacent areas or oscillate between one and the
other; but a dominant trend will usually be identifiable. And,
like the recognition of land surfaces, the identification of domi-
nant trends in landscape evolution provides us with a convenient

57 Physiographic trends in relation to successive 'time-planes'. Note that portions (a–d) of modern land surface coincide with former surfaces of different age (t1–5)

if artificial device for breaking down physiographic history into manageable chunks.

Given the diverse trends likely to affect different parts of a landscape over a given period, the corresponding rock sequence will not lend itself to ready subdivision once we try to go beyond the gross units demarcated by successive land surfaces. It is as well to be reminded that formations, members and related rock-stratigraphical units strictly speaking have no time connotations; what is more, unlike lithosomes – masses of rock or sediment essentially uniform in lithological character – they do not necessarily have sharp physical boundaries. Quantitative dating alone can provide the time-intervals required by the chronicle.

Some criteria that have fallen into disrepute among many earth scientists can still serve us well. Colour, a notoriously misleading environmental indicator, if treated with caution often leads on to more solid ground. The redness of red beds, it has been wisely observed, is often a red herring when it comes to evaluating the origin of the iron oxides responsible for it, yet the discovery of many depositional units rich in Palaeolithic artefacts throughout the Old World is owed to the ease with which such red beds could be identified over long distances or in thickly vegetated terrain. How far the association of the artefacts with the red deposits stems from the relative neglect by the archaeologists of drabber

57

beds near by remains uncertain (although the preference for red soil shown by earth-eating patients in Johannesburg is a warning against dismissing colour *a priori* as a factor in site selection[1]); the fact remains that the resulting enquiries ultimately led to the identification of a major physiographic episode.

Another physical clue which, treated with circumspection, can facilitate the identification of physiographic episodes, is degree of induration (see above, p. 41). Here, too, there may be no simple connection between the diagnostic feature and the archaeological import of the unit which it distinguishes. Indeed, as induration can greatly postdate deposition, we may be dealing with two sets of events that have little bearing on each other. The troglodytic dwellings to be seen near Garian, in Libya, have been dug into *58* the partially cemented silts that mantle the plateau. The removal of the cementing carbonates by acid treatment is a necessary prelude to mechanical size analysis, the results of which support the view that the silts were laid down by wind, but it destroys the bulk property that renders the silts suitable for troglodytic occupation. This is of course not the only case of an environmental interpretation which is in effect anachronistic.

58 Troglodyte dwellings near Garian, Libya

Dominant agencies

Ashes and lavas betray volcanic action, but the mechanics of their emplacement may concern us more than the character of the eruption. Many potassium-argon dates on ash have been applied to associated artefacts and fossils on the assumption that any redeposition of the ash took place shortly after the eruption to which the K/Ar (potassium/argon) dates refer. In the Omo basin, for example, the volcanic tuffs on whose radiometric ages hinge those of various hominid fossils appear to have been laid down by fluvial action.[2] The Neanderthal remains of the Rome area have likewise been dated both relatively and radiometrically by reference to volcanic materials incorporated in the river terraces of the Tiber and its tributaries.[3]

As the fate of Herculaneum shows, the issue is not confined to chronology: the muds that engulfed the city, though unmistakably volcanic, owed their effectiveness to water and gravity. Coastal dunes may be rich in Foraminifera, but this does not detract from their aeolian character. Landslides that displace lake beds are not thereby rendered lacustrine. In brief, the agency we are likely to wish to identify is the last in what is often a complex succession, and its imprint is frequently obscured by features inherited from earlier episodes.

We may follow the geologist in using every clue at our disposal to reduce the risk of mistaken attribution.[4] Where sediments are concerned, the physical evidence is commonly grouped under the headings of geometry, lithology, sedimentary structure and palaeocurrent pattern. The first two have much in common with what we have termed form and composition; the last two embrace items to be discussed later in this chapter.

Our paths diverge when we come to classify the environments to be resurrected. The division between continental (or land) and marine environments, with a possible intermediate zone embracing shorelines, raises no difficulties: this book says almost nothing about the offshore zone only because it is concerned with occupation, whereas a text directed at sub-aquatic exploration and excavation would soon correct the balance. But of the three standard subdivisions of the continental realm – aeolian, fluviatile and lacustrine – only the first suits us all. The other two lead to landscape units too diverse for our present purpose. A lake basin may be subject to still-water deposition near its centre, but its margins can experience cliff collapse and delta growth. A river valley will include zones out of reach of fluvial action and subject

59

MASSIVE

HORIZONTAL

GRADED

PLANAR
CROSSBEDDING

TROUGH
CROSSBEDDING

LENTICULAR

59 Common categories
of bedding

to slope wash or wind scour, and others which are dominated by silting ponds or scouring channels; downstream, the picture is enriched by the influx of coastal dunes and the presence of estuaries.

By giving due weight to local variations we may conceivably hit upon attributes of the landscape whose evolution was especially important to the success or failure of human settlement. In addition, we are led to concentrate on the dominant mechanism and can disregard those at the periphery. Of course failure will be all the starker: if we cannot tell whether a coastal deposit was produced by wind rather than waves, we can no longer seek refuge in the term 'littoral'; but by drawing attention to the ambiguity we may at the very least prevent its abuse.

As it happens, the distinction between water-laid and wind-laid deposits is one that continues to give serious trouble. There

60　Fossil wind-laid sands (*upper left*) near Sinop, Turkey. Note steep
dips (*above metre rule*)

61　Water-laid material (dark band) interbedded with aeolian sand in
kurkar ridge near Dor, Israel

62 Village built on surface of coalescing alluvial fans, in Jordan. Note cultivation on present valley floor (*lower left*)

63 Beach sands in southern Iran exposed at low water

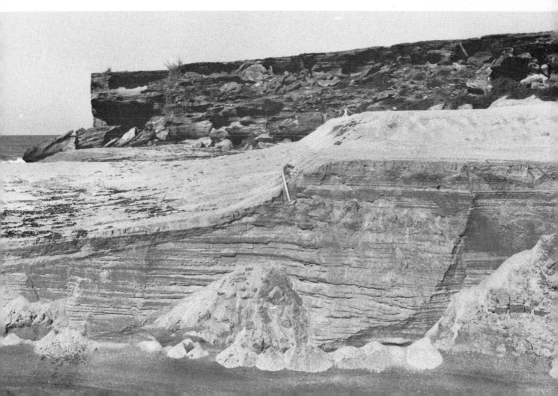

are, none the less, some features which can be labelled as aeolian with some confidence. Where fine and medium sands display a high measure of textural sorting, and occur in cross-stratified laminae of which at least some have gradients in the region of 30°, the case is reasonably clear. The admixture of water-borne sediment to an area undergoing dune development can complicate matters, but all need not be lost: thus, sieving of the *hamra* 'soils' in the *kurkar* ridges of the Israel coast reveals two particle populations, one composed of relatively coarse grains identical with those from other parts of the ridge, the other of fine, red clay- and silt-sized particles originating in the wadis to the east.

By the same token, there is a point along the wind-water spectrum where the latter agency manifestly had the upper hand. The 'aeolian' silt of the Hadhramaut, rich in Palaeolithic artefacts, is confined to rock-cut channels and includes horizontally stratified horizons of sand and gravel.[5] Like the wadi fills of Tripolitania, it would appear to owe its silt component to an earlier aeolian episode. Indeed, the presence of bedded particles too coarse to be readily transported by wind (say over 1 mm. in diameter) is perhaps the simplest *prima facie* indicator of water action, and experience teaches that the search for such material is often more rewarding than any attempt to distinguish between fluvial and aeolian ripples or other small-scale structures in sand. The recognition of units that are largely due to the action of water is also better served by morphology than are those aeolian in origin, not least because both erosional and depositional features can be brought into effective play. Alluvial fans, river terraces, and marine or lacustrine beaches are thus often bounded by distinctive constructional surfaces and water-cut bases.

If the grains are safely beyond the competence of the highest winds, one can at a pinch dispense with stratification. The precise nature of the mechanism does of course remain open: thus a bed of rolled gravels present in two of the caves of Carmel, and ascribed in one report to marine abrasion, had previously been explained by spring activity within the caves. If there is no coarse material, poor sorting of the fines is a useful hint of deposition by water. Low-angle cross-stratification associated with graded bedding (where there is an upward decrease in grain size within an individual stratum) characterizes many fine-grained valley deposits. Accumulation in standing water favours clay and fine silt, often in the company of chemical and organic sediment.

The third major agency to be looked for is gravity, a force which, though inherent in all depositional processes, can on

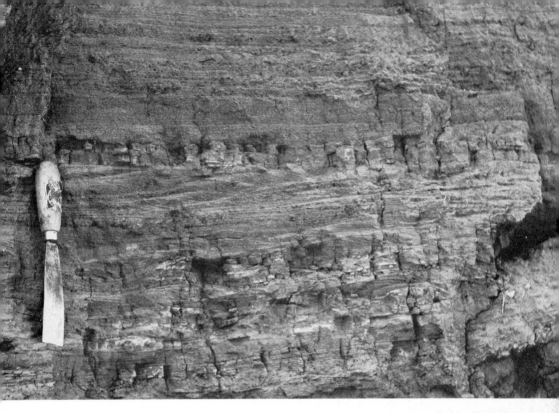

64 Cross-bedded fluvial sands and silts near Chihuahua, Mexico

65 Alluvial-fan deposits in Oman containing unbedded mudflow material

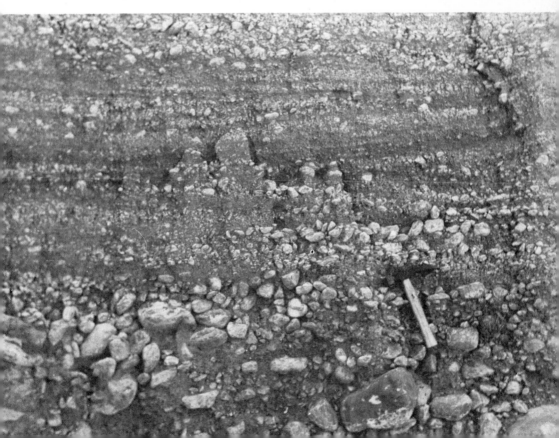

occasion dominate their outcome. The gradation between mass movement and the action of running water is often stressed; we may take mud flows as representing the transition. Their products are predominantly unbedded and wide-ranging in grain size, but it may be possible to distinguish individual tongue-shaped flows within a larger unit. At the dry extreme we find rock fragments accumulating as scree, which tends to be dominated by angular material crudely bedded at steep angles. Selective washing out of the matrix may enhance the stratification.

The products of these three agencies often pass one into another, and it may be the transitional zones that are archaeologically of greatest import. Similarly, although the action of ice in itself earns little mention in this book, many of the features listed in the litany of U-shaped valleys and other products of glacial scour were in fact laid down by wind, water and gravity to give loess, fluvio-glacial gravels, lacustrine beds and scree; and the archaeologist may well find this viewpoint more directly relevant to occupation than regional frigidity.

The above paragraphs run counter to the widespread, praiseworthy scorn for rules of thumb in environmental interpretation and the concomitant appeals to reliance on neutral support from sedimentology, fossils and geochemistry. But if the physical evidence alone is often undependable, there are times when it will perform the simple tasks we have set it quite adequately; and it is often the case that auxiliary sources do no more than reinforce its conclusions.[6] In Olduvai Gorge, Bed I could be subdivided into rock assemblages whose ages overlapped. Their texture and morphology proved crucial to the identification of lake, lake-margin, alluvial-fan and alluvial-plain depositional environments, and to the observation that traces of hominid activity were apparently restricted to lake margins where a relatively flat terrain was intermittently flooded by lake waters. The same may be said of the Lower Pleistocene deposits at 'Ubeidiya, in Israel, where lake beds interfinger with coarser units attributed to inflowing rivers and where hominids and animals were apparently attracted by 'the heterogeneous landscape offered them by the river tributary at the lake shore'.[7]

The conversion of this kind of descriptive terminology to a quantitative one is still hedged with difficulties. A promising approach is to calculate the flow required to shift sediment of the observed texture as bedload after taking into consideration the geometry of the original channels, and hence to obtain a measure of peak flow which can then be compared with that of

65

modern floods. In contrast, attempts to infer freeze-thaw fre-
quency and other climatic values from the rock record call for
an unacceptable level of conjecture.[8]

Rhythms within trends

Having made the attempt to identify the dominant agency, we
may seek out any rhythmic properties in the corresponding unit.
The annual floods of the Nile will do to demonstrate that the de-
tection of former physiographic periodicities can be of archaeo-
logical interest, just as the unpredictable nature of wadi flow in
many desert areas might argue for a similar concern for non-
periodic changes. Even so, the reason for the periodicity or its
absence will enter into our thinking only to the extent that it casts
light on local conditions.

In the present state of knowledge it is difficult to discern a pat-
tern in the laminae of a sand dune, and although it is suspected
that dunes of contrasting texture may be produced by winds of
different frequency, we can at best suggest that some such varia-
tions operated in the case of analogous fossil dunes. Again, careful
$C14$ dating of banded loess deposits in Iowa has failed to reveal
any uniformity in the time required for successive bands to de-
velop.[9] But other repetitive features stem from seasonal pro-
cesses; hence for example the use of varve-counting as a dating
technique. Varves are paired laminae produced in lakes fed by
melt-water and were originally thought to owe their regularity
to the graded deposition of material brought in during the sum-
mer months, the finest particles settling out only during the
placid conditions of winter. In other settings, varve-like features
may also be produced by a seasonal alternation between calcium
carbonate deposition and diatom 'flushes'.[10] It is now known that
varve pairs can form in a period as short as a single day, but $C14$
dates support an annual rhythm for the bulk of the varves in many
classic sequences.

Some bedded slope deposits are likewise ascribed to repeated
frost-shattering and movement of the scree over frozen ground
in winter followed by solifluxion and the removal of fines by melt-
water in summer. The Montignac Formation of Périgord (see
above, p. 44) invites this interpretation, the inclusion of gravel
bands of restricted lateral extent and the lack of well-defined bed-
ding suggesting deposition by debris flow and solifluxion rather
than along well-defined channels. Moreover, the presence of
abundant angular rock-fragments at the valley margins points to

66 frost-shattering. In places the fragments display bedding, the coarser horizons often lacking any matrix of fine material; such *grèzes litées* have been ascribed to the seasonal alternation of soil freezing and thawing. In brief, the Montignac Formation as a whole reflects both frost activity and the sludging of soil and rock downvalley by meltwater possibly abetted by frozen ground. But it would be premature to go beyond this and draw analogies between Périgord and modern periglacial or high-altitude environments. Some of the characteristics of the Montignac deposits are duplicated by alluvial fans found today in arid deserts as well as in Greenland and the mountains of the Yukon; and as has often been pointed out, the summer radiation received by low-latitude tundras (a term one is tempted to apply to Périgord during the period in question) would have been higher than in their high-latitude modern counterparts, to the probable benefit of plant growth.

66 Bedded scree deposits in Périgord, France

We have little idea of the temperature regime implied by frozen ground beyond the fact that below-freezing temperatures were attained. But there is much to be learned from the inference that, at a certain time of the year, the valleys of Périgord in France underwent freeze-thaw cycles and the transport of rock and soil *en masse* by short-lived sludging: for if, as seems likely, this was primarily a spring phenomenon, any migrations during this season presumably took place along the interfluves, rather than in the valleys on which the archaeologists have hitherto concentrated.

Unfortunately, cyclic sequences in fluvial deposits, though useful in identifying the kind of channel in which they were laid down, cannot at present be linked to any simple annual period; moreover, as close dating of alluvial deposits shows, a very large number of strata may result from a very small number of flow events.[11] In compensation, the evidence may suffice to show whether flow was perennial or not. In his study of Chaco Canyon, in New Mexico, Kirk Bryan used various lines of evidence (including the presence of numerous channels filled with sand in turn overlain by extensive clay horizons) to conclude that the alluvium laid down during Pueblo III occupation (AD 1100–1300) was accomplished by muddy floods resembling those of the present day. This interpretation led him to propose that the prehistoric inhabitants of the area had employed 'floodwater farming' rather than more familiar forms of irrigation. The ensuing phase of channel trenching brought an end to this benevolent process, and doubtless encouraged the abandonment of Chaco Canyon by the Pueblo III people.[12]

Another clue to the character of former stream regimes is supplied by the texture of the corresponding deposits once they are compared with those from which they were derived. For, if it can be shown that the area drained by a stream has not changed appreciably in the interim, and hence that the source of the material now represented by a dated fill can be circumscribed, then the texture of the 'parent' sediment provides a standard against which the texture of the 'daughter' sediment can be measured. Note that this standard, unlike those that underlie statistical methods of sediment interpretation, makes no assumptions about the prevalence of normal distributions in grain populations; on the other hand it cannot be used if the parent deposit is very well sorted, as this characteristic is not easily eliminated during redeposition.

In the pilot study designed to try this approach, samples were taken of parent and daughter deposits in various Iranian

67 Grain-size distribution of parent (*solid line*) and derived deposits (*broken line*) in various valleys in Iran

streams, the guiding principle being that the finest material to be observed was to be taken from each of the selected exposures: for, whereas some indication of peak discharge might be gained from analysis of the coarsest material present, the low stages – often of greater human concern – are reflected in the fine-grained component, as this can only be laid down when flow becomes very sluggish or ceases altogether.

67 Comparison of the sample pairs revealed 'silt-clay depletion' of most of the daughter deposits relative to their parents, suggesting that redeposition had been performed by streams whose flow was sufficiently prolonged for the fines to remain in suspension and to be carried out of the basins. This inference tallied with the evidence of morphology and sedimentary structures, which indicated that the parent material had been laid down in alluvial fans by shortlived ephemeral flash floods whereas the daughter deposits had accumulated in the flood-plain of meandering valleys. We can thus identify an earlier period (between

about 50,000 and 6000 years ago) which was characterized by spasmodic, localized aggradation, and a later period (during the Middle Ages) which witnessed the continuous if selective deposition of the coarser alluvium for at least some months in the year.[13]

The 'loess' of the Nahal Besor

The Nahal Besor, known in the older literature as Wadi Ghuzzeh, drains part of the northern plains of the Negev and enters the sea some 9 km. to the southwest of Gaza. The plains are rich in sites of various ages and ranging in type from flint scatters to imposing city mounds. Near Tell Fara (Sharuhen), for example, Lower Palaeolithic artefacts have been found on the surface; numerous Mousterian occupation horizons are currently being exposed by gullying of the valley floor; Chalcolithic sites are also common; and some late Palaeolithic, Epi-Palaeolithic and Neolithic material has also been found. The *tell* itself was

68 Location of Tell Gamma and Tell Fara, Israel, in relation to loess deposits

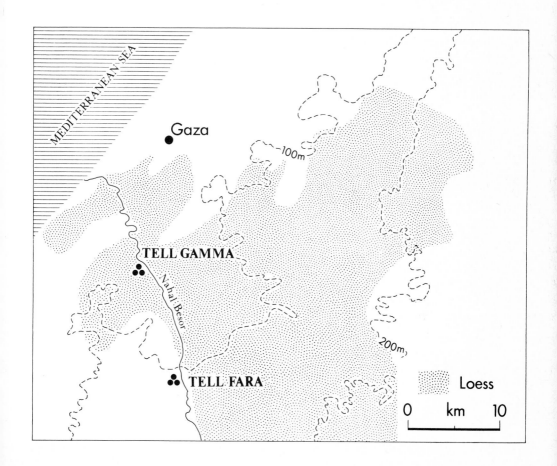

103

occupied from the Middle Bronze Age until the first century AD; the Byzantine period is represented by scattered farmsteads.[14]

Aridity renders precarious any form of animal husbandry or cultivation in the area, and most accounts of individual sites or of site distributions make some reference to the possibility of environmental change. A striking example is to be found in the report by Sir Flinders Petrie on his excavations at Tell Gamma 69 (Jemmeh) which he identified with ancient Gerar and in which he uncovered six levels of occupation dating from the fifteenth to the fifth century BC. Petrie suggested that the bluff on which the tell lay had been carved from 'a deposit of loam with shells washed down the Wady Ghuzzeh into an estuary at about 160 ft O.D.' (*c.* 49 m.) and then uplifted. He also found evidence for renewed 'submersion' up to 125 ft O.D. (*c.* 38 m.) in Roman times in the form of a second bed of loam and shells around the site. In his view, this could explain the lack of sites dating from the third to the sixth centuries AD in the coastal belt below the 125 ft contour; the corresponding rise in the water table would have made 'flourishing occupation' possible inland regardless of deficiencies in the rainfall. The final item in Petrie's account was a period of emergence which restored the coastline to the position it occupied at the time of Strabo.[15]

Petrie's book was published in 1928. Eleven years earlier, Bayer had reported the presence of loess near Gaza. An authoritative definition for loess is 'a sediment, commonly nonstratified and nonconsolidated composed dominantly of silt-sized particles ... and deposited primarily by the wind'.[16] In his account of the Beersheba–Gaza depression (1922), Range accepted the loess as a truly aeolian deposit, although he noted that it had locally undergone reworking by water. By 1936 Picard and Solomonica could argue that, as the loess was largely confined to the major wadis and depressions and frequently contained gravel beds, it was primarily the product of fluvial action. Indeed, they went so far as to suggest that some of the redeposited material could have been derived from local Pliocene rocks and that the loess on the interfluves had been laid down by wind *after* the wadis had filled up.[17]

Petrie's marine incursions were forgotten, the latest transgression of any note having been pushed back to the Pliocene. The aeolian label stuck more tenaciously. On the Soil Map of Israel the Nahal Besor is bordered by 'Loess raw soils' and 'Loess-like raw soils', the former consisting of desert dust which 'was transported primarily by winds, and to some extent by

69 Tell Gamma and bordering wadi terrace

runoff water', the latter of 'desert dust, mainly aeolian'. Accounts of the northern Negev which fully acknowledged the prominence of fluvial deposition continue to lump the deposits inland of the coastal dunes under the heading of loess and unequivocally give their composition as aeolian silt and clay.[18] It therefore comes as no surprise to find that the arid conditions one associated with loess deposition have been blamed for the paucity of sites intermediate in age between the Mousterian and the Chalcolithic near Tell Fara.

There is a school of thought which rejects a purely descriptive definition of loess because this would render it synonymous with 'silt', and which favours a genetic definition whereby wind is clearly given as the agent of deposition.[19] The corollary is that, once the loess has been redeposited by any agency other than wind, such as running water or mass movement, it reverts to being plain silt. The point will seem academic until one comes to consider those who witnessed the process of infilling. A river basin subject to a succession of silt-laden floods is one thing. A

70 Texture of fine material from terrace (a) and modern flood deposits (b) at Tell Gamma, compared with classic loess

landscape undergoing burial by loess is quite another matter: 'everywhere, especially in valleys and basins, where the power of the wind was abated, the wind-borne dust sank to earth ... every storm brought new beds of dust ... Great and terrible was the victory of the spirit of the air ... the day was darkened ...'[20] In brief, as in the Hadhramaut and the wadis of Tripolitania, using terms such as loessian, loess-like and loess-derived is destined to promote obscurity.

The field evidence suggests that any occupational hiatus in the Nahal Besor is more an accident of selective preservation (and exploration) than an environmental effect. At Tell Gamma the channel is cut into silts and fine sands which interfinger with clays and silty clays,[21] poorly sorted and well stratified. Between this site and Tell Fara, sections into the material that underlies the plain reveal many depositional structures diagnostic of channel and overbank deposition. At Fara, a series of basal gravels is overlain by up to 25 m. of silty sands displaying cross-bedded horizons and 'clay curls' indicative of periodic desiccation. Massive silty horizons are rare.[22] We may infer that the area would prove most attractive to grazing animals soon after the spates, and, as these were localized in their effects, that the valley favoured 'kill' and 'transit' rather than 'preferred' sites. The only advantage gained from the ensuing incision was the exposure of springs on the channel floor which now ensure a perennial if limited supply of water. A Roman revetment wall at the base of Tell Fara employed sandstone quarried from outcrops exposed by erosion, but as it was intended to halt further erosion this gain does not seem very real.

7
Local ancillary sources

Numerous additional sources of information can be used to amplify a local physiographic chronology. Some of them (termed 'complementary' in this chapter) allow us to check or improve on our existing findings. Others ('supplementary') may support or conflict with the physiographic evidence without having any direct bearing on it. Which of them are to be tapped is largely a matter of finance and fortune; in keeping with the mood of earlier chapters, it will be assumed that the former are restricted and the latter given to fitful smiles, and that one will therefore have to make do with rather less than the entire range of techniques theoretically at one's disposal.[1]

The need for independent dating is especially pressing where information is being derived from alien fields of study, as its chronological basis is consequently difficult to evaluate. Many of the disciplines with a long history of association with archaeology will be found to depend on (often outdated) climatic sequences, and hence could lead the unwary into circular argument. Take for example the statement that at Kamyk, in Poland, 'the fauna suggests a cool climate and steppe vegetation and so perhaps points to a stage of the 1-Günz' (i.e. the first of the four classic Alpine glaciations).[2]

If the ancillary evidence is intimately associated with the physiographic feature in question – as when macrofloral remains occur within a spring-laid deposit – identity of age may be assumed, but only provided that intrusion or redeposition can be ruled out. At the site of Sterkfontein, in South Africa, the Middle Breccia, which contains possible *Homo* remains, has yielded pollen which can be split into two groups according to the state of preservation of the grains. The badly preserved material is thought to represent the environment at the time the cave sediments accumulated, and reflects the prevalence of open grassland; the better preserved material was probably brought in later by percolating water and indicates warmer, perhaps more

71 Rock drawings from
Tibešti, in the Sahara

71 humid conditions.[3] In the case of rock drawings, burial by sedi-
ments of known age may salvage information which might other-
wise remain undated and hence unusable.

A related issue is that of compatibility. If two demonstrably
contemporaneous environmental indicators fail to give the same
answer, it does not follow that the fault lies with erroneous inter-
pretation, defective sampling, contamination, and the like. A cave
may attract, by virtue of the comforts it offers or perhaps through
the services of a hyaena, animals from 'related catchments' (Ill.
11) which differ profoundly in their character; a river deposit
could embody fossils from ecologically distinct tributaries.

Such discrepancies are too valuable to be discounted for the
sake of a harmonious picture. They provide a measure of local
variability and of the diverging ways in which organisms respond
to an apparently homogeneous setting. The alluvial deposits near
Tell Fara contain the impressions of leaves provisionally identi-
fied as *Populus euphratica* and *Salix acmophylla* – species now
found occupying bankside habitats elsewhere in Israel – and of

leaflets indicative of a Mediterranean vegetation. Charcoal identified as juniper has also been recovered from one horizon.[4] The conflict with an aeolian interpretation of the sediments is clear; the 'flash-flood' alternative appears to fare little better, as both the tree species require a reliable supply of moisture all the year round. The one plausible solution is that the alluvium, though flooded only at intervals, held a store of groundwater which the trees could tap, it being apparent that not all forms of plant life could thus circumvent the restrictions imposed by the rainfall regime.

More to the immediate point, apparent discrepancies may help to resolve some of the ambiguities in the physiographic evidence. The lack of a *lingua franca* for all the disciplines that contribute to environmental reconstruction, usually remedied by using climatic terminology, presents little difficulty when the task is cut down to testing and if possible amplifying the modest conclusions we have reached by the study of landforms and sediments.

The disagreement that may arise between workers investigating a particular item is of course part and parcel of all research although archaeologists will be the first to admit that their profession appears to offer unusual scope for this kind of activity. Some of the surplus scepticism could with advantage be transferred to the scrutiny of specialist reports. The recent finding that there is no evidence for a Romano-British marine transgression in the very area that nurtured the concept[5] demonstrates the need for unceasing vigilance.

Complementary evidence

We have made frequent reference to archaeological remains whose position served to identify or date surfaces and deposits. Topographic descriptions by travellers and poets were soon dismissed as inadequate for the reconstruction of landscapes; but there is no denying the reassurance to be gained from a good match between the physiographic inference and the account of a contemporaneous eyewitness, especially if no possible cause for axe-grinding is to be discerned. Thus, the fact that the Wadi Ziz of southern Morocco was compared to the Nile by the traveller El Bekri, though possibly a product of nostalgia, is difficult to reconcile with the deep ravine near the ruins of Sigilmasa down which flow only occasional and largely destructive floods; yet it tallies precisely with the evidence of the local depositional sequence once one allows for a channel eroded within the last

72

72 Ruins of Sigilmasa, southern Morocco

73

two or three centuries. The inference that gullying of the valley floors in the Roman Campagna is a post-Classical phenomenon is borne out by the observation that valley floors which were drained by means of subterranean drainageways (*cuniculi*) in the fourth century BC or earlier evaded surface erosion and hence retained their original 'gentle contours'.[6]

Prominent among items neglected in earlier chapters was the ecological interpretation of marine organisms associated with shifts in the shoreline. The need for this becomes pressing when the results of radiometric dating of shell and coral are being converted into elevations relative to the contemporaneous sea-level. Ambiguities in the physiographic and lithological evidence also invite a biological approach; indeed, in coastal areas which are lowlying or poorly endowed with sections the burden may have to be placed almost entirely on the organic evidence. For instance, it was largely through the analysis of marine mollusca that a lagoon was found to have linked the Romano-medieval city of Sipontum, in southern Italy, to the sea during the early Middle Ages.[7]

The identification of marine organisms and related estuarine species, and their attribution to specific habitats, are largely matters of patience coupled with access to reference collections and a good library. An archaeologist planning to devote some time to littoral sites may well find the investment a wise one; museum staff are overburdened with requests for help and in many cases are more interested in classification than in ecology. But whether or not the labelling is autodidactic, the excavator can put his specialist skills to good use by ensuring that the provenance of the material is critically documented: in the geological literature

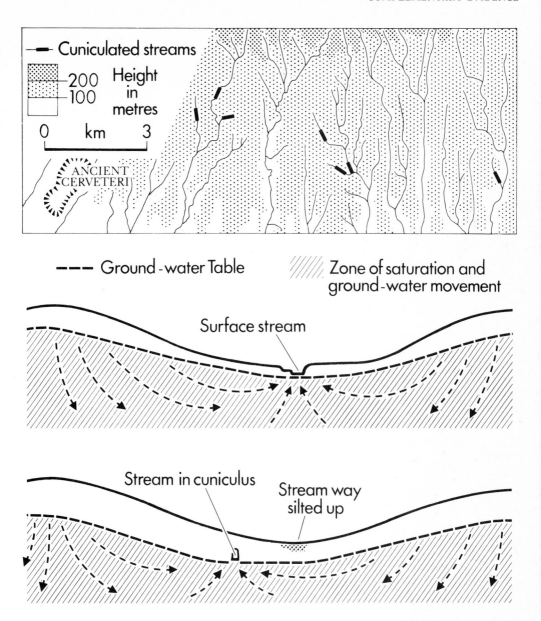

a surprisingly large area of dispute surrounds the precise relationship between shells for which expensive C14 dates have been obtained and the beds they are supposed to illuminate.

The point needs to be made all the more strongly if there is no opportunity at all for the archaeologist to perform the analysis, as where isotopic study of shell material is being contemplated. Shells from the Neolithic settlement of Nea Nikomedeia, in Greece, gave oxygen-isotope readings which suggested that the

73 The influence of *cuniculi* (underground drains) on valley development. Note that undrained valleys are prone to gullying

low land near the site had been an estuary subject to seasonal inflow of river water rather than a lake or an arm of the sea.[8] The presence of the shells at Nea Nikomedeia does not point unambiguously to their provenance from this portion of the landscape, and in view of the economic and other implications flowing from their analysis one can only hope that supplementary excavations will be conducted in the plain to confirm the link.

To go beyond the crude textural analysis of superficial sediments into the province of soil chemistry and biology requires more than just a modicum of application. But fairly simple chemical analyses can be employed to discover whether or not prolonged deposition by wind or water underwent interruptions sufficiently prolonged for the surface to undergo leaching (or the converse) even when there is no erosional feature to betray the *74* halt. In Clear Creek, Wyoming, a calcareous horizon which appeared to represent a period of soil development under arid conditions was traced away from the section by measuring calcium carbonate content at different depths along a line transverse to the channel. Besides confirming the continuity of the feature, the results demonstrated that the carbonate had formed on a land surface which postdated the Ucross formation and antedated deposition of the Kaycee formation.[9]

74 The calcareous fossil soil in Clear Creek, Wyoming

75 Drainage catchment of wadis Rama and Kofrein, Jordan, above section (marked by bar) sampled for pollen, fauna and sediment. Dots indicate location of springs

The ecological interpretation of plant remains tends to be delegated, but not – one again hopes – their placing in the sequence; and, as we saw with Tell Fara, results which are climatically confusing are valuable clues to former ground conditions. In the tufas of Wadi Derna, in Cyrenaica, the presence of impressions and casts of Aleppo pine (*Pinus halepensis* Mill), still to be found some 20 km. away, indicates warm and dry summers, whereas the associated gravels apparently reflect colder winters than those of today. More certain is the evidence for perennial flow provided by reeds (*Arundo* sp.) and bramble (*Rubus* sp.), both of which grow there today.[10] Tree-ring analysis is also dogged by the problem of local conditions, to the benefit of parochial scholars. The fact that the rings can be dated directly by $C14$ is a great source of strength; and the emphasis on microclimate is likely to be increased by advances in the isotopic analysis of tree rings, which promises to yield information on air temperatures to within $0·1°C$ or better.[11]

Likewise, the environmental requirements of Coleoptera and molluscs, though subject to regional controls, are prey to very local factors. Deposits containing the mollusc *Ancylus fluviatilis* have enabled a phase in the history of the Baltic to be identified during which the Yoldia Sea, which communicated with the open sea, was temporarily replaced by a lake; the discharge of this lake, and the resultant change in the coastline, are thought to have had some bearing on the replacement of the Maglemose culture

by the Ertebølle culture. As *A. fluviatilis* is 'only characteristic of streams with a stony bottom and an absence of mud',[12] it could prove just as useful in tracing the evolution of individual valleys.

Consideration of ground conditions leads on to what we have termed agencies of change, again at the local level and without much regard at this stage for underlying climatic or other causes. 75 The presence of freshwater mollusca in a stream deposit in Jordan reinforced the sedimentological evidence for perennial flow, or at any rate for much greater availability of water than now prevails, during aggradation; the associated pollen indicated arid steppe conditions, perhaps because streamflow generated in the headquarters had produced wetter conditions in the channel than the local vegetational pattern might suggest.[13] The lower layers of the Ali Kosh mound in southwest Iran yielded remains of bullrush, turtle, catfish, carp, and freshwater clam in sands and clays, the resulting picture being one of seasonal swamps and intermittent streams like those to be found in the area today.[14]

As our final item in this section, let us take engineering structures. These can often be linked to particular physiographic features more confidently than mobile artefacts, but they invite environmental interpretations loaded by preconceived notions. Like the Roman dams of North Africa, the *gabar-bands* of Baluchistan were initially regarded as devices for the storage of water, but whereas the dams were seen as tokens of aridity the *gabar-bands* were held to indicate a greater (though still precarious) rainfall in the past. Again like the Roman dams, the *gabar-bands* are now considered to have been either check dams designed to trap soil or flood-spreading diversionary structures, and while this tells us little about climate it implies that ephemeral or intermittent silt-laden flows were the rule. In Wadi Fasayil, Jordan, 76 a Roman aqueduct was rebuilt at least twice because it had become blocked with tufa, a problem which afflicts modern irrigation channels fed by the same spring. Estimates of the former volume of flow may also be possible. In the Nahal Lavan, in the Negev, there is an ancient diversion canal with a capacity equivalent to 100,000 cubic metres per hour. The maximum capacity of aqueducts can also be measured where the remains are sufficiently well preserved.[15] Computations of this kind do not enable us to calculate the discharge of streams or springs, it being quite possible that the canal was intended to cope with peak flow and that the aqueduct tapped only part of the available spring flow. But they remain useful measures of the amount of water actually reaching the areas they served.

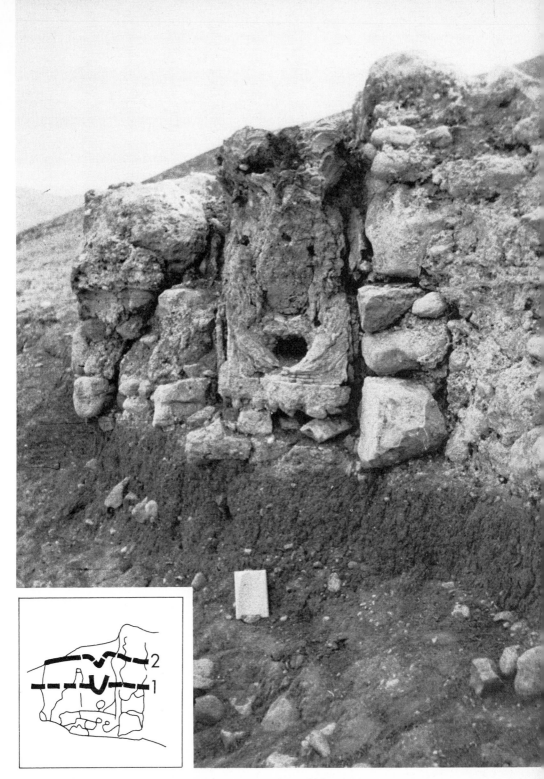

76 Remains of Roman aqueduct in Wadi Fasayil, Jordan, which was rebuilt at least twice to counteract blockage by tufa deposition

Supplementary sources

There is no limit to the range of material that can be used to develop the findings of a physiographic study. The paragraphs that follow are intended purely as a reminder that keeping one's aims at a modest level can have a beneficial effect on the coherence and reproducibility of the results as a whole.

Pollen analysis is perhaps the source of environmental information most familiar to readers of archaeological reports. Yet, as a prominent practitioner of the art had observed, pollen counts are primarily a reflection of changes in pollen rain, and any conclusions drawn from such counts about vegetational changes, let alone about their possible climatic origin, are matters of inference.[16] An important obstacle to such inference is our inability to specify the provenance of the pollen grains prior to their deposition by wind. We have seen that pollen redeposited by water can at least be exempted from the task of revealing what the vegetation was like at the point of deposition; in certain circumstances the archaeologist may be able to provide more positive clues to provenance. It has been suggested that much of the pollen recovered from the cave of Shanidar, in northern Iraq, was probably brought in by animals and men;[17] hence, though a poor guide to the regional vegetation pattern – if not any worse than that from a lake bed – the record is probably dominated by species which were present in the immediate vicinity of the cave and will consequently tell us something about the combined effects of soil and local climate.

The potential fruitfulness of conflicting results was broached in the opening paragraphs of this chapter; an example rich in promise is the presence of charcoal of *Pinus sylvestris* in various Neolithic and Bronze Age sites in southern England when compared with the 'poor showing' of *Pinus* pollen in deposits held to be of corresponding age.[18] In similar vein, the fact that 'scatological' assemblages may represent prey caught in a variety of communities[19] is no more disturbing than the likely diversity of habitats exploited by the inhabitants of a site, because any divergence between the regional pattern and the excavated assemblage is a better pointer to the factors of taste or fashion than would be total agreement.

We can extend the argument to embrace evidence which initially appears to be disappointing yet which can make a contribution to the environmental picture once it is looked at from a fresh viewpoint. Vast numbers of mammoth bones have been re-

covered from various Palaeolithic sites in the Ukraine; 500 in-
dividual mammoths are represented in a mere eight sites in the
Dnieper–Desna basins, but none appears to have been killed on
the spot and some of the mammoths were apparently dead long
before the bones were gathered. But there is no disputing that
the bones were used as building material, and that some of the
shelters thus constructed were artificially heated,[20] findings
which are of profound importance to the prehistorian because
they show that, at least in the Ukraine, man was already free from
the bondage of caves as shelter – and as locational factors – by
Middle Palaeolithic times.

The faunal remains at the Haua Fteah, Cyrenaica, were also
initially subjected to climatic interpretation, and yielded results
which were in fair agreement with the marine palaeotem-
peratures obtained by isotopic analysis of marine shells presum-
ably brought to the cave for food, with the temperatures inferred
from the texture of the cave deposits, and with the sequence of
cold and warm oscillations obtained in other parts of the Mediter-
ranean area. While freely concurring with the conclusion that
'fragile evidence from a single discipline can be corroborated by
equally fragile evidence from other disciplines to provide con-
vincing evidence for conclusions which it might not otherwise
be possible to make', one is tempted to ask: *cui bono*? The palaeo-
climatologist, perhaps, and he is unlikely to take much heed of
such a frail edifice.

Archaeologically speaking, there is more to be gained from
comparing the fauna at the Haua with that at corresponding
levels in other sites. Higgs suggested that the observed dif-
ferences in the faunal record of the Haua and of Hagfet ed Dabba,
56 km. to the southwest, stems from the contrasting setting of
the two sites, the Haua being a coastal site with perennial water
supplies and Hagfet ed Dabba lying in more desertic surround-
ings; and he raised the possibility that the former was occupied
in the drier summer season and the latter in the wet season by
a single human group, an interpretation which among other
things would account for the resemblances as well as the dif-
ferences between the tool assemblages found at the two sites.[21]

The problematic character of many tool types means that such
suggestions are not easily tested by typological criteria; what is
more, like the dog that failed to bark in the night the absence
of certain kinds of artefact could prove more informative than
their presence. One possible avenue is to compare assemblages
by the 'parent–daughter' approach proposed earlier for sediment

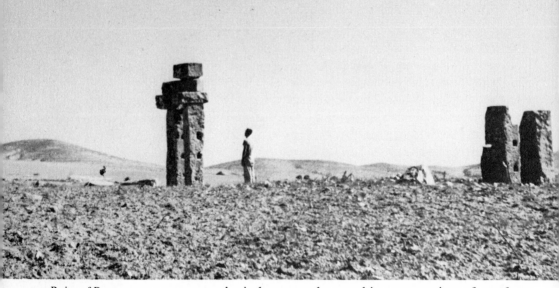

77 Ruins of Roman olive presses in Libya (formerly thought to be megaliths). The close match between their distribution and that of modern olive farms suggests that the climate of Roman times was very similar to that of today.

textures. As it happens the graphic presentation of artefact assemblages favoured particularly by French prehistorians was originally derived from the grain-size distribution curves of the sedimentologist, but its stress on form rather than function limits its potential for the present purpose. Indeed, the continuing inclusion of page after page of costly drawings of almost identical tools in the Palaeolithic literature would seem to indicate that the analogy between tools and sand grains has a long way to go.

Ethnographic parallels remain a fruitful if hazardous source of insights into modes of resource exploitation. The Bedouin herdsmen of Cyrenaica move their flocks between coast and hinterland to a seasonal rhythm analogous to that postulated for Oranian times. The range of animals hunted by the G/wi and !Kung Bushmen of the Kalahari is very similar to that recovered from beds I and II at Olduvai, for which comparable semi-arid conditions and seasonal rainfall are postulated. The proportions of Chelonia (tortoises and turtles), bovids and carnivores killed by the Bushmen in the dry season are very different from those killed in the wet season; the Olduvai assemblages give very similar groupings and the majority appear to correspond to occupation during the dry season,[22] a finding which nicely complements the sedimentary evidence cited in Chapter 6 (p. 98).

Once this kind of hypothesis has been broached, specialist sources can be called in for additional data. Isotopic analysis of different portions of midden shells, for example, may indicate during which season the shells were gathered and, by implication,

when the site was occupied; the dietary contribution of organic remains can also be assessed so that the periodicity or total duration of site occupation can be estimated.[23]

Climatic evidence, hitherto shelved, at last comes into its own. Data on present-day conditions may help to resolve, among other things, whether an ancient site or pattern of settlement is compatible with the climatic resources currently available. Dull though an affirmative answer may seem, it does obviate gratuitous appeals to climatic change which, quite apart from their *ad hoc* quality, imply related shifts in adjoining areas where they could be unwanted. Conversely, plotting sites against the modern isohyets is hardly a safe way of determining whether or not their inhabitants practised irrigation, as climatic stability cannot be assumed either. Nevertheless it has the edge on appeals to climatic change in that it forces one to investigate the technology practised at the time.

77

There is no quick substitute for a long run of reliable meteorological records when one is seeking to pin down not only the mean situation but also the range of temperature and rainfall values likely to be encountered, and if no such runs are to be had, a few meteorological observations carried out with portable equipment are likely to be of little value. But if a relative set of measures is required to assess how far aspect or topographic position influenced local conditions, then even a short series of observations will prove informative. Caves and shelters are obvious candidates for this kind of investigation, but different kinds of artificial shelter have to be taken into account when the attractiveness of a particular microclimate is under review.[24]

The Central Plateau of Mexico

In an account of his pioneering studies on the recent geological evolution of central Mexico, Helmut de Terra stressed the importance of correlating 'the history of the human settlements with geological and geographical phenomena and especially with the variations in lake level and the consequent changes in the distribution of arable land available to the earliest agriculturalists'.[25] Much remains to be done. Hitherto, the theme that has dominated physiographic and allied studies of the area has been climatic chronology, and the findings of earth scientists have been made available to archaeologists chiefly in terms of fluctuations in moisture and temperature. Thus the Tehuacán Project, referred to in an earlier chapter (see p. 36), was from the outset

78

78 Locations in Mexico discussed in text

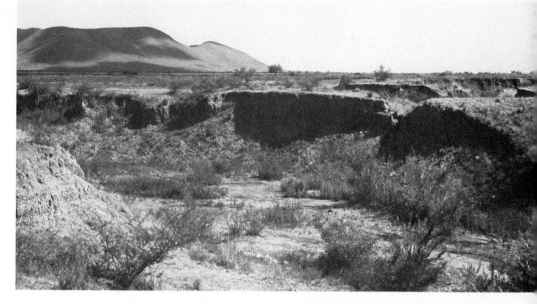

a wide-ranging interdisciplinary effort, but, as its director himself admits, neither soil studies nor 'in-depth' geomorphological research played an important part in it.[26]

An attempt was made in 1974 to formulate an alluvial chronology applicable to the central Plateau as a whole. The primary aim was simply to discover how far its physiography had changed in late prehistoric and historical times in the hope of contributing to various current debates, among them the extent to which human activity had led to soil erosion. Although the results were by no means conclusive, they gained a good deal from the fusion of the physiographic evidence with that obtained by other workers from various ancillary sources.[27]

Throughout the Plateau, from Ajalpan in the south to Chihuahua in the north, the streams are incised into a well-bedded, generally fine-grained deposit which contains potsherds. Its thickness is generally in the region of 5 m., but locally it exceeds 10 m. In previous accounts the presence of sherds had been taken as an indication that soil erosion, promoted by deforestation and unwise cultivation, supplied the sediment.[28] The modern landscape was seen as a skeletal, impoverished version of what it had once been. The Spaniards, wrote de Terra, 'assumed the Aztec heritage of defeat in the struggle with erosion'.[29] During its heyday, Teotihuacán was a paradise running with springs and brooks; today the downpours of summer briefly fill the ravines with muddy torrents because deforestation has laid bare the hills

79

and robbed them of the ability to absorb the rains. And physical decay spelt cultural decline.[30]

If the deposit is indeed a product of human improvidence one might expect the onset of erosion to vary from place to place according to local circumstances. Cook, who believed that the process had been in operation for between 3000 and 5000 years, identified one area in which it occurred in the early and middle sixteenth century as a result of tree-cutting for fuel and the introduction of plough cultivation.[31] If an environmental shift – such as the progressive desiccation invoked by various authors – was primarily responsible, deposition would probably display less regional variation in its timing.

The sherds in the deposits range in age from Purrón (2300–1500 BC) to Aztec IV (AD 1507–1519) but the controlling factor appears to be the age of the nearest source of pottery. Of the 17 sections that were studied in detail, nine yielded material dating from AD 600 or later: C14 ages were obtained at two of the sections, one of 1410 ± 95 and the other of 1930 ± 100 yr BP (I-4596 and 4601), but as the latter refers to a horizon containing Aztec IV sherds, the charcoal on which it was determined may have come from a long-lived or long-dead tree. Where the sherds reported by earlier workers could be identified, they postdated AD 650. It is therefore conceivable that all the deposits were laid down between AD 500 and 1519 or later. In one of the valleys, eyewitness reports[32] place entrenchment between AD 1590 and 1643; in another a bridge was built in about 1630, 'when erosion had already done its fearful work in the Aztecs' fields'.[33]

The chronological evidence, though compatible with a single phase of aggradation, is by no means compelling. But it gains support from the morphology and internal character of the deposit, and from 'parent–daughter' analysis of its texture in comparison with that of the sediments from which it was derived, all of which indicate a change from 'flashy' stream regimes to seasonal if not perennial flow. In addition, the deposit is poorer in iron oxides than the parent sediments. The difference bears no simple relationship to the amount of silt-clay depletion and is therefore not a mechanical effect; the removal of iron in solution under reducing conditions and in the presence of organic material provides an alternative explanation which is consistent with the floodplain environment postulated here.

The physiographic and sedimentological evidence of greater available moisture is usefully complemented by lake history. It is known that Lake Texcoco rose in level between the Classic

period and the time of the Conquest (1620); the Late Archaic site of El Tepalcate was submerged, and Cortes' capture of Tenochtitlán was facilitated. The Beaumont map, which probably dates from the late sixteenth century, shows that Lake Pátzcuaro experienced a phase of high lake level at about the same time.

80 The conquest of Tenochtitlán facilitated by high lake level

The pollen record of the two lakes points in the same direction. Using high values of oak, alder and fir relative to pine as an indicator of moist conditions, and basing his chronology on artefacts found with the pollen, Sears showed that the Texcoco basin had enjoyed a relatively wet phase between AD 800–900 and 1521. A similar though less pronounced moist interval has been identified at Lake Pátzcuaro, although its dating depends principally on correlation with the Texcoco sequence. In this basin, the preceding dry episode, attributed to the period of late Archaic-

Teotihuacán occupation is represented in the cores by high calcium contents and by the presence of shallow-water and littoral diatoms. These two items are thought to show that the dry phase was a product of climatic factors rather than a local anomaly created by volcanic activity or human interference.[34]

The meteorological records suggest that, at least since 1920, oscillations in the July rainfall totals in different parts of the Plateau have been broadly in phase.[35] As erosive rains are largely confined to the summer, it is possible for the Plateau as a whole to experience changes in their relative severity. Taken in conjunction with the lake evidence, this conclusion further strengthens the case for a depositional phase which, though doubtless influenced in its timing and extent by land use, affected central Mexico for the seven centuries that preceded the Conquest and perhaps for some decades after it.

Whether the process was economically beneficial would clearly depend on antecedent conditions and practices. In certain topographic settings, the deposition of predominantly fine-grained alluvium could have favoured certain types of flood farming; at Teotihuacán existing irrigation systems may have been disrupted by silting. What is certain is that the thesis of widespread, man-induced soil erosion destroying an ancestral Garden of Eden is no longer secure.

8
External sources

When all the parochial sources have been exhausted and the answer remains unresolved, ambiguous, or in need of confirmation, it is time to set aside 'local prejudice' and consider 'the general reason of the whole'. The difficulty lies in delaying the move. A high-latitude site dating from 15,000 years ago, for example, will almost inevitably earn the label of 'glacial' or 'periglacial', and if its environs are found to lack any traces of ice or frost the explanation is likely to be sought in the ravages of erosion or in inadequate exploration.

But one does not need to pretend not to have heard of the Ice Age or, more generally, of the physiographic conclusions reached in neighbouring or distant areas, to treat the extrapolation of environmental data as a last (or at any rate not as a first) resort. If the example of Pleistocene studies is any guide, *correlatio praecox* is both unproductive and unsatisfying: for the literature on the subject is dominated by sequences whose identity with an existing prototype owes more to the expectations of the investigator than to hard evidence, and whose departures from the model are treated as aberrations where they could serve to isolate the effects of local conditions and ultimately to reveal the underlying mechanisms.[1]

The risk of introducing unwarranted facts is reduced if the data source is either linked physically to the slot in need of filling or has the same quantitative age. The proposal is nothing more than an extension of the procedures governing all fieldwork at the local level and which are implicit in the use of terms such as 'bed' and 'unconformity'.

Once he has dealt with this question, the prospective borrower will be faced with the task of selecting his sources. He will know from experience in his own field that authoritative views sometimes owe more to repetition and dogmatism than to validity, but is unlikely to find this sufficient basis for opting for the least authoritative of the available interpretations. A reasonable course

of action would seem to be that of adopting a widely-accepted view and of ensuring, by adequate acknowledgement, that any revisions of that view can be allowed for without difficulty. Should the outcome prove incompatible with the rest of the evidence, an alternative view can be tried out. This kind of experimentation, though time-consuming, can prove beneficial to all parties by exposing two sets of data to some measure of testing.

We might with some justification include under the heading of suspect imports any chronological data derived from artefact typology that have not been locally calibrated by radiometric methods. One tends to assume that the Middle Palaeolithic in area X will, as in areas Y and Z on either side of it, follow the Lower Palaeolithic and precede the Upper Palaeolithic, and that its age will be broadly similar to that in the areas of comparison. The discrepancies that are now emerging between the dates obtained for the Acheulian of Europe and that of East Africa amount to over 500,000 years[2] and are a useful warning against abuse of the modern version of the 'three-ages' scale of human progress; the wealth of new Palaeolithic dates from Africa could of course merely reverse the direction in which extrapolation is conducted. The use of equations such as 'Late Pleistocene=Late Glacial+Last Interglacial=Middle Stone Age'[3] extends the approach to related environmental matters, and assumes that all areas experienced the same basic pattern of climatic changes.

Direct links

Perhaps the most popular external source is the literature on fluctuations in sea level, on the reasonable grounds (which qualify it for inclusion in the present section) that the oceans are interconnected and hence will respond in unison to any change in their capacity or content. There is general agreement that about 18,000 years ago the sea lay some 100–120 m. below its present level and that its subsequent rise (generally known as the Flandrian transgression) had been accomplished 5000–6000 years ago; and this is good enough for someone in the initial stages of a coastal study bearing on this period. The fine detail, however, is much in dispute, as is the question of whether the rise overshot the zero mark and then fell back; and there is growing evidence that, even if we discount the kind of localized movements of the land that often confuse the picture, ground motion is sufficiently widespread for no single worldwide (eustatic) curve to be generally applicable.[4] In other words, it would be mislead-

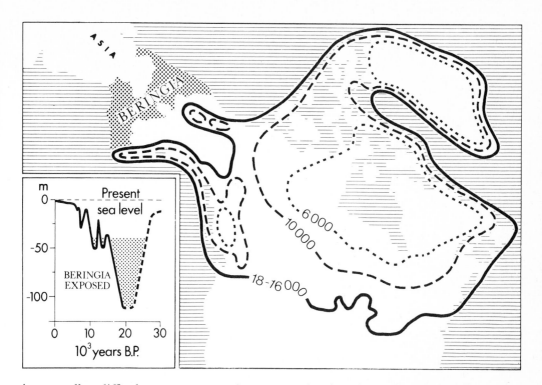

81 The land bridge of
Beringia and positions
of ice cover between
18,000 and 6000 years
ago

ing as well as difficult to treat a coastal reconstruction based on
the global evidence as more than a crude approximation.

For earlier periods the doubts become serious. Thus some
workers believe that sea level remained low for at least 40,000
years prior to the Flandrian transgression; others maintain there
was a transgression some 30,000 years ago which brought sea
level to within a few metres of present-day datum. We are here
dealing with a period too remote for confident C_{14} assay of
marine organisms and consequently where the indirect evidence
of palaeotemperatures derived from ocean cores or of glacial his-
tory on land strongly colours eustatic reconstructions. If the
period at issue straddles the disputed transgression the archaeo-
logist would seem well advised to examine his evidence in the
light of both interpretations. It is not inconceivable that his ulti-
mate preference could carry some weight in oceanographic
circles.

A subject that lends itself to preliminary eustatic assessment
is the history of land bridges. It is generally accepted that the
last, major marine regression brought into being a belt of country
('Beringia') linking Alaska to Siberia. Its effectiveness as a transit
route hinged not only on the local shoreline history but also on
terrain and vegetation; and there are indications that movement

81

127

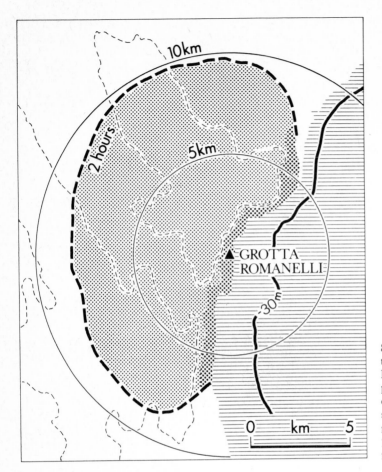

82 The exploitation territory of Grotta Romanelli, Italy, and the position of the coastline during occupation. Light stipple = primarily rough grazing; heavy stipple = primarily cliff and poor grazing

into the New World was blocked by the ice sheet contemporary with the marine regression, a factor which has been invoked to explain some of the parallels between the Akmak culture of Alaska (*c.* 13,000–6500 BC) and its Siberian counterparts, and the lack of resemblance between it and the Palaeo-Indian cultures to the south.[5] Needless to say, there is still much uncertainty surrounding both the coastal chronology and the history of the ice-free 'corridor' into Canada, but such attempts to build on existing knowledge should at least stimulate the earth scientists to perfect the palaeogeography of the crucial periods. At the same time, one is left with a suspicion that man, like viable seeds, has long been capable of remarkable sea voyages and that the study of land bridges is as inconclusive in archaeology as in palaeobotany.

Catchment analysis can provide some guide to the possible contribution of changes in marine resources resulting from fluctuations in sea level thus reconstructed and their bearing on

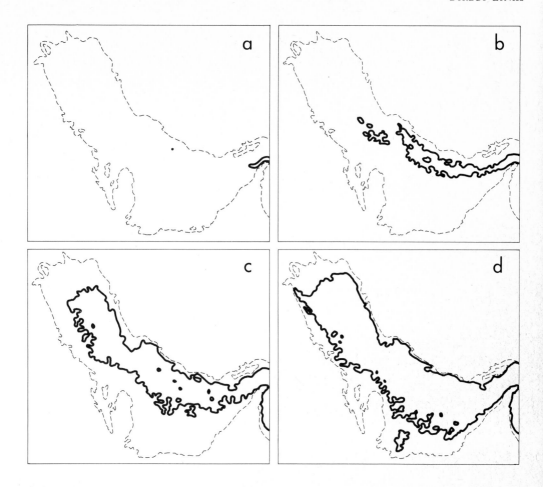

the economy of a site. Grotta Romanelli (South Italy), which has
been investigated by Jarman, yields an exploitation territory
which is about half the size of a circle of comparable radius
centred on the cave. During Upper Palaeolithic occupation of
the cave, dated by C14 to 10,320 yr BP for the later stages,
sea level presumably lay about 35 m. below its present position,
and as the coast slopes offshore little territorial gain resulted. The
importance of red deer (*Cervus elaphus*) and the European wild
ass (*Equus hydruntinus*) in the cave deposits shows that grazing
land played an important part in the economy; yet the location
of the cave at the margins of the terrestrial part of the territory
suggests that the static marine component (namely shellfish)
exerted the greater locational 'pull' because it was a labour-
intensive and static resource.[6]

As a device for checking the local record, the well-documented
part of the eustatic curve proves its worth in the Persian Gulf, *83*

83 Successive positions
of the coastline of the
Persian Gulf derived
from sea-level data from
outside the Gulf.
(a) 20,000 years ago;
(b) 14,000 years ago;
(c) 10,000 years ago;
(d) 8000 years ago

where a regression amounting to −120 m. fits the topographic evidence for total emergence of the sea bottom and the depth at which the alluvial fans at Ra's al Khaymah are in contact with Tertiary bedrock (see above, p. 70). As regards the littoral history of the head of the Gulf, however, the eustatic record has to be taken in conjunction with another external source, namely the alluvial history of the headwaters of the Tigris and Euphrates. In an influential paper published in 1952, Lees and Falcon challenged the then accepted view that there had been a gradual retreat of the sea southeastwards owing to delta-building by the Tigris, Euphrates and Karun, with the coast of 4000 BC lying some 100 km. northwest of Baghdad. Their opinion was that there had been little change during historical times and that the coast could conceivably have lain seawards of its present position; and they presented geological evidence for the belief that the three rivers were discharging their sediment loads into a long-established tectonic basin whose episodic subsidence, locally countered by minor anticlinal uplifts, had accommodated the alluvium and also given rise to a series of extensive floods.[7]

The alluvial sequence of the Tigris and Euphrates headwaters in fact suggests that between 40,000 and 10,000 years ago little sediment was discharged by the major rivers, and indicates that sediment yields comparable with those of today have prevailed only during the last 10,000 years. The case for an *archaeological* reappraisal of the archaeological and epigraphic evidence for shifts in the coastline would seem a strong one.

In contrast, our understanding of conditions in the headwaters of the Nile has benefited from work on its middle reaches. The 'Sebilian Silts', named after the Palaeolithic culture whose artefacts they contain, are represented by terraces standing as much as 40 m. above modern flood level. The classic studies by Sandford in the 1930s indicated that by late Sebilian times the rainfall in Nubia had dwindled to the point of extinction. In 1962, Fairbridge re-examined the evidence, and became convinced that only a drastic reduction in discharge could have precipitated such a massive depositional phase; and he found support for this contention in the wealth of unweathered feldspars and other readily decomposed minerals in the silts, and in the stunted character of the freshwater mussels (*Unio wilcocksi*) he obtained from the sediments. It followed that conditions of negligible flow had also prevailed in the Ethiopian headwaters which now nourish the Nile's annual floods. Radiocarbon dating of the silts showed that this phase had lasted between 25,000–20,000 and 10,000 years

ago, at a time when high latitudes were experiencing glacial conditions.[8]

Earth movements would seem to provide the greatest scope for the direct extrapolation of evidence for physiographic change, especially at a time when the layman is confronted with a flood of publications which explain plate-tectonic theory but fail to make it clear that rigid plates are not necessarily either platiform or inflexible. One often meets the assumption that large chunks of land will move in unison unless the reverse can be demonstrated. Dangerous though this procedure may seem, it is at least open to disproof. The use of distant earth movements to explain local hydrological changes – as at Beidha and Mohenjo-daro[9] – has to be handled with great caution, as it risks diverting attention away from the evidence at the site, and from equally plausible alternative explanations, without any corresponding gain in our understanding of physiographic history.

Indirect relations

Smalley has suggested that the spread of Neolithic culture into Shantung 'occurred under a simple geomorphological control: the Yellow River had to supply the land before it could be settled'. His argument is that the Shantung delta was built up *84* by the Yellow River with sediment eroded from the loess deposits of north China. Besides helping to account for the absence of Yang-shao remains in Shantung, the proposed mechanism suggests that coastal settlement benefited from soil deterioration inland, to which the Yang-shao people may in fact have contributed.

By the same token, settlement of the primary loess had perforce followed its accumulation. The loess was formerly regarded as of desert origin; as recently as 1934 the idea of a glacial mechanism was dismissed as 'quite improbable'. It is now known that mountain glaciation was widespread in China, and that several advances and retreats occurred. If, as in other major loess areas, glacial grinding supplied the particles, progress in the dating of glacial history will indirectly illuminate the chronology of loess deposition. As it is, the assumption that loess deposition coincided with glacial phases can be dismissed: for suitable material to be made available to the winds the ice had first to retreat.[10]

Volcanic ash has the edge over loess, at least as things stand at present, in lending itself to mineralogical tests of provenance, although, as with human paternity, the results are better fitted

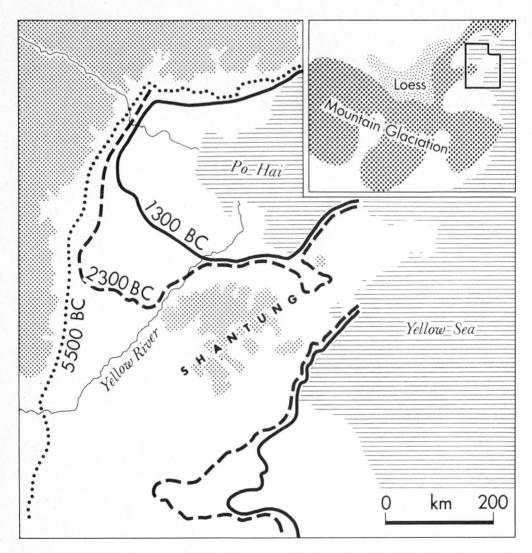

84 Relationship of loess to areas of mountain glaciation in China and progressive advance of the coastline according to various sources

to excluding than to confirming alleged relationships. In certain contexts two other advantages stand out: the scope offered by ash for potassium-argon dating, and the closeness with which the ash fall produced by a single, short-lived eruption approximates to an isochronous (time-parallel) horizon.

The thesis that an eruption on Santorini (Thera) was responsible for the destruction of the Minoan civilization of Crete has recently received a good deal of attention. Put briefly, the argument *85* is that, when Santorini erupted some 3500 years ago, ashes from it were dispersed over a very large area as indicated by their recovery from deep sea cores. In addition, giant waves crashed against distant coastlines following the devastating explosion that

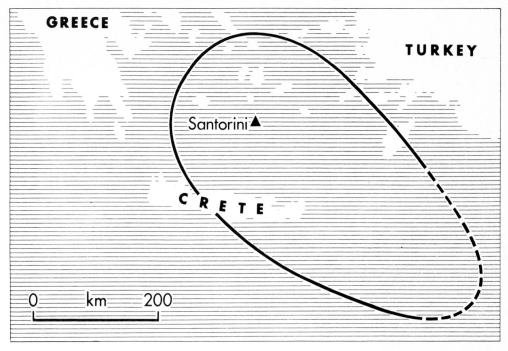

85 Extent of ash fall from Santorini 1400 BC

led to the collapse of the caldera of which Santorini is a remnant. The combined effects of ash-fall and destructive wave action, it is argued, account for the demise of the Minoan civilization.

As Finley has shown, the available dates do not fit. The C14 dates obtained on Santorini are inconsistent, and most workers accept the evidence of pottery which puts the onset of the eruption at about 1500 BC. They also concur in dating the sharp decline in the fortunes of Crete to about 1450 BC, with the palace of Knossos persisting until 1400 BC if not later. Any hope of spinning the eruption out to bridge the gap must be abandoned in the light of geological evidence for a very short-lived outburst. Moreover, most of the material was probably ejected as ash flows; in other words, the analogy that is often drawn with the eruption of Krakatoa in 1883 is misleading. The extensive windblown ash deposit whose discovery in cores taken from the sea floor re-ignited the debate – the first flame having been lit by Marinatos in 1939 – had a refractive index similar to that of the Santorini deposits, but the dates available for it were both too loose and too great for the purpose; in any case, more recent work suggests that it consists of three or four layers of different age of which the youngest was laid down earlier than 3000 BC. Again, although ash of the right refractive index has been found on Crete, it is present in trace amounts – as is also material from an Italian

eruption which is 21,500 years older. Finally, no sure sign of destructive waves has yet come to light on Crete.[11] In short, the evidence that has hitherto been adduced in favour of the suggestion is not only too little but also too early.

Extrapolation is thus seen to be risky unless the time of arrival of the 'signal' can be harmonized with that of its transmission. The degree of confidence to be placed on interpolated evidence is to a large extent inversely proportional to the distance between known items. The age of periods of high lake level in Africa was formerly derived from the assumption that they corresponded with European glacial phases. In due course radiometric dating showed that the assumption was generally erroneous and that the 'pluvials' were if anything in antiphase with glacials. The last few years have witnessed an impressive and fruitful attempt to cut short the conjecture by documenting the chronology of numerous individual lakes and, even though the mechanisms underlying their fluctuations remain uncertain and always subject to tectonic or other complications, the resulting network is close enough to furnish preliminary studies of unexplored basins lying within it with an initial working hypothesis. Many African lakes experienced high levels between 9000 and 8000 years ago; this is true of 31 of the 58 lake basins recently reviewed by Street and Grove[12] and could be said to dominate the pattern between latitudes 6°S and 21°N. At the same time there are exceptions, not all of which can be blamed on inadequate data; but it is implicit in the procedure being advocated here that the investigator will be a willing participant in what T. H. Huxley called the great tragedy of Science – the slaying of a beautiful hypothesis by an ugly fact.

Where the former position of the permanent snowline is in question, interpolation from better-documented neighbouring areas is again a useful preliminary step. One must of course guard against the temptation to accept smooth curves on a map as anything more than cartographic devices, and adjust the inferred values in the light of local topography, aspect and the like, if possible using lake levels to cross-check the result. The archaeologist may also need to guard against accepting some of the more extreme interpretations to be found in the glaciological literature, where, for example, it may be suggested that mountain ranges lacking traces of a sought-for glacial episode had not been uplifted in time for the ice to do its work. If the local uplands display fossil cirques, moraines and other products of ice action, the hope remains that they will in time be subjected to detailed

86

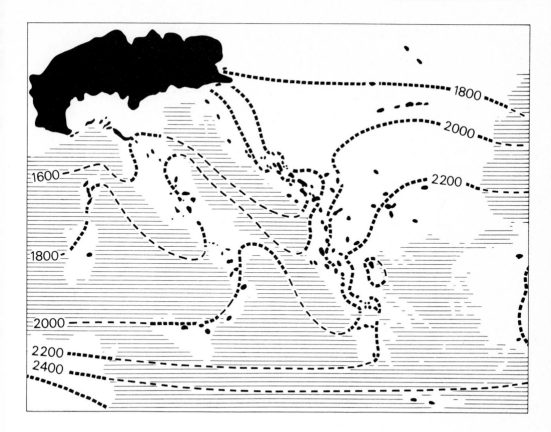

study so as to yield both a height value and material suitable for dating; the altitudinal difference between the ancient and the modern permanent snowlines is, clearly, a source of information which usefully complements changes in lake level as a means of evaluating the relative importance of changes in temperature and precipitation.[13] If the uplands are not high enough to bear any permanent snows, interpolation can again fill the gap.

86 Elevation of Würm snowline in part of the Mediterranean Basin. Black areas indicate former presence of ice

The Algerian littoral

Some of the most influential early studies of eustatic change were carried out by de Lamothe in Algeria at the turn of the century. By then the fourfold Alpine chronology of Penck and Brückner was sufficiently well established for its marine counterpart to seem a desirable prize; and Algeria proved a good hunting ground.

These classic surveys relied for their dating on correlation between the coastal sections and the Alps, based on the relative age and height of various fossil beaches. They also subordinated

the fluvial evidence to the eustatic theme, with river terraces used mainly as pointers to the elevation of the sea levels to which they were allegedly graded. Anderson's study of the coastal Atlas of Algeria, which was published in 1936, kept the tradition alive by taking it for granted that aggradation would result from periods of high, and therefore interglacial, sea level. More recent work has sought to use palaeontological and archaeological dating of beach deposits wherever possible, but the number of radiometric determinations remains too small for the erection of a sea-level sequence based solely on local data.[14]

Any attempt to investigate the possible effects of fluctuations in sea level on coastal settlement must therefore rely on the kind of procedure proposed earlier in this chapter. Until recently consideration of such matters has been largely confined to individual sites: at Kouali, for example, a decline in the intensity of occupation in a late stage of the Aterian has been tentatively blamed on increasing exposure to the effects of heavy storms associated with a gradually rising sea. In 1975 Saxon presented the results of a study designed to assess the extent and nature of economic adaptation to the environmental changes associated with the Flandrian transgression between 18,000 and 8000 years ago.[15] In it, he traced the physiographic evolution and settlement history of parts of the Algerian littoral with the help of a eustatic curve derived from evidence from the Atlantic Shelf of the United States and supported by observations made elsewhere.

87　Variations in the offshore topography suggested that off Annaba Bay the transgression began to have an appreciable effect some 13,000 years ago, whereas in the Beni Segoual area 250 km. to the west its impact was delayed for a further 3500 years. Once the rise had been completed, however, practically no exploitable littoral remained in the Beni Segoual area, as the sea came up to the base of the coastal mountains; again, the steepness of the local offshore topography meant that the coastal plain at its maximum had never exceeded a width of 6 km. At Annaba Bay, a marshy coastal plain persists to this day; at the peak of the regression the shoreline lay some 22 km. north of its present position.

The first step towards giving these inferences an archaeological bearing was to plot the distribution of sites dating from the period of submergence, namely those generally attributed to the Oranian (or Iberomaurusian). It should be noted in passing that many of the sites yield Aterian artefacts, but whether this represents continuity of occupation or stems from technological

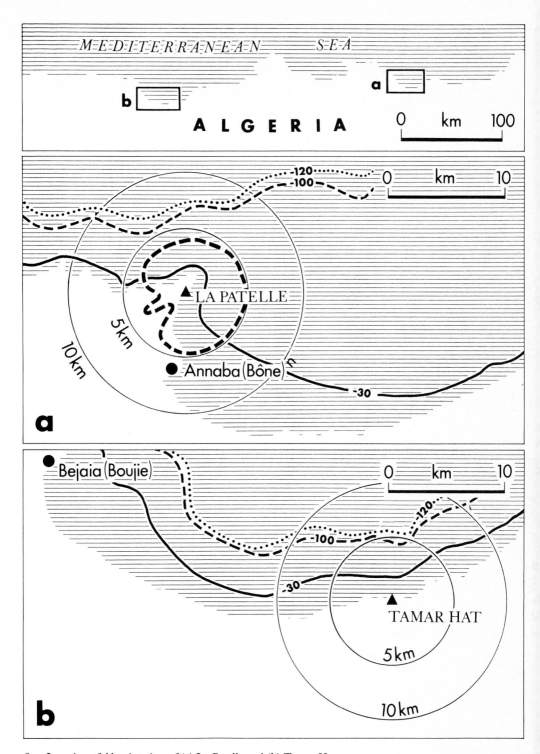

87 Location of Algerian sites of (a) La Patelle and (b) Tamar Hat, some
250 km. to the west. Note 30 m., 100 m. and 120 m. isobaths, and 1-hour
territory of La Patelle

conservation remains uncertain. The resulting pattern, in conjunction with the results of catchment analysis at a number of sites, was interpreted as the product of a subsistence herding economy operating within annual territories which included coastal winter grazing and littoral-mountain summer grazing.

Saxon also suggested that the Capsian site map implied an analogous scheme, with the sub-desert steppe and the sub-mediterranean steppe here providing the winter and summer resources. In his view the coastal plain was initially the more productive of the winter grazing zones, and submergence of part of the plain swung the balance in favour of the Capsian hartebeeste economy. This view may be compared with earlier suggestions to the effect that Capsian technology, which was adapted to desert conditions, superseded the Oranian as post-glacial desiccation progressed.

The excavation of Tamar Hat, now lying a mere 400 m. from the sea, produced C14 ages ranging from $10,375 \pm 375$ to $20,600 \pm 500$ yr BP. The Barbary Sheep (*Ammotragus lervia*), a species that is well suited to grass and woodland grazing, accounted for more than 94 per cent of the ungulate remains yielded by the cave. The bones indicated a kill pattern very different from what one might expect in a wild population, being dominated by large young males and older females; this, coupled with the animal's great elusiveness, lends credence to the suggestion that it was herded rather than hunted. Saxon suggested that Tamar Hat had to be abandoned once the coastal plain became too restricted for grazing. It is thus interesting to note that the remains of edible mollusca appear late in the cave sequence, a hint, perhaps, of a novel need for supplementary protein sources, and that isotopic analysis of one of the more common marine molluscs, *Monodonta turbinata*, indicated collection in the winter.

The real thrust of Saxon's study came from the comparison he drew between his Algerian findings and those he obtained in a similar manner on the Israeli coast. Lack of space forbids a detailed account, but two points deserve stressing. The first is that the Flandrian transgression, which impinged on this coast some 2000 years earlier than in Algeria, ultimately reduced the coastal plain of Israel to half its original size. The second is that the Upper Palaeolithic, Epipalaeolithic and Natufian populations which successively inherited the area appear to have been deflected by the loss of exploitable coastal territory from the herding of fallow deer to a similar dependence on gazelle. It is to be hoped that others will submit the original thesis to further testing by subjecting additional areas to eustatic analysis.

9
Integration

In due course enough material will have been collected to justify an attempt at integration. Nothing is lost by making the attempt prematurely: if inconsistencies emerge the ensuing research can be directed at resolving the issue, whereas if harmony prevails the work can be channelled into the more promising avenues.

The case-study that forms the bulk of this chapter represents a fair – though by no means exemplary – attempt at developing those aspects of the physiographic narrative that were deemed of greatest archaeological import, and at tapping related fields only where they promised to throw light on the selected themes. Needless to say any account written in retrospect will present a misleadingly tidy picture of a piece of research; conversely, the reader may well decide that some of the alleys which appeared blind or which were ignored would have repaid investigation.

As the first few paragraphs of the account will show, the study began as a piece of exploration and passed through a palaeoclimatic phase before becoming strongly physiographic in its tone. Other participants are unlikely to see it in exactly the same light, and some of them may have been wholly unaware that landforms had even been considered. Reference to the numerous publications mentioned in the notes to this chapter will easily rectify this imbalance and compensate for the cavalier way in which their contributions to the study have been treated here. What these sources may fail to make explicit is the extent to which the project as a whole was inspired and orchestrated by Eric Higgs, and the extraordinary exertions to which he drove his associates by a cunning blend of challenge and disbelief.

Epirus: physiographic evolution

In 1923 it was still possible to state that not one Palaeolithic artefact had been found in Greece. The cave of Seidi was excavated in 1941; there followed the discovery of a series of fossiliferrous

Palaeolithic assemblages in the terraces of the Penios River in 1958, and of a Neanderthal skull at Khalkidiki in 1960, as well as of several minor surface flint scatters. In 1962 the first of a series of field seasons by a group under Professor Leroi-Gourhan was devoted to the Palaeolithic remains of the Amalias area in the Peloponnese and to their position in the local Quaternary sequence. In the same year, a team from Cambridge University led by Higgs began a survey of the Palaeolithic of northern Greece.

In Macedonia little was found beyond an Acheulian handaxe which, though significant in its own right given the elaborate explanations that had previously been put forward to account for the absence of Lower Palaeolithic occupation in Greece, was of little import in any attempt to understand patterns of early occupation. In Epirus, however, the search was richly rewarded. Numerous Palaeolithic, Neolithic and Bronze Age sites were discovered, and, in due course, two of them – the shelter of Asprochaliko and the open site of Kokkinopilos – were excavated.

Initially, an important aim of the study was seen as that of discovering 'evidence for climatic oscillations related to the late Pleistocene which might serve to link those of North Africa with the changes inferred from pollen analysis, radiocarbon and other disciplines in North-Western and Central Europe'.[1] The preliminary geological work was accordingly aimed at reconstructing the climatic conditions responsible for the deposition of certain prominent sedimentary units and at inferring their age (and that of associated artefacts) by correlation with analogous units in Cyrenaica. In addition, a record was kept from the outset of the colour and type of deposit containing or underlying flint assemblages. It soon became evident to the surveyors that 'a certain type of bright-red weathered deposit overlying limestone was likely to contain Neolithic and on its surface Bronze Age artefacts, while a yellow clay overlying a dark red clay contained Middle Palaeolithic implements';[2] and by looking for these two types of deposit they were able to discover numerous further sites.

88 The area over which the fieldwork ultimately extended encompasses marine, riverine and lacustrine settings. Attention was initially focussed on the Louros valley simply because of the wealth of artefacts yielded by the Kokkinopilos area.

89 Kokkinopilos figures prominently as the 'Red Dunes' in Hammond Innes' *Levkas Man*.[3] It is an extensive red, clayey deposit which is separated from the Louros gorge by a narrow limestone

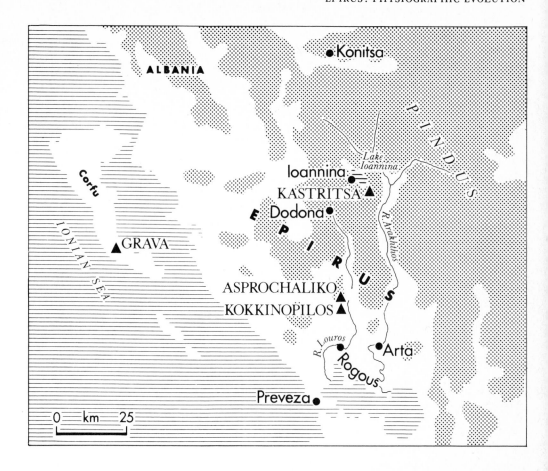

ridge. Large quantities of Palaeolithic material were found, principally in the gullies by which the deposit is currently being attacked, and a few items ascribed to the Bronze Age occurred on what was taken to be the original surface of the deposit. Excavation subsequently revealed an Advanced Palaeolithic chipping floor at a depth of about 4 m. and a concentration of Middle Palaeolithic artefacts 5–6 m. lower down, of which the larger pieces were in mint condition. Colour differences had led to an initial subdivision of the red deposits into three superimposed zones. As little beyond colour differentiated the zones, it was assumed that the breaks represented brief periods of erosion interrupting more or less continuous deposition; the location of both of the artefact concentrations at the contacts between colour zones reinforced the impression already given by their character that they were *in situ*. Unfortunately no exact counterparts to the Kokkinopilos industries emerged from the excavations at the near-by cave of Asprochaliko, but one can at least date by C14

88 Locations in Epirus, Greece, discussed in text

89 View of
Kokkinopilos, showing
ventilation shaft (*inset*, A)
and Roman land surface
(RS) cut by gully (g)

the transition from Middle to Advanced Palaeolithic there to between 40,000 and 24,000 years ago. Hence it is safe to conclude that the Kokkinopilos deposits were already being laid down by 24,000 years ago and that (as indicated by the Bronze Age surface material) deposition ended before the second millennium BC.

90, 91 The presence of Roman ventilation-shafts (*spiramina*) protruding from the red beds suggests that little erosion had taken place by Roman times. The aqueduct they served had been constructed to take spring water from Aghios Georgios to the coastal colony of Nikopolis, built near Preveza to commemorate the victory of Augustus over Caesar and Cleopatra at Actium. The aqueduct crossed the Louros at Aghios Georgios, burrowed through the limestone ridge and then through the Kokkinopilos deposit, and emerged as a surface channel for the rest of the way.

92 Deposits very similar to those at Kokkinopilos are present in other parts of the Louros basin and indeed the rest of Epirus.[4] As at Kokkinopilos, they rest directly on Tertiary or older bedrock. Many of them contain Middle and Advanced Palaeolithic artefacts often showing little or no sign of rolling. In some

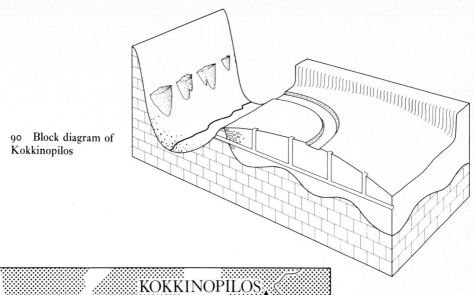

90 Block diagram of Kokkinopilos

KOKKINOPILOS

100m

R. Louros

NIKOPOLIS

0 km 5

Preveza

91 Route followed by Roman aqueduct between Kokkinopilos and Nikopolis

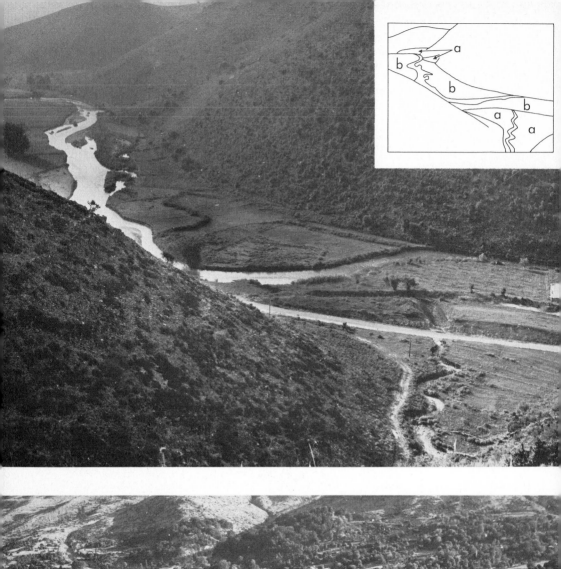
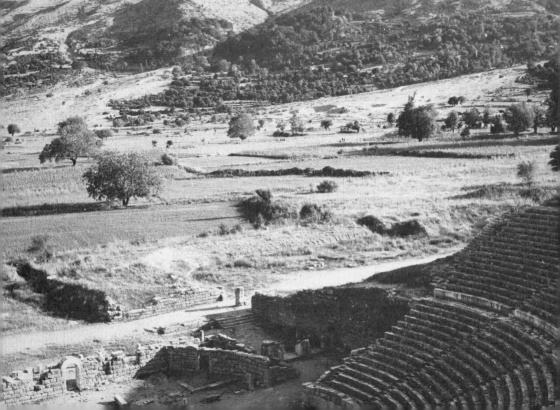

of the smaller valleys they form an unbroken, concave land sur-
face transverse to the stream. But more usually they have been
eroded into terraces or form isolated fans, and the streams are
entrenched in a younger deposit, predominantly buff or grey in
colour and with a maximum observed thickness of 5 m., whose
flat surface slopes downvalley to meet the sea at the river mouths.
This second deposit yields Roman sherds; at Dodona it has
buried the orchestra of the ancient theatre to a depth of 3 m.,
and at Rogous it is overlain by a midden containing Turkish
material. In some of the steeper lateral gullies, the grey deposit
overlies the red (as opposed to filling channels cut into it) presum-
ably because trenching had not progressed sufficiently prior to
the second phase of deposition.

On the working assumption that all the red deposits – which
will henceforth be referred to as the Kokkinopilos beds – were
broadly contemporaneous, an attempt was made to discover what
relationship they bore to lacustrine and marine sequences. On
the steep southwestern coast of Epirus, near Prevenza, they were
found to overlie a fossil beach previously described as Tyrrhenian
in age,[5] and to interfinger with cemented sands forming reefs off-
shore, the implication being that their deposition took place at
a time of lowered relative sea level. In contrast, the level of Lake
Ioannina was apparently higher than it is now during deposition

93

Opposite

92 Valley fills in Louros
Valley. (a) Kokkinopilos
formation; (b) historical
deposit

93 Recent alluvium
overlying part of Dodona,
Greece

94 Kokkinopilos beds
(*above*) interfingering with
fossil dunes (*centre left*) at
Preveza, Epirus

95 of the Kokkinopilos beds. The lake is fed principally by springs, and it is drained partly by swallow holes; a canal completed in 1944 acts as storm drain and leads to the adjacent Thiamis basin by way of a tunnel through an intervening limestone ridge. Evidence for a level higher than that which would have prevailed in the absence of the artificial ditch was found in sections exposed by the canal and by a quarry south of Kastritsa, in the form of clean gravels indicative of deltaic deposition. The delta deposits

96 on the banks of the canal pass into Kokkinopilos beds in one direction and into lacustrine beds in the other, and they yield a few Middle Palaeolithic flints. The elevation of the uppermost deltaic beds in the quarry indicated a shore lying some 3 m. above the present.

95 Lake Ioannina and section of deposits in the cave of Kastritsa

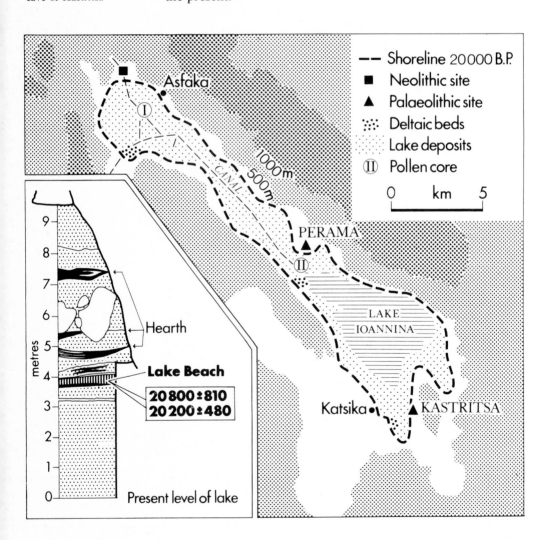

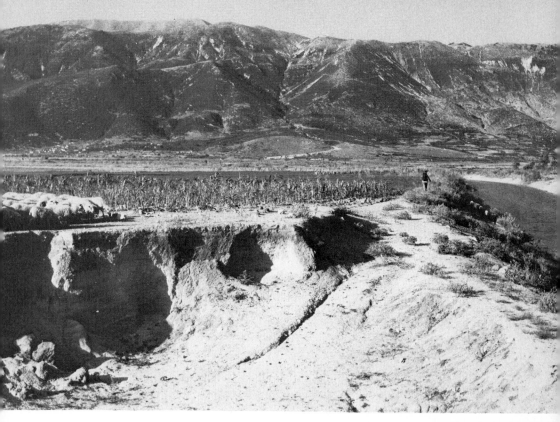

96 Deltaic beds (D) overlain by alluvium (A) at
the northern end of Lake Ioannina

This finding prompted a search for habitation sites along the
Kastritsa ridge in the belief that any traces of settlement along
the swollen lake would probably survive along the foot of the
ridge, and led to the discovery by Dr D. L. Clarke of flint blades
at the mouth of a cleft in the limestone cliff. Excavation in due
course revealed the important Advanced Palaeolithic cave of
Kastritsa. A series of lake beaches were found within the cave *97*
interstratified with hearths and overlying water-lain sand and silt
3·2 m. above lake level. The hearths yielded C14 dates of
20,800±810 and 20,000±480 yr BP (I-2466 and I-2468). So,
whatever the subsequent history of the lake, one could specify
its former extent at a particular period.

The lake basin also supplied a useful terminal date for the close
of the Kokkinopilos phase of aggradation: Clarke found a Neo-
lithic ditch dug into the surface of the deposit near Katsika from *98*

147

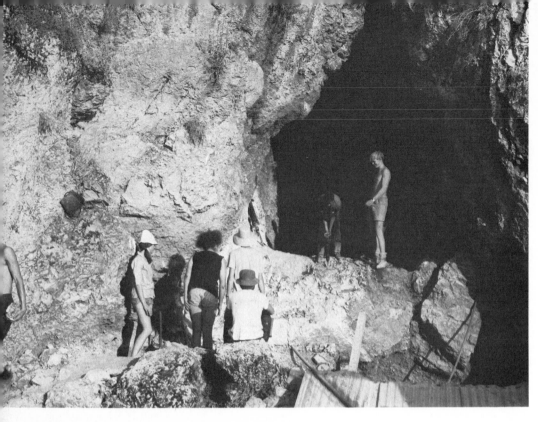

97 Working at the entrance to the cave of Kastritsa

98 Neolithic ditch (*in foreground, right of centre*) filled with debris and
exposed by gully, near Asfaka

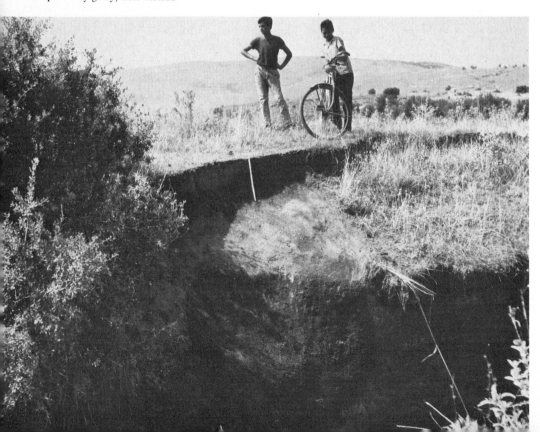

which he obtained a C14 age of 7380 ± 240 yr BP (I-1959). More-over, cemented screes were found to pass into the lake deposits that border the cave of Kastritsa. The rear of the ridge is mantled by extensive talus deposits; at Kokkinopilos itself, cemented screes can be observed interfingering with the alluvium by the limestone ridge that borders the deposit to the east.

Depositional environments

The initial impression gained from the fine-grained character of the red beds at Kokkinopilos and from their peculiar position in an elevated col had been that only wind could have been re-sponsible for their deposition, but detailed study of the gully sides was to reveal the presence of lenses and beds of gravel reflecting deposition by water. Mechanical analysis of the sedi-ment supported this view by showing that sorting was far poorer than an aeolian origin would be likely to produce, and the dis-covery of small flat-topped patches of similar material on the opposite (eastern) bank of the Louros gorge but at the same level as the original Kokkinopilos surface showed that the main deposit merely represented the eroded remains of a valley fill which had formerly occupied the entire gorge.

The form, bedding and texture of the remaining Kokkinopilos beds indicated deposition predominantly by ephemeral stream flow. The 'parent–daughter' approach was applied to a part of the Louros basin where it could be shown that a soil-filled hollow had served as the sole possible source of sediment for the Kok-kinopilos beds in the tributary draining from it. Redeposition was accompanied by depletion of clay and silt but led to little im-provement in the degree to which the sediment was sorted; this tallied with the presence of some bedding in the Kokkinopilos beds and with the evidence from alluvial fans elsewhere for deposition by stream flows in conjunction with mudflows and mass movement.

The inclusion of large quantities of scree in the Kokkinopilos deposits appeared to call for active frost-shattering. At Ioannina frost now occurs on average on $27 \cdot 6$ days each year; in the Pindus range, east of the lake, fossil cirques occur at elevations which, according to Sestini, represent a snowline depression of some 1100 m. These features have not been dated, but Sestini's value comes close to the 1200 m. estimated by Messerli for the region as a whole during the last glacial and hence at a time correspond-ing to the period of high lake level.[6]

Various attempts have been made to calculate the corresponding temperatures at Ioannina, on the assumption that the elevation of the permanent snowline was controlled primarily by the July temperature.[7] The results range from 9°C at one extreme to 13–17°C at the other for the mean July temperature, as compared with present-day values put at 32·7 and 23·8°C by different authorities. As regards winter values, it is possible to argue that the coldest month was little, if at all, colder than today, especially as Epirus was not located adjacent to a continental ice sheet, and hence that the January mean lay near 5°C; the contrary view is that the January temperature was depressed as much as the July one, and therefore lay between −3·4 and −4·9°C. All these results suggest at the very least that any snow falling at Ioannina, which now has an annual mean of 4·5 days with snow, would have persisted longer than it does today; and that the lake, which now freezes occasionally, would have done so rather more frequently. The accompanying diagram attempts to show the approximate extent of snow cover in Epirus in January and in July on the basis of mean temperatures approximately halfway between the extremes given above.

99

The pollen record obtained from two cores taken from the floor of the Ioannina basin cannot be linked intimately to the geological evidence: according to Bottema, the five radiocarbon dates available for the cores were incompletely pre-treated and therefore only represent minimum ages; and as they lie on either side of the period between 10,190 and 37,660 years ago, no simple match can be made between the pollen spectra and the lacustrine sequence. At all events, Bottema suggests that his zone V corresponds to about 15,000–32,500 years ago and that the local vegetation was dominated by *Artemisia* steppe, with a marsh flora at the coring site. The preservation of the pollen in Core I varied from good to bad and implied a fluctuating water table, just as one might expect from the character of the beaches in the cave of Kastritsa. There is no evidence that the lake was as deep as the beaches suggest, but nor is there any evidence to the contrary. A re-analysis of the preliminary pollen results was carried out by Higgs and Webley using sorted correlation coefficients and wind records (on the assumption that, as today, winds blew predominantly from the west during the seasons of pollen dispersal at the crucial period); they concluded that the record was distorted in favour of communities to the southwest, and that the conditions near Kastritsa were if anything 'cooler' than the pollen spectrum might suggest.[8]

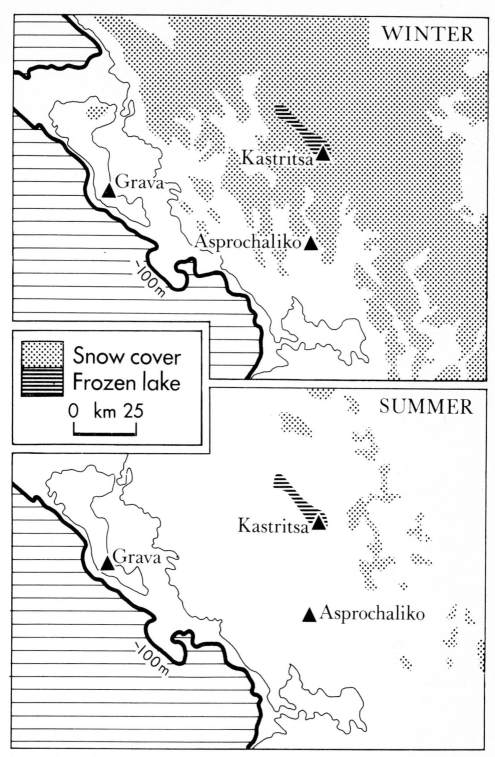

99 Summer and winter snow cover and sea level in Epirus 20,000 years
ago, reconstructed from physiographic and climatic sources

The faunal record has not been analysed in detail, but certain generalizations are possible. Kastritsa yielded deer, horse, sheep or goat, *Bos primigenius*, and bear, with Red Deer (*Cervus elaphus*) and steppe ass (*Equus hydruntinus*) predominant. At Asprochaliko, Red Deer was again dominant, but steppe ass was rare. Though hardly overwhelming, this information is in accord with the greater climatic severity postulated for the Kastritsa area. The lake beds themselves yielded *Viviparus fasciatus* (Müller), *Dreissena polymorpha* (Pallas), *Lymnaea palustris* (Müller), *Planorbis corneus* L. and *Bythinia tuberculata*, all of them fresh-water species.[9]

The form and internal character of the historical valley fills reflect floodplain deposition. When compared with the Kokkinopilos deposits their finer fractions are found to be better sorted as well as poorer in silt and clay.[10] Procopius states that floods and marshes grew more extensive in Epirus at the time of Justinian, that is, the sixth century AD. The fact that Rogous was 'the main port of call' in the Gulf of Arta during the thirteenth century AD[11] is less informative, as access could have been along the Louros by schooner, but it seems reasonable to infer that progressive silting of the Gulf played some part in demoting Rogous in favour of Preveza.

To summarize, the picture one obtains for late Palaeolithic times is of winter conditions prolonged beyond their present span and accompanied by severe frost, short-lived violent rainfalls, high lake level and perhaps a more drastic seasonal alternation of temperature than now prevails. Near the coast, however, it is reasonable to suppose that propinquity to the sea tempered any such extremes of climate and hence that the contrast between upland and lowland was also magnified during this phase. The post-classical period was apparently typified by stream aggradation which led to the partial refilling of channels cut into the Kokkinopilos land surface and the silting up of coastal embayments.

Patterns of land exploitation

To judge from our seasonal snow-cover maps, Kastritsa, when compared with Asprochaliko, appears very poorly located for winter occupation. A series of 24-hour observations on the temperature regimes of the two sites carried out by A. J. Legge[12] succeeded in going beyond the well-known fact that caves mitigate external temperature extremes by demonstrating that Asprochaliko and Kastritsa differ more than might be expected

100

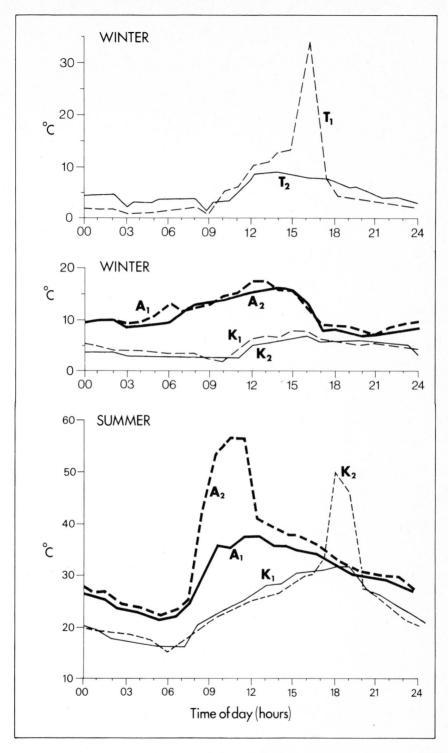

100 Cave climates: Asprochaliko (A) and Kastritsa (K). Winter temperatures
on talus of Kastritsa (T) for comparison. Solid line=air temperature;
broken line=radiant temperature; both in °C.

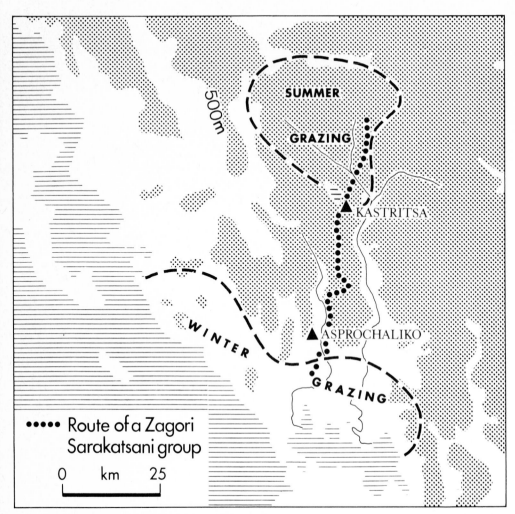

500m

SUMMER

GRAZING

▲ KASTRITSA

▲ ASPROCHALIKO

WINTER

GRAZING

••••• Route of a Zagori
Sarakatsani group

0 km 25

101 Migration routes of a Zagori Sarakatsani group set against seasonal pastures

from their different altitudes and geographical locations. In summer, black bulb (radiant) temperatures in the cave of Kastritsa were found to lie below air temperature except when the sun shone directly into the cave, and even then there was always some part of the cave in the shade. At Asprochaliko the sun could not be avoided during the day, and radiant temperatures remained above air temperatures throughout the 24-hour period thanks to the release of heat stored in the rock walls. In winter, temperatures at Kastritsa were generally lower; more important, radiation from the walls of the shelter at Asprochaliko maintained its night-time radiant temperature above air temperature. In brief, the suggestion that Kastritsa offered advantages for summer occupation and Asprochaliko for winter occupation makes sense even under present-day conditions.

Taken in conjunction with the importance of Red Deer in the economy of both sites, the environmental information invites the hypothesis that the strategy 'most favourable to human survival would have been a migratory movement of the hunting bands from the coast to the inland areas to which the game would have migrated in order to exploit the summer flush of upland grass' and a reverse move in winter to escape the hostile conditions of the Ioannina area. The ethnographic data show that the hypothesis is not unreasonable. The Zagori Sarakatsani, a semi-nomadic pastoral group, today use both Asprochaliko and Kastritsa as halting places during their spring and autumn migrations to and from the winter and summer pastures inland and on the coast – a practice also recorded in Antiquity.[13] 101

Moreover, if the behaviour of Red Deer elsewhere is any guide, the control of herds would have been least troublesome where large tracts of pasture were bordered by steep, rocky outcrops. The location of Asprochaliko immediately above the aggraded 102 floor of the Louros valley was at the time particularly advantageous in this respect. The same cannot be said of Kastritsa, but the absence of fish remains or fishhooks there suggests it was not the lake resources that attracted occupation, while traces of post holes outside the cave indicate that even as a shelter it left something to be desired.

There is ample evidence from other parts of Greece to suggest that the proposed physiographic sequence is generally valid,[14] but it remains to be seen whether other upland-lowland site complexes can be identified and interpreted in a manner analogous to that adopted for Epirus. Where external sources are of special value is in enabling the position of sea level to be specified for the period of high lake level. The outcome demonstrates without ambiguity that Corfu was then linked to the mainland and that the area of coastal lowlands was greatly enhanced. It also suggests that the late Palaeolithic shelter of Grava,[15] for example, could justifiably be included in the proposed exploitation scheme as a 'lowland' site.

As regards the historical deposit, the numerous parallels from elsewhere in Greece reinforce the case for a climatic, as opposed to an anthropogenic, origin for the erosion that supplied the requisite sediment. Indeed the dates available for the Epirote fills contribute to a time-transgressive pattern which could be taken to reflect a progressive southward shift in the European cyclonic belts whose outcome was to promote less 'flashy' stream regimes than now prevail.[16]

In any case, it is debatatable how far the progressive build-up to the valley floors at the expense of the more patchy and shallow upland soils represents impoverishment: once drained, the new Plain of Arta could support much greater population densities than was possible inland. Again, the fact that Epirus appears to have been more thickly populated in pre-Roman times does not necessarily imply a progressive loss of soil fertility. The two items that loom large in accounts of the area are cattle and dairy products, and fish; and one can see how both could be restored to their former levels without necessarily replacing the soils on the bare slopes. Indeed it should by now be abundantly clear that the erosion that bared the hillsides of Epirus took place largely in Palaeolithic times and that the geological changes of the historical period were if anything agriculturally beneficial.

Opposite: 102 View of the Louros valley from Asprochaliko, showing narrow alluvial terrace beyond the river

10

Epilogue

In any study of sites in their setting the flow of information between archaeology and the earth sciences will inevitably be two-way. Judson's study of erosion rates near Rome brought together measurements of suspended sediment in streams since 1936 and mean values derived from the depth to which ancient structures had been exposed or buried.[1] Our understanding of soil development and peat initiation has benefited from knowledge of human activity during the crucial periods.[2] We have already seen how the evolution of coastal settlements is not to be scorned as a clue to sea-level chronology. The evidence for recent fault movement on the Israeli coast includes the submerged Herodian harbour of Caesarea and the relationship of shell beds dated by C14 to sites ranging in age from Roman to Crusader.[3] But, as the controversy that still surrounds this particular issue amply demonstrates, even when the archaeological contribution is purely chronological the scope for diverse interpretations is large. Consider then the fragility of a physiographic reconstruction which rests on any other item in the archaeological repertoire.

The alarm has been sounded more than once. In the study of seismicity, the period covered by modern instrumental records is far too short for the statistical analyses required by any attempt at prediction, and the historical record alone can help to put things right. Yet changes in architectural and engineering practice may mean that the record is wrongly read: an earthquake which did little damage in a fifth-century city could well prove very destructive today. Conversely, because a few ancient monuments are still standing it does not follow that damaging earthquakes have not there taken place, as it could be that only the more resistant structures were spared.[4]

The risks here can be circumvented by blending scepticism with care, as witness the studies of earthquakes in ancient Cyrenaica by R. G. Goodchild. At Cyrene the fallen columns

Opposite: 103 The site of Cyrene, Libya, which has yielded traces of ancient earthquakes

of the Temple of Zeus had been linked by previous workers to an earthquake in about AD 180. Excavation then yielded an inscription which stated that Jewish insurgents had been responsible for overturning them (in AD 115) and showed that the columns had been undercut and underpinned with timber props which were then set alight to bring the columns down in unison. At El-Beida, a coin hoard lying close to a skeleton crushed by fallen masonry enabled Goodchild to infer that a violent earthquake known from numerous literary sources and dated to AD 365 had left its mark at this site as well as elsewhere in Cyrenaica.[5]

Other items, however, appear to elude a single interpretation acceptable to all. The view that a flood of 'unprecedented magnitude' had occurred at Mohenjo-daro was supported by alluvial beds lying well above the bed of the Indus; a critic has suggested that one of the key deposits consists of mud-brick.[6] At Gafsa, in Tunisia, Acheulian artefacts are held by some workers to occur within a series of steeply-folded gravel beds and hence to antedate their deformation; others claim that the artefacts are confined to a superficial crust which overlies the folded beds.[7] The reader will be astonished: can it be so difficult to differentiate between alluvium and rotten bricks? Why not use a bulldozer to resolve the Gafsa problem once and for all? But, as things stand, the ambiguities persist; and, like the archaeologist looking for a eustatic curve, the earth scientist will, in all good faith, go to the source that appears to him the most authoritative without any desire to embroil himself in internecine bickering.

There is clearly scope for an archaeological input into geology and geomorphology – and other fields besides – which is self-sufficient and which boasts the highest standards attainable at the time. The archaeologist alone can supply the sections – chronological data banks – which other fields crave; there is no reason why their location should remain confined to sites dominated by human debris.

This activity is perfectly compatible with the integrated approach espoused by this book. Now the archaeologist may resent another attempt to sell him a subject, another arrow in his overstuffed quiver. He may fear that the natural sciences will 'go on to monopolize a field which does not strictly belong to them – the study of Man as reflected in the work of his brain and hands'.[8] Yet there is nothing to stop him moulding physiography to his needs, in the knowledge that expert assistance can always be called in when it comes to checking and amplifying his conclusions.[9]

Those who scorn 'amateurism' may need to be reminded that a training in physiography is not acquired from books (let alone an undergraduate degree) but from sustained fieldwork, and that some of the least helpful and at times most misleading literature on the subject has been produced by 'professionals'. It is only when principles and conclusions are ingested uncritically that the multidisciplinary approach deserves the label of 'interdilettante';[10] and the presentation of one's own findings without the protection afforded by appeals to the authority of others can do wonders for the digestive juices.

Moreover there is no way of investigating the setting of a site or site complex which is wholly sterile. Compare Wheeler's dictum: 'There is no right way of digging, but there are many wrong ways.'[11] Whereas a badly conducted excavation will destroy even more evidence than one which adheres to the highest contemporary standards (as well as yielding less information), a shoddy study of the setting will at worst damage reputations. But there is a more important difference between the two operations. Excavation cannot afford to fail, and certain canons of excellence are within the reach of most excavators; there is everything to be said for experimentation and the occasional failure in its environmental counterpart.

What of the sterility of materialism? If the ash of Santorini did bring about the complete breakdown of Minoan civilization (we are cautioned by a historian), 'then all the painful efforts of nearly a century to seek historical explanations, that is to say explanations according to human behaviour, wars, revolutions and the rest, have been an unnecessary exercise'.[12] To which we may reply that, whether or not Santorini had any such effect (and, as we have seen, it appears unlikely), the verdict owes nothing to the painfulness of our predecessors' endeavours.

Notes

Chapter 1

1 Sir M. Wheeler quoted in *Observer Magazine*, 23.4.72. Compare Pl. IV in E. G. J. Amos and R. E. M. Wheeler, 'The Saxon-Shore Fortress at Dover', *Arch. J.* *86*, 1929, pp. 47–58, with Fig. 32 in S. Johnson, *The Roman Forts of the Saxon Shore*, London 1976
2 Sir M. Wheeler, *Archaeology from the Earth*, Oxford 1954, p. 4. See also J. Bradford, *Ancient Landscapes*, London 1957, pp. vii ff.
3 L. Woolley, *Digging up the Past*, 2nd edn (1st edn 1930), Harmondsworth 1960, pp. 35–6.
4 M. C. Burkitt, *Prehistory* (2nd edn), Cambridge 1925, p. viii.
5 K. M. Kenyon, *Beginning in Archaeology* (2nd edn), London 1961, pp. 27–8.
6 R. J. Braidwood, 'Greetings', *Paleorient* *1*, 1973, pp. 7–10.
7 F. Hole and R. F. Heizer, *An Introduction to Prehistoric Archaeology* (2nd edn), New York 1969.
8 cf. G. Daniel, *The Idea of Prehistory*, Harmondsworth 1964.
9 J. Needham, *Science and Civilisation in China*, vol. 2, Cambridge 1956, p. 45.
10 C. Vita-Finzi, 'Geological opportunism', *in* P. J. Ucko and G. W. Dimbleby (eds), *The Domestication and Exploitation of Plants and Animals*, London 1969, pp. 31–4.
11 K. W. Butzer, 'Archaeology and geology in ancient Egypt', *in* J. R. Caldwell (ed.), *New Roads to Yesterday*, New York and London 1966, p. 217.
12 For Western viewpoints see C. J. Glacken, *Traces on the Rhodian Shore.* Berkeley and Los Angeles 1967; for their Chinese counterparts see Needham, *op. cit.* (note 9 above).
13 K. W. Butzer, 'Physical conditions in eastern Europe, western Asia and Egypt before the period of agricultural and urban settlement', *Cambridge Ancient History*, vol. I, ch. 2, 39 pp.
14 See M. I. Finley, 'Back to Atlantis', *New York Review of Books*, 4.12.69, p. 51, and H. G. Wunderlich, *The Secret of Crete*, London 1976, p. 127.
15 See G. Daniel, *150 Years of Archaeology* (2nd edn), London 1975.
16 The section that follows summarizes the writer's *Recent Earth History*, London and New York 1973.
17 T. Heyerdahl, *Sea Routes to Polynesia*, Futura 1974, p. 139.
18 C. Vita-Finzi, 'Late Quaternary alluvial chronology of northern Algeria', *Man* 2, 1967, pp. 205–15.
19 C. Vita-Finzi, 'Late Quarternary alluvial chronology of Iran', *Geol. Rdsch.* 58, pp. 951–73.
20 C. Vita-Finzi, 'Observations on the Late Quaternary of Jordan', *Palest. Explor. Q.* 45, 1964, pp. 19–33.
21 L. Copeland and C. Vita-Finzi, 'Archaeological dating of deposits in Jordan', *Levant* (in press).

Chapter 2

1 P. B. Medawar, *The Hope of Progress*, London 1972, p. 65.
2 K. W. Butzer, *Environment and archaeology* (2nd edn), London 1971, pp. 7, 238; 'Archaeology and geology in ancient Egypt', *in* J. R. Caldwell (ed.), *New Roads to Yesterday*, New York and London 1966, p. 210.

3 M. D. Coe and K. V. Flannery, 'Microenvironments and mesoamerican prehistory', *in* Caldwell (*op. cit.*), pp. 348–59.

4 D. Q. Bowen, 'The palaeoenvironment of the "Red Lady" of Paviland', *Antiquity* XLV, June 1970, pp. 134–6.

5 C. Vita-Finzi and E. S. Higgs, 'Prehistoric economy in the Mount Carmel area of Palestine: site catchment analysis', *Proc. prehist. Soc.* 36, 1970, pp. 1–37; E. S. Higgs and C. Vita-Finzi, 'Prehistoric economies: a territorial approach', *in* E. S. Higgs (ed.), *Papers in Economic Prehistory*, Cambridge 1972, pp. 27–36. Many colleagues contributed to the development of this approach, in particular P. L. Carter, J. Harriss, H. N. Jarman, M. R. Jarman, A. J. Legge, D. A. Sturdy, H. Tippett and D. Webley.

6 R. B. Lee, '!Kung Bushman subsistence: an input-output analysis', *in* A. P. Vayda (ed.), *Environment and Cultural Behaviour*, New York 1969, pp. 47–79.

7 M. Chisholm, *Rural Settlement and Land Use* (2nd edn), London 1968, pp. 66, 131.

8 P. A. Jewell, 'The concept of home range in mammals', *Symp. Zool. Soc. Lond.* no. 18, 1966, pp. 85–109.

9 D. A. Sturdy, 'The exploitation patterns of a modern reindeer economy in west Greenland', *in* E. S. Higgs (ed.), *Papers in Economic Prehistory*, Cambridge 1972, pp. 161–8. For a constructive and readable critique of site catchment analysis in a Mexican context, see K. V. Flannery (ed.), *The Early Mesoamerican Village*, New York 1976.

10 G. Clark, 'Prehistoric Europe: the economic basis', *in* G. R. Willey (ed.), *Archaeological Researches in Retrospect*, Cambridge, Mass. 1974, pp. 33–57.

11 For an example of drainage systems as 'natural barriers to gene flow' see N. G. White and P. A. Parsons, 'Population genetic, social, linguistic and topographical relationships in north-eastern Arnhem Land, Australia', *Nature* 261, 1976, pp. 223–5.

12 J. G. Evans, *The Environment of Early Man in the British Isles*, London 1975, p. 43, Fig. 17.

Chapter 3

1 A. Geikie, *Landscape in History*, London 1905, pp. 8–10.

2 M. I. Finley, 'Atlantis or bust', *New York Review of Books*, 22 May 1969, pp. 38–40.

3 A. Stein, *Old Routes of Western Iran*, London 1940, p. vii.

4 A. Stein, *Archaeological Reconnaissances in North-Western India and South-Eastern Iran*, London 1937, pp. 238–40.

5 R. L. Raikes, 'Beidha – prehistoric climate and water supply', *in* D. Kirkbride, 'Five seasons at the pre-pottery Neolithic village of Beidha in Jordan', *Pal. Explor. Q.* 98, 1966, pp. 68–72, and R. L. Raikes, *Water, Weather and Prehistory*, London 1967, pp. 148–9, 172–4.

6 For details and references see C. Vita-Finzi, 'Recent alluvial history of the southern Plateau of Mexico', *Geol. Rdsch.* 66, 1976, pp. 99–120.

7 M. D. Coe and K. V. Flannery, 'Microenvironments and mesoamerican prehistory', *in* J. R. Caldwell (ed.), *New Roads to Yesterday*, New York and London 1966, pp. 348–59.

8 D. S. Byers (ed.), *The Prehistory of Tehuacan Valley*, Vol. I, Austin and London 1967.

9 C. Vita-Finzi, 'Diachronism in Old World alluvial sequences', *Nature* 263, 1976, pp. 218–19.

10 L. Deuel, *Flights into Yesterday*, Harmondsworth 1973, p. 253.

11 C. Lyell, *Principles of Geology* (11th edn), London 1872, Vol. 2, p. 519.

12 For details and references see C. Vita-Finzi, *The Mediterranean Valleys*, Cambridge 1969; and *in* C. Gray (ed.), *Geology of Libya*, Tripoli 1971, pp. 409–29.

13 D. Oates, 'The Tripolitanian Gebel: settlement of the Roman period around Gasr ed-Dauun', *Pap. Brit. Sch. Rome* XXII (n.s. vol. IX), 1954, pp. 81–117.

14 '... la vallée était déjà à cette époque [l'âge du renne] dans son état actuel', E.

Massenat, Ph. Lalande and E. Cartailhac, 'Découverte d'un squelette humain de l'âge du Renne', *in* H. du Cleuziou, *La Création de l'Homme*, Paris 1887, pp. 572–5. Laugerie-Basse had been discovered in 1862.

15 P. Fénelon, *Le Périgord. Étude Morphologique*, Paris 1951; M. Bourgon, 'Les industries moustériennes et pre-moustériennes du Périgord', *Archives Inst. Paléont. hum.*, Mem. 27, Paris 1957. An interesting aside is made by Fénelon (p. 285) when he observes that the river beds occupied by Mousterian man had been stripped clear of sediment whereas those known to the 'Acheulians' were some 20 m. shallower than they are today.

16 F. Bordes, 'On the chronology and contemporaneity of different palaeolithic cultures in France', *in* C. Renfrew (ed.), *The Explanation of Culture Change: Models in Prehistory*, London 1973, pp. 217–26.

17 For details and references see C. Vita-Finzi, 'Age of valley deposits in Périgord', *Nature* 250, 1974, pp. 568–70; P. E. L. Smith, 'The Solutrean culture', *Sci. Amer.* 211, 1969, pp. 85–94. Our Montignac unit encompasses the bulk of the *alluvions anciennes* and some of the *alluvions modernes* of the *Carte Géologique*, and part of the high and low terraces and most of the *dépôts de pente* of Bourgon.

18 P. A. Mellars, 'The character of the middle-upper palaeolithic transition in south-west France', *in* Renfrew 1973 (see note 16 above), pp. 255–76.

19 Restated in these terms, the data in Mellars' Table 1, which yielded the percentages cited earlier, give the following percentages: Mousterian, 41; Chatelperronian, 50; Aurignacian, 79·4; Upper Perigordian, 78·2; Solutrean, 100; Magdalenian, 95·5.

20 L. R. Binford, 'Interassemblage variability – the Mousterian and the 'functional argument', *in* Renfrew 1973 (see note 16 above), pp. 227–54.

21 E. S. Burch, Jr, 'The Caribou/Wild Reindeer as a human resource', *Am. Antiq.* 37, 1972, pp. 339–68.

22 D. A. Sturdy, 'The exploitation patterns of a modern reindeer economy in west Greenland', *in* E. S. Higgs (ed.), *Papers in Economic Prehistory*, Cambridge 1972, p. 164.

Chapter 4

1 For details and references see N. C. Flemming, 'Archaeological evidence for eustatic change of sea-level and earth movements in the western Mediterranean during the last 2000 years', *Spec. Pap., geol. Soc. Am.* 109, 1969.

2 See, for example, C. Lyell, *Principles of Geology*, London, 1830–3.

3 C. B. McBurney and R. W. Hey, *Prehistory and Pleistocene Geology in Cyrenaican Libya*, Cambridge 1955, p. 162.

4 H. A. McClure, 'Radiocarbon chronology of late Quaternary lakes in the Arabian Desert', *Nature* 263, 1976, p. 755.

5 C. Vita-Finzi, 'Late Quaternary continental deposits of central and western Turkey', *Man* 4, 1969, pp. 605–19.

6 G. Plafker, 'Tectonic deformation associated with the 1964 Alaska earthquake', *Science N.Y.* 148, 1965, pp. 1675–87.

7 D. Bowman, 'Geomorphology of the shore terraces of the late Pleistocene Lisan Lake (Israel)', *Palaeogeography, Palaeoclimatol., Palaeocol.* 9, 1971, pp. 183–209.

8 R. W. van Bemmelen, 'The influence of geologic events on human history', *Verh. Geol. Mijnb. Gen.*, Geol. Ser. 16, 1956, pp. 1–36.

9 G. F. Dales, 'Harappan outposts on the Makran coast', *Antiquity* XXXVI, 1962, pp. 86–92; R. L. Raikes, 'The end of the ancient cities of the Indus', *Amer. Anthrop.* 66, 1964, pp. 284–99.

10 R. W. Fairbridge, 'Shellfish-eating Preceramic Indians in coastal Brazil', *Science N.Y.* 191, 1976, pp. 353–9.

11 W. C. Brice, 'The Turkish colonization of Anatolia', *Bull. John Rylands Lib.*, 38, 1955, pp. 18–44; M. F. Hendy, 'Byzantium, 1081–1304: an economic reappraisal', *Trans. Roy. Hist. Soc.* 19, 1969, pp. 31–52.

12 K. W. Butzer, G. J. Fock, R. Stuckenrath and A. Zilch, 'Palaeohydrology of Late Pleistocene Lake, Alexandersfontein, Kimberley, South Africa', *Nature* 243, 1973, pp. 328–30; J. M. Bowler, A. G. Thorne and H. A. Plach, 'Pleistocene Man in Australia: age and significance of the Mungo skeleton', *Nature* 240, 1972, pp. 48–50; R. Huckriede and G. Wisemann, 'Der jungpleistozäne Pluvial – See von El Jafr und weitere Daten zum Quartär Jordaniens', *Geologica et Palaeontologica* 2, 1968, pp. 73–95; L. H. Barfield, 'Recent discoveries in the Atacama Desert and the Bolivian Altiplano', *Amer. Antiq.* 27, 1961, pp. 93–100.

13 H. Müller-Beck, 'Prehistoric Swiss lake dwellers', *Sci. Amer.* 205, 1961, pp. 138–47.

14 A. E. Gunther, 'Re-drawing the coastline of South Italy', *Illus. London News* 246, 1964, pp. 86–9; 'Historical marine levels in South Italy', *Nature* 201, 1964, pp. 909–10; Fleming, *op. cit.* (note 1 above), pp. 47–9; C. Vita-Finzi, 'Historical marine levels in Italy', *Nature* 209, 1966, p. 996.

15 H. G. Wunderlich, *The Secret of Crete*, London 1976, p. 112.

16 R. F. Black, 'Late Quaternary sea level changes, Umnak Island, Aleutians – their effects on ancient Aleuts and their causes', *Quat. Res.* 4, 1974, pp. 264–81; 'Geology of Umnak Island, eastern Aleutian Islands as related to the Aleuts', *Arctic & Alpine Res.* 8, 1976, pp. 7–35.

17 G. Bibby, *Looking for Dilmun*, Harmondsworth 1972.

18 For details and references, see C. Vita-Finzi, 'Environmental history', *in* B. de Cardi, *Qatar*, Oxford (in press).

19 The glacial interpretation is cited by K. O. Emery, 'Sediments and water of the Persian Gulf', *Bull. Am. Ass. Petrol. Geol.* 30, 1956, pp. 2354–83 (ref. on p. 2355). For a review of earlier literature and details of the data summarized here, see P. F. Cornelius *et al.*, 'The Musandam Expedition 1971–72: Scientific Results, Part I', *Geogrl J.* 139, 1973, pp. 414–21; B. de Cardi, 'Archaeological survey in northern Oman,

1972', *East and West* 25, 1975, pp. 9–74. For the raised beaches see K. W. Glennie, *Desert Sedimentary Environments*, London 1970. For Old Hormuz, see A. Stein, *Archaeological reconnaissances in northwestern India and south-eastern Iran*, London 1937, p. 185.

20 M. Sarnthein, 'Sediments and history of the postglacial transgression in the Persian Gulf and northwest Gulf of Oman', *Marine Geol.* 12, 1972, pp. 245–66. For further details see articles in B. H. Purser (ed.), *The Persian Gulf*, Berlin 1973.

21 The lyrical description of the Gulf plain comes from A. Holmes, *Principles of Physical Geology* (1st edn), London 1944, p. 417.

Chapter 5

1 K. W. Butzer, 'Archaeology and geology in ancient Egypt', *in* J. R. Caldwell (ed.), *New Roads to Yesterday*, New York and London 1966, p. 215.

2 M. W. Thompson, note on p. 91 of his translation of A. L. Mongait, *Archaeology in the USSR*, Harmondsworth 1961.

3 G. W. Dimbleby and M. C. D. Speight, 'Buried Soils', *Adv. Sci.* 26, 1969, pp. 203–5.

4 G. R. Clarke, *The Study of the Soil in the Field* (5th edn), Oxford 1971.

5 For details see R. U. Cooke and J. C. Doornkamp, *Geomorphology in Environmental Management*, Oxford 1974, Ch. 13.

6 H. G. Wunderlich, *The Secret of Crete*, London 1976, p. 107.

7 J. Needham, *Science and Civilization in China*, vol. 3, Cambridge 1959, p. 501; K. D. White, *Roman Farming*, London 1970.

8 J. G. Evans, *The Environment of Early Man in the British Isles*, London 1975, p. 137.

9 Most of the required techniques are to be found in British Standards Institution, *Methods of Test for Soils for Civil Engineering Purposes*, BS 1377, London 1975, and the manuals of the US Soil Conservation Service.

10 M. R. Jarman and D. Webley, 'Settlement and land use in Capitanata, Italy', *in*

E. S. Higgs (ed.), *Palaeoeconomy*, Cambridge 1974, pp. 177–221; R. W. Dennell and D. Webley, 'Prehistoric settlement and land use in southern Bulgaria', *ibid.*, pp. 97–109.

11 Varro, *de rerum rusticarum* (tr. by W. D. Hooper), London 1960, I, ix, pp. 203–4. The translator uses 'rocky' for *lapidosa*; 'stony' would seem more apt.

12 K. V. Flannery, A. V. T. Kirkby, M. J. Kirkby and A. W. Williams, Jr, 'Farming systems and political growth in ancient Oaxaca', *Science N.Y.* 158, 1967, pp. 445–54.

13 T. Jacobsen and R. M. Adams, 'Salt and silt in ancient Mesopotamian agriculture', *Science N.Y.* 128, 1958, pp. 1251–8; A. Hardan, 'Archaeological methods for dating of soil salinity in the Mesopotamian Plain', *in* D. H. Yaalon (ed.), *Paleopedology*, Jerusalem 1971, pp. 181–7; comments by D. H. Yaalon and J. J. Reynders, *ibid.*

14 D. Webley, 'Soils and site location in prehistoric Palestine' *in* E. S. Higgs (ed.), *Papers in Economic Prehistory*, Cambridge 1972, pp. 169–80; cf. E. W. Russell, *Soil Conditions and Plant Growth* (10th edn), London 1973.

15 V. C. Robertson and R. F. Stoner, 'Land use surveying: a case for reducing the costs', *in* I. H. Cox (ed.), *New possibilities and techniques for land use and related surveys*, Berkhamsted 1970, pp. 3–15.

16 B. J. Meggers, 'Environmental limitation on the development of culture', *in* J. B. Bresler (ed.), *Human Ecology*, Reading, Mass. 1966, pp. 120–45.

17 J. S. Bibby and D. Mackney, 'Land use capability classifications', *Soil Survey Technical Monog. 1*, Aberdeen and Harpenden, 1969.

18 See, for example, E. C. Saxon, *Prehistoric Economies of the Israeli and Algerian littorals: 18,000–8000 B.P.*, unpublished Ph.D. thesis, Cambridge University, 1975.

19 J. Kostrowicki, 'Data requirements for land use survey maps', *in* Cox 1970 (see note 15 above), pp. 73–84.

20 Cooke and Doornkamp 1974 (see note 5 above), p. 341.

21 L. D. Stamp, 'The measurement of land resources', *Geogrl Rev.* 48, 1958, pp. 1–15. It may be helpful to note that in Britain, under efficient mixed farming, one acre of improved land can be made to produce 1 SNU.

22 D. G. Vilenskii, *Soil Science* (3rd edn), Israel Prog. for Scient. Trans., Jerusalem 1963, p. 231.

23 See, for example, A. Issar, 'Geology of the Coastal Plain of Israel', *Israel J. Earth-Sci.* 17, 1968, pp. 16–29; F. E. Zeuner, 'The shore-line chronology of the Palaeolithic of Abri Zumoffen, Adlun Caves, Lebanon', *Bull. Musée Beyrouth* 16, 1961, pp. 49–60; D. Neev *et al.*, 'The geology of the eastern Mediterranean', *Bull. geol. Surv. Israel* 68, 1976, pp. 1–51.

24 D. A. E. Garrod, 'The Middle Palaeolithic of the Near East and the problem of Mount Carmel Man', *J. Roy. anthrop. Inst.* 92, 1962, pp. 241–2.

25 W. R. Farrand and A. Ronen, 'Observations on the Kurkar-Hamra succession on the Carmel Coastal Plain', *Tel Aviv* I, 1974, pp. 45–54. The chronology offered here departs from that of Farrand and Ron_n.

26 Garrod 1962 (see note 24 above); Saxon 1975 (see note 18 above), p. 31a.

27 D. Nir, 'Artificial outlets of the Mt. Carmel valleys', *Israel Explor. J.* 9, 1959, pp. 46–54.

28 D. A. E. Garrod and D. M. A. Bate, *The Stone Age of Mount Carmel: I*, London 1937.

29 E. C. Saxon, 'The mobile herding economy of Kebarah Cave, Mt. Carmel: an economic analysis of the faunal remains', *J. Archaeol. Sci.* 1, 1974, pp. 27–45.

30 C. Vita-Finzi and E. S. Higgs, 'Prehistoric economy in the Mount Carmel area of Palestine: site catchment analysis', *Proc. prehist. Soc.* 36, 1970, pp. 1–37.

Chapter 6

1 *The Times*, 12.9.1974. This is not to endorse the increasing use of Munsell or analogous colour charts, as they give read-

ings which vary according to time of day, moisture content and observer.

2 F. H. Brown, 'Radiometric dating of sedimentary formations in the Lower Omo Valley, Ethiopia', *in* W. W. Bishop and J. A. Miller (eds), *Calibration of Hominoid Evolution*, Edinburgh 1972, pp. 273–87.

3 J. F. Evernden and G. H. Curtis, 'The Potassium-Argon dating of Late Cenozoic rocks in East Africa and Italy', *Curr. Anthrop.* 6, 1965, pp. 343–85.

4 An entertaining and judicious introduction to the study of depositional evidence is R. C. Selley, *Ancient Sedimentary Environments*, London 1970.

5 G. Caton-Thompson and E. W. Gardner, 'Climate, irrigation, and early man in the Hadhramaut', *Geogrl J.* 93, 1939, pp. 18–38.

6 Sedimentary structures are discussed with a wealth of illustration in H. E. Reineck and I. B. Singh, *Depositional Sedimentary Environments*, Berlin 1975.

7 R. L. Hay, 'Lithofacies and environment of Bed I, Olduvai Gorge, Tanzania', *Quat. Res.* 3, 1973, pp. 541–60; L. Picard and U. Baida, *Geological Report on the Lower Pleistocene Deposits of the 'Ubeidiya Excavations*, Israel Acad. Sci. Hum., Jerusalem 1966.

8 V. R. Baker, 'Paleohydrologic interpretation of Quaternary alluvium near Golden, Colorado', *Quat. Res.* 4, 1974, pp. 94–112; L. K. Lustig, 'The geomorphic and paleoclimatic significance of alluvial deposits in southern Arizona: a discussion', *J. Geol.* 74, 1966, pp. 95–102.

9 R. V. Ruhe, G. A. Miller and W. J. Vreeken, 'Paleosols, loess sedimentation and soil stratigraphy', *in* D. H. Yaalon (ed.), *Paleopedology*, Jerusalem 1971, pp. 41–60.

10 N. J. Shackleton and C. Turner, Correlation between marine and terrestrial Pleistocene successions, *Nature* 216, 1967, pp. 1079–82.

11 See E. McM. Larrabee, 'Ephemeral water action preserved in closely dated deposit', *J. sedim. Petrol.* 32, 1962, pp. 608–9.

12 K. Bryan, 'The geology of Chaco Canyon, New Mexico', *Smithsonian Misc. Coll.* 127, No. 7, 1954.

13 C. Vita-Finzi, 'Late Quaternary alluvial chronology of Iran', *Geol. Rdsch.* 58, 1969, pp. 951–73; 'Heredity and environment in clastic sediments: silt/clay depletion', *Bull. geol. Soc. Am.* 82, 1971, pp. 187–90.

14 D. Price Williams, 'Environmental archaeology in the western Negev', *Nature* 242, 1973, pp. 501–3.

15 F. Petrie, *Gerar*, London 1928.

16 R. F. Flint, *Glacial and Quaternary Geology*, New York 1971, pp. 251–2.

17 L. Picard and P. Solomonica, 'On the geology of the Gaza–Beersheba district', *Bull. Geol. Dep. Hebr. Univ. Jerusalem* 2, 1936, pp. 1–44. See also L. Picard, 'Geomorphogeny of Israel: Part I – the Negev', *Bull. Res. Council Israel* 1, 1951, pp. 5–32; D. Nir, 'Remarques sur le Quaternaire de la plaine côtière du Néguev septentrional (Israël)', *Bull. Ass. géogr. Fr.* 352–3, 1967, pp. 2–10.

18 R. Ravikovitch, Soil Map, *Atlas of Israel*, Jerusalem 1970; D. H. Yaalon and J. Dan, 'Accumulation and distribution of loess-derived deposits in the semi-desert and desert fringe areas of Israel', *Z. Geomorph.*, Suppl. 20, 1974, pp. 91–105.

19 I. J. Smalley and C. Vita-Finzi, 'The formation of fine particles in sandy deserts and the nature of "desert" loess', *Jour. sedim. Petrol.* 38, 1968, pp. 766–74; I. J. Smalley (ed.), *Loess: Lithology and Genesis*, Stroudsburg 1975.

20 J. G. Andersson, *Children of the Yellow Earth*, London 1934, pp. 131, 142 and 143. The descriptions refer to loess deposition in China.

21 J. Dan and D. H. Yaalon, 'On the origin and nature of the paleopedological formations in the coastal desert fringe areas of Israel', *in* D. H. Yaalon (ed.), *Paleopedology*, Jerusalem 1971, pp. 245–60.

22 D. Price Williams, 'The environmental background of prehistoric sites in the Fara region of the western Negev', *Bull. Inst. Arch. Lond.* 12, 1975, pp. 125–43.

Chapter 7

1 For details of some of these see for example D. Brothwell and E. S. Higgs (eds), *Science in Archaeology* (2nd edn), London 1969.

2 B. Kurtén, *Pleistocene Mammals of Europe*, London 1968, p. 25.

3 A. Horowitz, 'Preliminary palaeoenvironmental implications of pollen analysis of Middle Breccia from Sterkfontein', *Nature* 258, 1975, pp. 417–18; S. Bottema, 'The interpretation of pollen spectra from prehistoric settlements (with special attention to Liguliflorae)', *Palaeohistoria* 17, 1975, pp. 17–35.

4 I am indebted to Mrs Juliet Prior for this information.

5 J. W. Murray and A. B. Hawkins, 'Sediment transport in the Severn Estuary during the past 8000–9000 years', *J. geol. Soc. Lond.* 132, 1976, pp. 385–98.

6 J. Boulaine, *Etude sur les sols des plaines du Chélif*, Trav. Sect. Agrol. Pedol., Et. Reg. no. 7, Algiers 1957, p. 91; S. Judson and A. Kahane, 'Underground drainageways in southern Etruria and northern Latium', *Pap. Brit. Sch. Rome* 31, 1963, pp. 74–99.

7 C. Delano Smith, 'The Tavoliere of Foggia (Italy): an aggrading coastland and its early settlement patterns', *in* D. A. Davidson and M. L. Shackley (eds), *Geoarchaeology*, London 1976, pp. 197–212.

8 N. Shackleton, 'Stable isotope study of the palaeoenvironment of the Neolithic site of Nea Nikomedeia, Greece', *Nature* 227, 1970, pp. 943–4; cf. J. Bintliff, 'The Plain of Western Macedonia and the Neolithic site of Nikomedeia', *Proc. prehist. Soc.* 42, 1976, pp. 241–62.

9 L. B. Leopold and J. P. Miller, 'A Postglacial chronology for some alluvial valleys in Wyoming', *U.S. Geol. Surv. Water-Supply Pap.* 1261, 1954. The carbonate content was determined in the laboratory by a standard volumetric technique which took about five minutes per sample.

10 C. B. M. McBurney and R. W. Hey, *Prehistory and Pleistocene Geology in Cyrenaican Libya*, Cambridge 1955, p. 119.

11 A. T. Wilson and M. J. Grinsted, 'Palaeotemperatures from tree rings and the D/H ratio of cellulose as a biochemical thermometer', *Nature* 257, 1975, pp. 387–8.

12 The reference to the Maglemose Culture comes from F. E. Zeuner, *Dating the Past* (4th edn), London 1958, p. 405. For *Ancylus* see J. G. Evans, *Land Snails in Archaeology*, London and New York 1972, pp. 130–2.

13 B. W. Sparks *in* C. Vita-Finzi, 'Observations on the late Quaternary of Jordan', *Palest. Explor. Q.* 15, 1965, pp. 32–3; C. Vita-Finzi and G. W. Dimbleby, 'Medieval pollen from Jordan', *Pollen et Spores* 13, 1971, pp. 415–20.

14 F. Hole, K. V. Flannery and J. A. Neely, 'Prehistory and human ecology of the Deh Luran Plain', *Mem. Mus. Anthrop., Univ. Michigan* 1, 1969, pp. 33–4.

15 R. L. Raikes, 'The ancient Gabarbands of Baluchistan', *East and West* 14, 1965, pp. 3–12; C. Vita-Finzi, 'Roman dams in Tripolitania', *Antiquity* XXXV, Mar. 1961, pp. 14–20; C. Vita-Finzi and O. Brogan, 'Roman dams on the Wadi Megenin', *Libya Antiqua* 2, 1966, pp. 65–71; H. W. Underhill, 'Carbonate scale in Roman and modern canals in the Jordan Valley', *J. Hydrol.* 7, 1969, pp. 389–403; M. Evenari, L. Shanan, N. Tadmor and Y. Aharoni, 'Ancient agriculture in the Negev', *Science N.Y.* 133, 1961, pp. 979–96; G. B. D. Jones and J. H. Little, 'Coastal settlement in Cyrenaica', *J. Rom. Stud.* 61, 1971, pp. 64–79, for the Hadrianopolis aqueduct.

16 W. H. Zagwijn, 'Variations in climate as shown by pollen analysis especially in the Lower Pleistocene of Europe', *in* A. E. Wright and F. Moseley (eds), *Ice Ages: Ancient and Modern*, Liverpool 1975, pp. 137–52.

17 R. S. Solecki and A. Leroi-Gourhan, 'Palaeoclimatology and archaeology in the Near East', *Ann. N.Y. Acad. Sci.* 95, 1961, pp. 729–39.

18 G. W. Dimbleby, 'Archaeological evi-

dence of environmental change', *Nature* 256, 1975, pp. 265–7.

19 J. S. Mellett, 'Scatological origin of microvertebrate fossil accumulations', *Science N.Y.* 185, 1974, pp. 349–50.

20 F. Klein, 'Ice-Age hunters of the Ukraine', *Sci. Amer.* 23, 1974, pp. 95–105.

21 J. M. Coles and E. S. Higgs, *The Archaeology of Early Man*, London 1969, p. 193; E. S. Higgs, 'Environment and chronology: the evidence from mammalian fauna', *in* C. B. M. McBurney, *The Haua Fteah (Cyrenaica)*, Cambridge 1967, pp. 16–44.

22 J. D. Speth and D. D. Davis, 'Seasonal variability in early hominid predation', *Science N.Y.* 192, 1976, pp. 441–5.

23 N. J. Shackleton, 'Oxygen isotope analysis as a means of determining season of occupation of prehistoric midden sites', *Archaeometry* 15, 1973, pp. 133–41; W. Shawcross, 'An investigation of prehistoric diet and economy on a coastal site at Galatea Bay, New Zealand', *Proc. prehist. Soc.* 33, 1967, pp. 107–31; G. N. Bailey, 'The role of molluscs in coastal economies: the results of midden analysis in Australia', *J. Arch. Sci.* 2, 1975, pp. 45–62.

24 See A. J. Legge, 'Cave climates', *in* E. S. Higgs (ed.), *Papers in Economic Prehistory*, Cambridge 1972, pp. 97–103.

25 H. de Terra, *Man and Mammoth in Mexico*, London 1957, pp. 72–3.

26 R. S. MacNeish, 'Reflections on my search for the beginnings of agriculture in Mexico', in G. R. Willey (ed.), *Archaeological Researches in Retrospect*, Cambridge, Mass. 1974, pp. 207–34.

27 For details and references to previous work see C. Vita-Finzi, 'Recent alluvial history of the southern Plateau of Mexico', *Geol. Rdsch.* 66, pp. 99–120. I am greatly indebted to Professor J. L. Lorenzo for arranging for laboratory analysis of samples I collected in the field.

28 S. F. Cook, 'Erosion morphology and occupation history in western Mexico', *Anthropol. Records Univ. Calif.* 17, 1963, pp. 281–334.

29 H. de Terra, 1957 (see above, note 25), p. 177.

30 J. L. Lorenzo (ed.), *Materiales para la Arqueología de Teotihuacan*, Invest. Inst. Nac. Anthrop. Hist. 17, 1968.

31 S. F. Cook, 'The historical demography and ecology of the Teotlalpan', *Ibero-Americana* 33, 1949, pp. 1–59.

32 *ibid.*, p. 49.

33 H. de Terra, 1957 (see above, note 25), p. 177.

34 P. B. Sears, 'Palynology in southern North America. I: archaeological horizons in the Basin of Mexico', *Bull. geol. Soc. Am.* 63, 1952, pp. 241–54; G. E. Hutchinson, R. Patrick and E. S. Deevey, 'Sediments of Lake Patzcuaro, Michoacan, Mexico', *Bull. geol. Soc. Am.* 67, 1956, pp. 1491–1504.

35 C. C. Wallén, 'Some characteristics of precipitation in Mexico', *Geogr. Annlr* 37, 1955, pp. 52–8.

Chapter 8

1 Another discreet plug for the author's *Recent Earth History*, London and New York 1973.

2 G. Ll. Isaac and G. H. Curtis, 'Age of early Acheulian industries from the Peninj Group, Tanzania', *Nature* 249, 1974, pp. 624–7.

3 C. E. Stearns, 'Dates for the Middle Stone Age of East Africa: a discussion', *Science N.Y.* 190, 1975, pp. 809–10.

4 R. I. Walcott, 'Recent and later Quaternary changes in water level', *Trans. Am. Geophys. Union* 56, 1975, pp. 62–72.

5 D. D. Anderson, 'A Stone Age campsite at the gateway to America', *Sci. Amer.* 218, 1968, pp. 24–33; D. M. Hopkins (ed.), *The Bering Land Bridge*, Stanford 1967.

6 M. R. Jarman, 'A territorial model for archaeology: a behavioural and geographical approach' *in* D. L. Clarke (ed.), *Models in Archaeology*, London 1972, pp. 705–33.

7 G. M. Lees and N. L. Falcon, 'The geographical history of the Mesopotamian plains', *Geogrl J.* 118, 1952, pp. 24–39; W. C. Brice (ed.), *A historical geography of the Near East*, London (in press).

8 K. S. Sandford and W. J. Arkell, *Palaeolithic Man and the Nile Valley in Nubia and Upper Egypt*, Publ. Orient.

Inst. Chicago 17, 1933; R. W. Fairbridge, 'Nile sedimentation above Wadi Halfa during the last 20,000 years', *Kush* 11, 1963, pp. 96–107.

9 R. L. Raikes, *Water, Weather and Prehistory*, London 1967.

10 I. J. Smalley, 'The loess deposits and Neolithic culture of northern China', *Man* 3, 1968, pp. 224–40; cf. Ho Ping-ti, *The Cradle of the East*, Chicago 1975; W. S. Ting, 'The geomorphology of the North China Plain and history of the early Chinese', *Bull. Inst. Ethnol., Acad. Sinica* 20, 1965, pp. 155–62.

11 See M. I. Finley, 'Atlantis or bust', *New York Review of Books*, 22.5.69, pp. 38–40; 'Back to Atlantis', *ibid.*, 4.12.69, p. 51; D. Ninkovich and B. C. Heezen, 'Santorini tephra', *in* W. F. Whittard and R. Bradshaw (eds), *Submarine Geology and Geophysics*, London 1965, pp. 413–53; P. J. Smith, 'Volcanic tephra on Crete', *Nature* 253, 1975, pp. 9–10; A. Bond and R. S. J. Sparks, 'The Minoan eruption of Santorini, Greece', *Jl geol. Soc. Lond.* 132, 1976, pp. 1–16.

12 For a recent review see F. A. Street and A. T. Grove, 'Environmental and climatic implications of late Quaternary lake-level fluctuations in Africa', *Nature* 261, 1976, pp. 385–90.

13 See, for example, C. C. Reeves, Jr, 'Pleistocene climate of the Llano Estacado', *J. Geol.* 73, 1965, pp. 181–9; L. J. B. de Lamothe, 'Les anciennes lignes de rivage du Sahel d'Alger et d'une partie de la côte algérienne', *Mem. Soc. géol. Fr.* 1 (6), 1911; R. van V. Anderson, 'Geology in the coastal Atlas of Western Algeria', *Mem. geol. Soc. Am.* 4, 1936; C. Vita-Finzi, 'Late Quaternary alluvial chronology of northern Algeria', *Man* 2, 1967, pp. 205–15. For a regional snowline reconstruction for the Mediterranean, see B. Messerli, 'Die eiszeitliche und die gegenwärtige Vergletscherung im Mittelmeerraum', *Geogr. Helvetica* 1967, pp. 105–228.

14 L. C. Briggs, 'Archaeological investigations near Tipasa, Algeria', *Bull. Am. Sch. Prehist. Res., Peabody Mus., Harvard* 21, 1963, p. 24.

15 E. C. Saxon, *Prehistoric economies of the Israeli and Algerian littorals*, Ph.D. thesis, Cambridge 1975; 'The mobile herding economy of Kebarah Cave, Mt. Carmel: an economic analysis of the faunal remains', *J. Arch. Sci.* 1, 1974, pp. 27–45.

Chapter 9

1 S. I. Dakaris, E. S. Higgs and R. W. Hey, 'The climate, environment and industries of Stone Age Greece: Part I', *Proc. prehist. Soc.* 30, 1964, pp. 199–244.

2 *ibid.*, p. 200.

3 H. Innes, *Levkas Man*, London 1971.

4 The rest of this section is based on E. S. Higgs and C. Vita-Finzi, 'The climate, environment and industries of Stone Age Greece: Part II', *Proc. prehist. Soc.* 32, 1966, pp. 1–29; E. S. Higgs, C. Vita-Finzi, D. R. Harris and A. E. Fagg, 'The climate, environment and industries of Stone Age Greece: Part III', *Proc. prehist. Soc.* 33, 1967, pp. 1–29.

5 I. Paraskevaidis, 'Observations sur le Quaternaire de la Grèce', *Actes IV Cong. Int. Quat. (INQUA)*, Rome-Pisa 1953–6, pp. 167–8.

6 A. Sestini, 'Tracce glaciali nel Pindo epirota', *Boll. Soc. geogr. ital.* 10, 1933, pp. 136–56; B. Messerli, 'Die eiszeitliche und die gegenwärtige Vergletscherung im Mittelmeerraum', *Geogr. Helvetica* 22, 1967, pp. 105–228.

7 See Higgs *et al.*, 1967 (note 4, above), p. 11; S. Bottema, *Late Quaternary Vegetation History of Northwestern Greece*, Groningen University, Groningen 1974, pp. 109–11.

8 Bottema 1974 (note 7, above); E. S. Higgs and D. Webley, 'Further information concerning the environment of Palaeolithic man in Epirus', *Proc. prehist. Soc.* 37, 1971, pp. 367–80.

9 I am indebted to Dr C. P. Palmer and Dr John D. Taylor of the British Museum (Natural History) for the determination of the lake-bed fauna.

10 C. Vita-Finzi, 'Related territories and alluvial sediments', *in* E. S. Higgs (ed.), *Palaeoeconomy*, Cambridge 1975, pp. 225–31.

11 N. G. L. Hammond, *Epirus*, Oxford 1967.

12 A. J. Legge, 'Cave climates', *in* E. S. Higgs (ed.) *Papers in Economic Prehistory*, Cambridge 1972, pp. 97–103.

13 J. K. Campbell, *Honour, Family and Patronage*, Oxford 1964.

14 See, for example, J. Chavaillon, N. Chavaillon and F. Hours, 'Industries paléolithiques de l'Élide', *Bull. Corresp. Hellénique* 91, 1967, pp. 151–201; B. Schröder, 'Das Alter von Schuttfächern östlich Korinth/Griechenland', *N. Jb. Geol. Paläont.* 6, 1971, pp. 363–71; J. C. Bintliff, 'Mediterranean alluviation: new evidence from archaeology', *Proc. prehist. Soc.* 41, 1975, pp. 78–84.

15 A. Sordinas, 'Investigations of the prehistory of Corfu during 1964–1966', *Balkan Studies* 10, 1969, pp. 393–424.

16 D. R. Harris and C. Vita-Finzi, 'Kokkinopilos: a Greek badland', *Geogrl J.* 134, 1968, pp. 537–46.

Chapter 10

1 S. Judson, 'Erosion rates near Rome, Italy', *Science N.Y.* 160, 1968, pp. 1444–6; cf. C. Vita-Finzi, 'Chronicling soil erosion', *in* A. Warren and F. B. Goldsmith (eds), *Conservation in Practice*, London 1974, pp. 267–77.

2 D. L. Merryfield and P. D. Moore, 'Prehistoric human activity and blanket peat initiation on Exmoor', *Nature* 250, 1974, pp. 439–41.

3 D. Neev *et al.*, 'Recent faulting along the Mediterranean coast of Israel', *Nature* 245, 1973, pp. 254–6.

4 N. N. Ambraseys, 'Earth sciences in archaeology and history', *Antiquity* XLVII, Sept. 1973, pp. 229–31.

5 R. G. Goodchild, 'Earthquakes in ancient Cyrenaica', *in* P. T. Barr (ed.), *Geology and archaeology of northern Cyrenaica*, Petrol. Explor. Soc. Libya, Tripoli 1968, pp. 41–4; 'A coin-hoard from "Balagrae" (El-Beida), and the earthquake of A.D. 365', *Libya Antiqua* 3–4, 1966–7, pp. 203–12.

6 See H. T. Lambrick, 'The Indus floodplain and the "Indus" civilization', *Geogrl J.* 133, 1967, pp. 493–4.

7 R. Coque, *La Tunisie Présaharienne*, Paris 1962.

8 D. A. E. Garrod, *Environment, Tools and Man*, Cambridge 1946.

9 See G. W. Dimbleby, 'Climate, soil and man', *Phil. Trans. R. Soc. Lond.* B, 275, 1976, pp. 197–208.

10 Review in *Antiquity* XLI, Dec. 1967, pp. 330–1.

11 Sir M. Wheeler, *Archaeology from the Earth*, Oxford 1954, p. 1.

12 M. I. Finley, 'Atlantis or Bust', *N.Y. Rev. of Books*, 22.4.69.

Bibliographical note

The following books may be found helpful as introductions to the study of landform evolution:

A. L. Bloom, *The Surface of the Earth*, New Jersey 1969

G. H. Dury, *The Face of the Earth*, Harmondsworth 1959

A. Holmes, *Principles of Physical Geology* (2nd edn), London 1965

R. C. Selley, *Ancient Sedimentary Environments*, London 1970

List of illustrations

Index

(Note: some of the entries below refer to illustrations)

174